IMAGES
of America

JEWISH LIFE IN AKRON

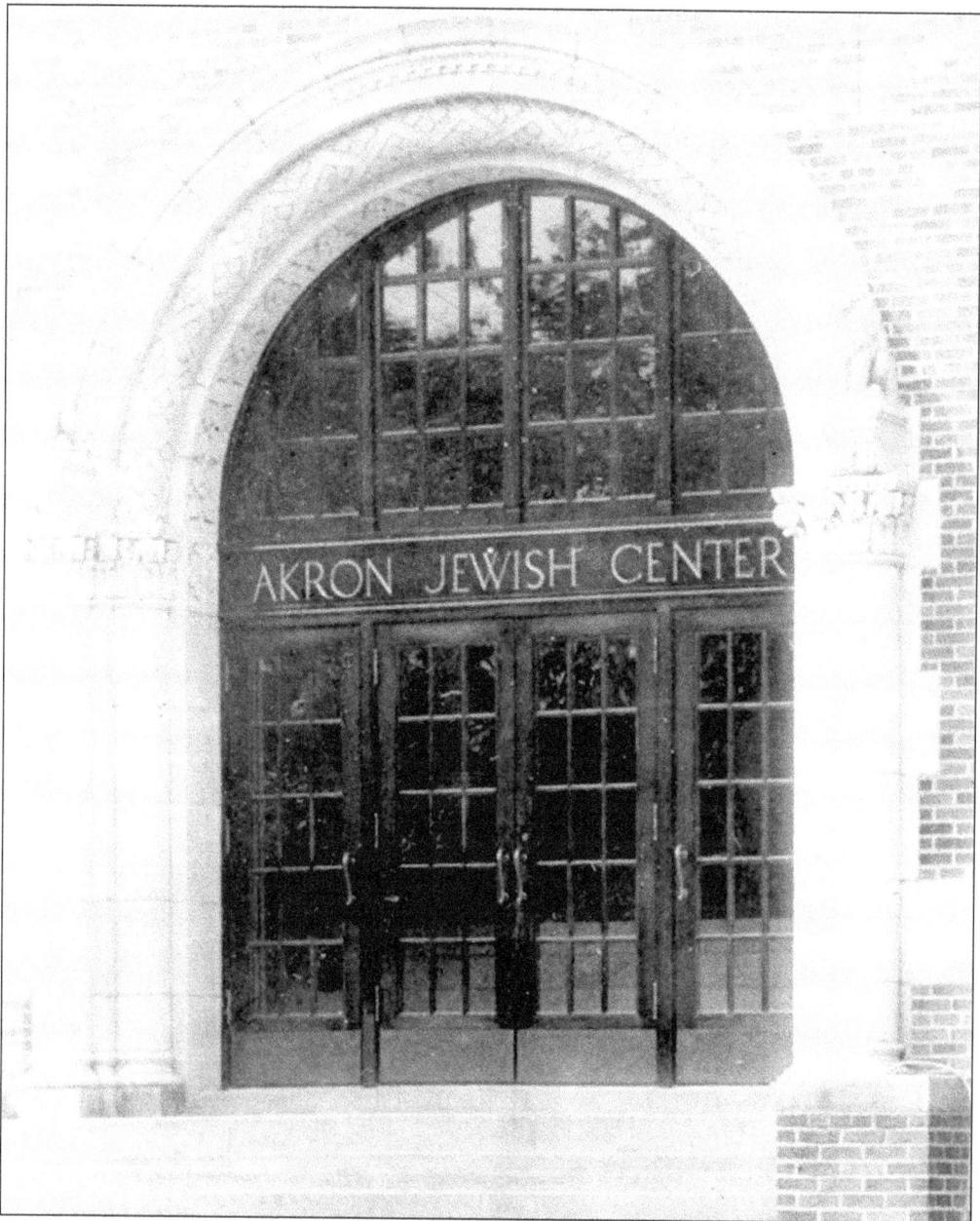

This imposing arch gracefully framed the main entrance to the Balch Street Akron Jewish Center, and for tens of thousands of people who crossed the threshold from 1929 until 1971, it was a gateway to dreams, to educational experiences, to cultural events, to a social life for all generations, to a testing ground for ability in sports, and to religious celebrations; but most of all, it was the place where the Jewish people of Akron truly became a community.

IMAGES
of America

JEWISH LIFE IN AKRON

Arlene Cohen Rossen and Beverly Magilavy Rose

Published by Arcadia Publishing
Charleston SC, Chicago IL, Portsmouth NH, San Francisco CA

Library of Congress Catalog Card Number: 2005935047

For all general information contact Arcadia Publishing at:
Telephone 843-853-2070
Fax 843-853-0044
E-mail sales@arcadiapublishing.com
For customer service and orders:
Toll-Free 1-888-313-2665

Visit us on the internet at http://www.arcadiapublishing.com

On the cover: The Sacks family in their dining room on Bell Street in 1934, ready to begin the traditional Passover seder. Pictured here around the table from left to right are James, Ada (known as "Sollie's Ada"), Robert (on Sol's lap), Sol, Selma, mother Helen, father Henry, Charlie, Laurel, Ada (known as "Charlie's Ada"), Nonnie, Shirley, Morris, Melvin, and Irene Sacks. Standing in the rear are Leon and Selma's husband, Manny Mazur. Present but not shown are Sandra, Bess, and Sydney Sacks. (Photograph courtesy of Shirley Friedman.)

This book is dedicated to the memory of those who came before us. (Photograph by Aaron Rapport.)

CONTENTS

ACKNOWLEDGMENTS

As in all major volunteer endeavors, this book was the work of a "village." It is difficult to name all who expended enormous amounts of time and energy to complete this text. In the beginning, 32 native Akronites sat around a table to sort old photographs, laugh together, and share old family stories. In some cases, memories were all that remained. The authors realized that the by-product of this effort was a feeling of pride in the accomplishments of the Jewish community over the past 150 years.

We want to recognize Bessie Stile Rothkin for her remarkable memory and gift for storytelling; Jerry Holub for his extensive research; Sandra Levenson, Sylvia Lewis, Mel Mermelstein, Carolyn Narotsky, Esther Posen, Lourie Rapport, Lois Reaven, and Bev Rothal for their determination to find "just the right" images; Sally Eichner and Gloria Reich for carefully proofreading; and Kyle Verette for her technical expertise and ability to remain calm under pressure. Judy James, director of Special Collections at the Akron-Summit County Public Library, and Steve Paschen, senior archives associate at the University of Akron, were extremely knowledgeable and helpful. Permission was granted by Helga Kaplan to include source material from her 1975 thesis entitled *A History of the Akron Jewish Community*. Dr. Katherine Endress was the chief "cheerleader" for the authors, as she encouraged, advised, and shared her expertise. For her help, we are extremely grateful.

The authors extend sincere appreciation to Mike Wise, who gave permission for use of archival photographs. Unless otherwise attributed, photographs are provided courtesy of the Jewish Community Board of Akron.

Special love to Arlene's husband, Dick Rossen, for framing, consulting, and taking great interest in our work. His artistic eye gave us a new perspective.

It is to those who came early on (especially our parents and grandparents), to secure a future for us, our children, and our grandchildren, that we dedicate this book. Most are in Jewish cemeteries throughout Akron, and we know they are taking pride in their achievements.

We also wish to acknowledge the staff of Arcadia Publishing, particularly acquisitions editor Melissa Basilone, for making this book possible.

This book is a project of the Shaw Jewish Community Center and the Akron Celebrates 350/150/75 Committee. Initial funding for the book was donated by the Jewish Identity Development Fund of the Jewish Community Board of Akron. All royalties from the sale of books will be donated to the Jewish community through a fund established by the authors at the Jewish Community Board of Akron.

INTRODUCTION

The Jewish community of Akron was established by European immigrants, whose dream was to create a home where their children and future generations could be economically secure, enjoy varied cultural and educational opportunities, find other Jewish people of like mind, practice their religion with little fear of persecution, and interact with the secular population in a meaningful relationship. Jewish immigrants first came to Akron, Ohio, in the mid-19th century as part of the "westward expansion." The opening of the Ohio and Erie Canal in the 1830s and rail service between Cleveland and Cincinnati in 1852 increased the development of Akron as a trade center.

These early settlers came with a spirit of adventure that has always permeated the Jewish community and that enabled other generations to enlarge upon the basic values established by their ancestors. Many found what they sought in Akron. From their backpacks and wagons, peddlers saved to become small shopkeepers, larger store merchants, and department store owners. In the 1930s and 1940s, most of the stores on the main mercantile streets were owned by Jews. Although Akron had become the rubber capital, only a few Jewish people worked in the factories. Instead they sought economic stability in the service industry, in professions, and in land development.

Early immigrants came from Germany, Bavaria, and Hungary and were generally more affluent than later settlers from Eastern Europe, who fled the ghettos and the rising anti-Semitism in the 20th century. There was little internal assimilation among these Jewish people, although benevolence was shown through welfare programs and charity. Finally, in 1929, the spirit of cooperation came together with the formation of the Akron Jewish Center (AJC). This facility serves families with educational programs and recreational facilities. As the AJC celebrates its 75th anniversary, its place in the community remains strong.

At its peak in the 1960s, the Akron Jewish community numbered about 6,500. Unfortunately the community has shown little growth over the past two decades, and now there are only about 3,000. Some younger people return after college to work in successful family businesses, medical professionals are attracted to the highly rated health care facilities, and educators and professors come to the University of Akron and Kent State University, but the outflow of older adults to the "sun belt" states has had a major negative impact on the demography of the Jewish community.

With four congregations in the greater Akron area, the community enjoys cooperation among its constituent groups. Rabbis from all congregations and leaders of organizations meet regularly to plan joint programs and activities. This is a great source of pride for Akron. Credit is given to the leadership of the Akron Jewish Federation (now known as the Jewish Community Board of Akron) and the Akron Jewish Center (now known as the Shaw Jewish Community Center) for their persistence in encouraging a healthy dialogue among organizations and people.

As the Jewish community celebrates 150 years of settlement, and the Shaw Jewish Community Center celebrates 75 years of existence, it seems an appropriate opportunity to spotlight the achievements of the members of the community over the years. With this long history, it was impossible to name everyone whose lives are woven into the fabric of the community. A cross section is represented, but it is the authors' hope that younger people will realize the pride that their ancestors took in these achievements and the spirit that was shown throughout the years. It is to these previous generations that the authors dedicate this book.

In this book, the authors will attempt to show this community spirit and its effect on Jewish life in Akron through images and words.

One

NEW BEGINNINGS

It takes a hearty person of mind and spirit to leave the country of his birth and create a new home in a less-developed city among people whose language is foreign. But hearty souls came to Akron in the middle of the 19th century to begin anew. Many had come from Europe to New York City to find the "golden" shores of the United States. Men left their families in the old country with the idea of earning enough money to bring them to the United States. New York City did not fulfill these dreams. Crowded living conditions and insufficient work made these early immigrants look farther west.

By this time, other Ohio cities, Cleveland and Cincinnati, had become developed enough to support larger populations. Lake Erie in the north and the Ohio River in the south provided economic development opportunities. In the 1830s, businessmen bought the rights to the Ohio and Erie Canal and opened a route between Cleveland and Cincinnati, with Akron as one of the stops. Families already settled in the other Ohio cities wrote to others in New York and indicated that a move to Akron gave opportunity for a better future.

The difficult times continued for many years until immigrants established themselves in business and community. Slowly they sent for their loved ones, and family life resumed. Most photographs and images of the time glorified the lifestyle. Families struggled, but children had lovely clothes and attended public schools.

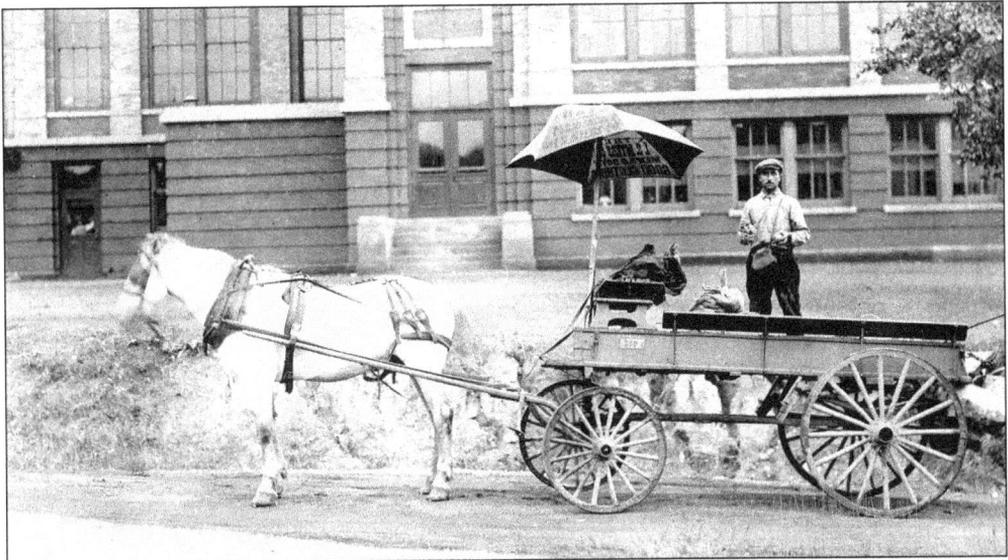

A good example of this was William Stile, who came to Akron in 1916 to seek work as a carpenter, a trade he learned in Warsaw, Poland. The building trades were in a depressed state at that time, so he sought to earn a living for his large family by peddling groceries from his horse-drawn wagon. In this photograph, Stile stands proudly on his wagon. (Photograph courtesy of Bessie Stile Rothkin, daughter of William Stile.)

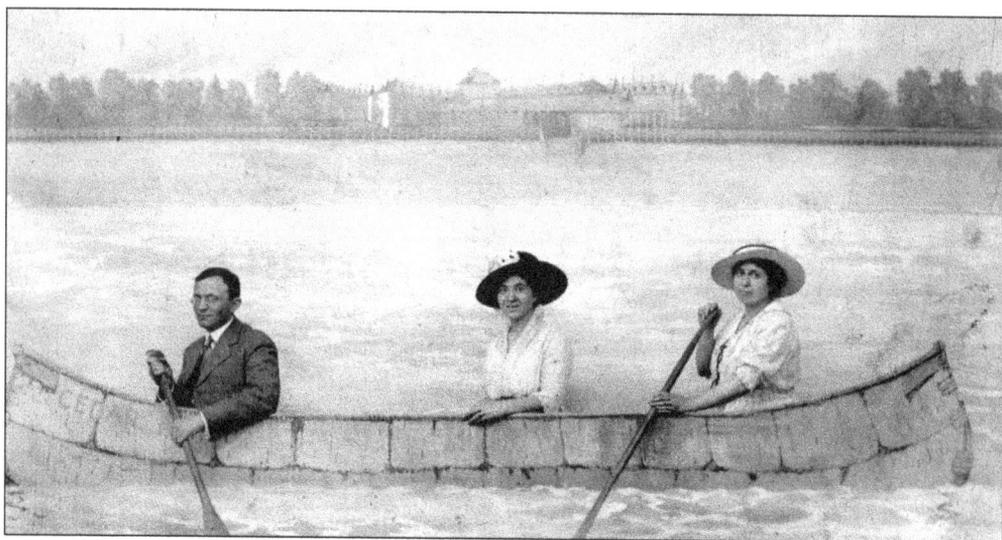

In the early part of the 20th century, enjoying the outdoors with your sweetheart was a much more formal affair than it is today. Louis Friedman is chaperoned by his sister-in-law, Julia, while Deborah Hahn, his fiancée, steers the canoe at Summit Lake in 1915. (Photograph courtesy of the Hahn family.)

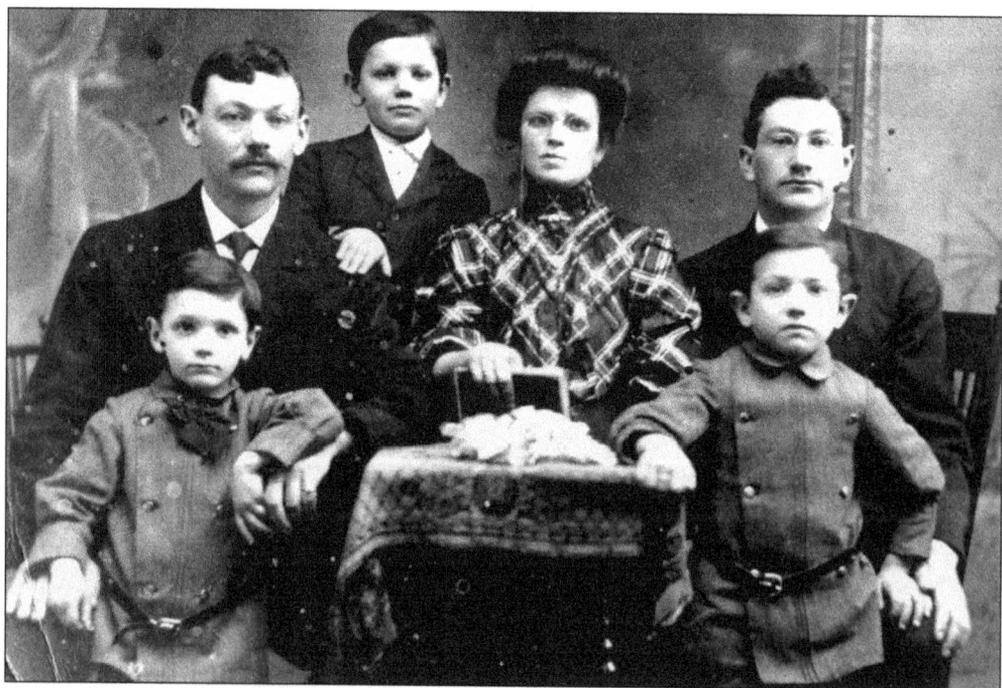

Brothers Charlie and Morris Sacks, with their father, Henry Sacks, and Bernard Mack, established the Sacks Electric Company. This formal Sacks family portrait, taken in the early 20th century, pictures, from left to right, Sol, Henry, Morris, Helen, Helen's brother (name unknown), and Charlie. (Photograph courtesy of the Sacks family.)

Rae Eichner came to Akron as a young girl. She worked hard to learn English. She lived in Akron until her death at age 92. She remembered the streetcars, the horse and buggy trips, and the cow pastures on Sherbondy Hill. She remembered shopping on Wooster Avenue, lunch at the Georgian Room of O'Neils, and Kazdin's Delicatessen. In this 1920 photograph, Rae stands proudly with her son Sidney and daughter Lillian. (Photograph courtesy of the Eichner family.)

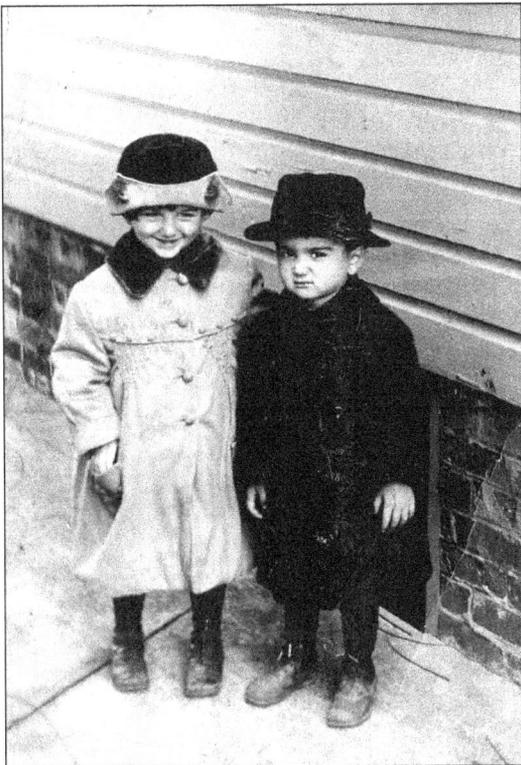

Leona Magilavy and her younger brother, Jack, pose in front of their Clark Street home in the early 1920s. Jack's scowl reflects his unhappiness at being forced to wear the hat that his cat had earlier used as a litter box. (Photograph courtesy of Nachelle Whitlow.)

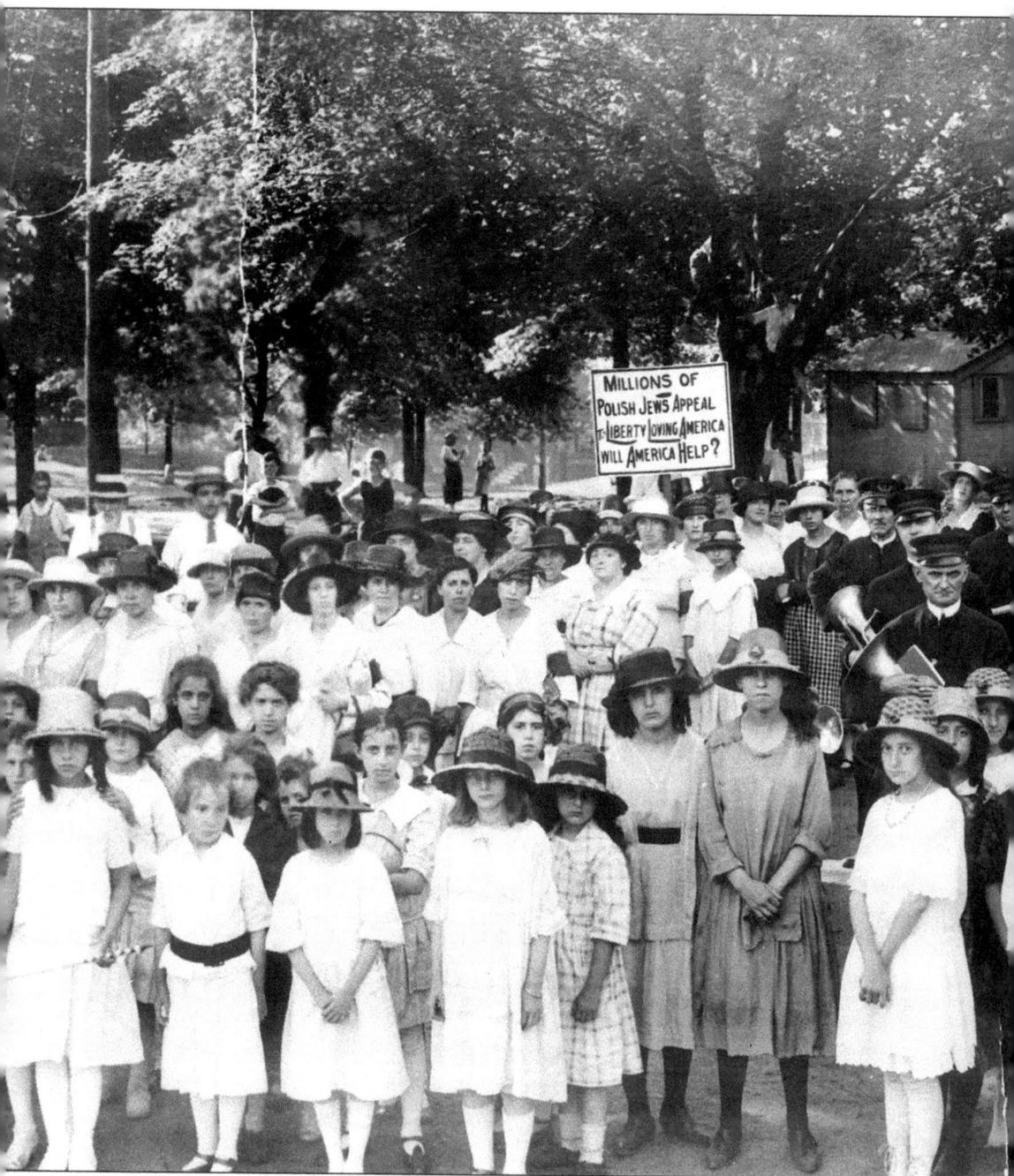

Polish immigrants in Akron join a protest against the ghettos and pogroms of Poland between

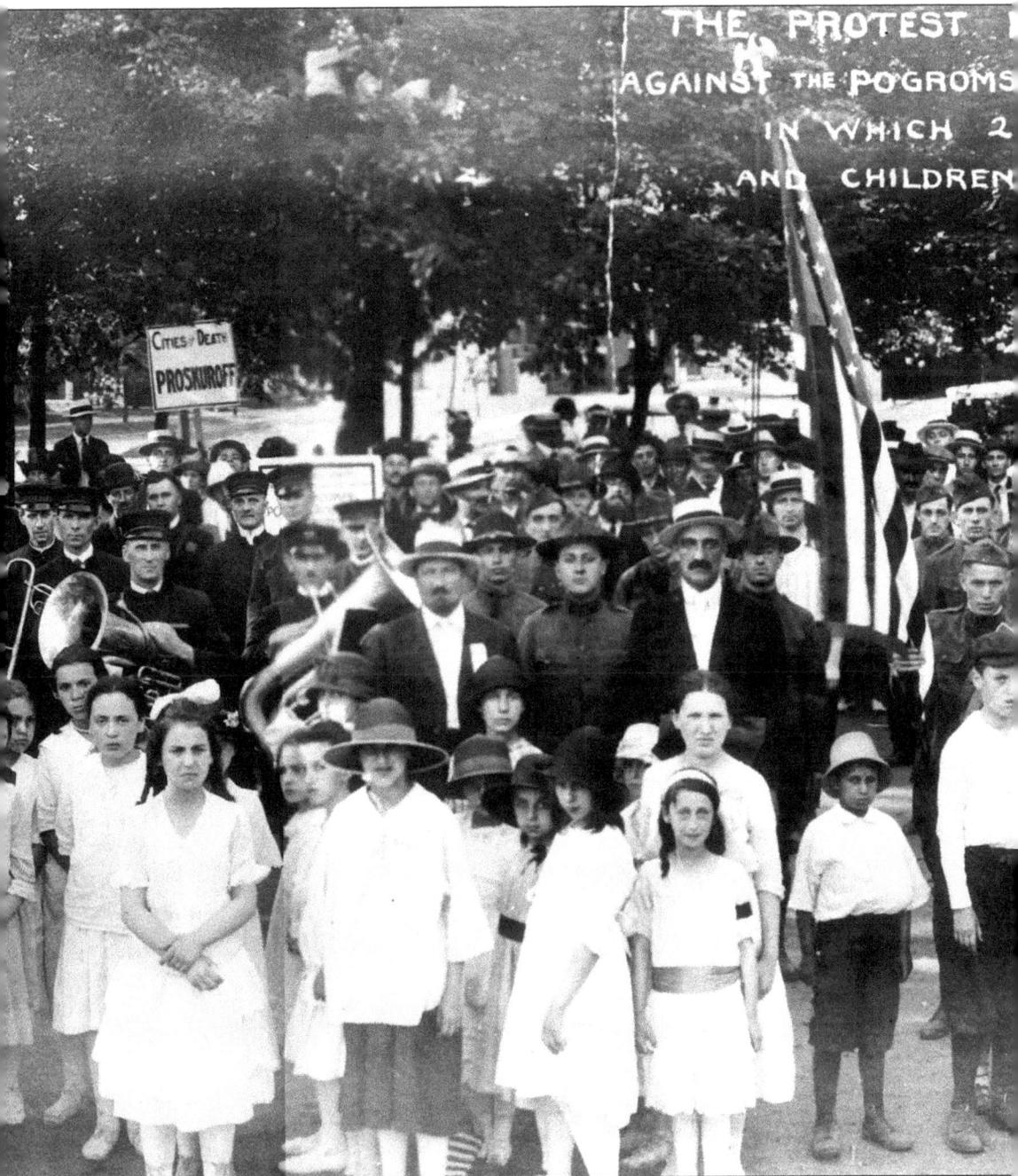

the two World Wars. In this photograph, a brass band adds to the excitement of the day.

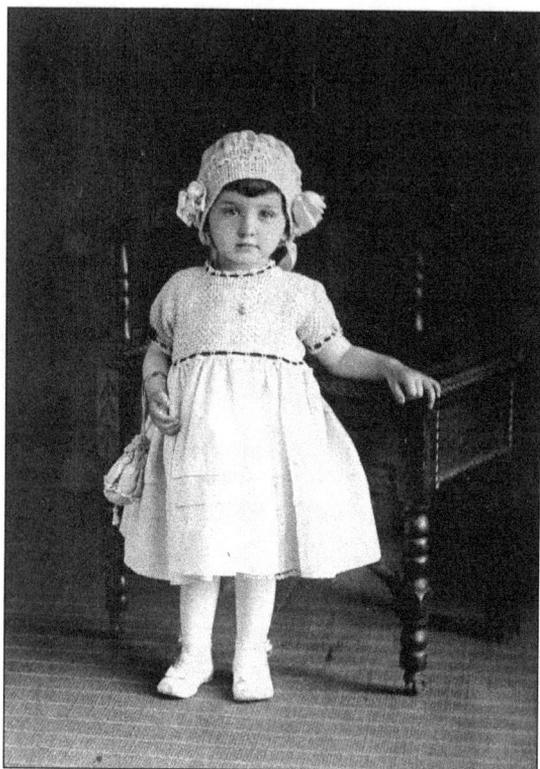

This photograph of Leona Magilavy in 1918 reveals a beautiful little girl dressed in exquisite fashion. She lived in East Akron with her parents, immigrants from Lithuania and Romania, and her parents' extended family. Her father owned a small, struggling clothing store for rubber workers on Case Avenue. But all parents hoped their children would have what they did not, i.e., the life reflected in photographs, and luckily for most, they did. (Photograph courtesy of Michael Sacks.)

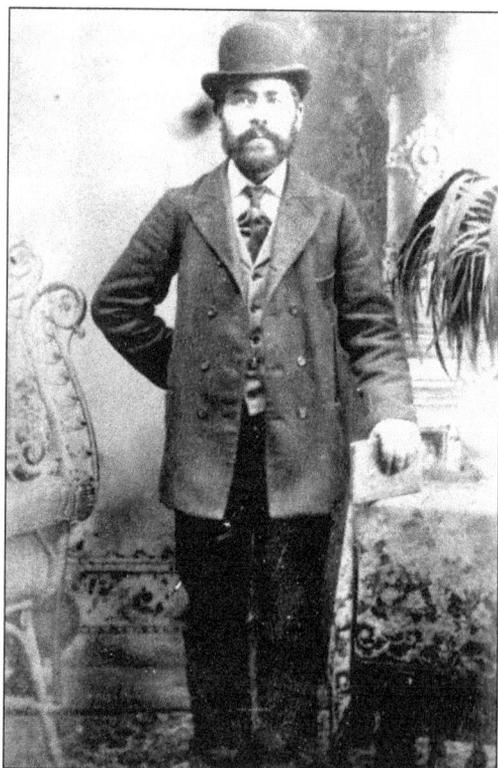

Samuel Milkman came to the United States in 1902 and temporarily settled in New York. His wife and children remained in Lithuania to await money for passage. He earned enough for them to sail to New York. He knew they would move "to the country" (Akron) because other family was already there. Unfortunately, Samuel died in 1908, shortly after arriving in Akron. He is buried in the front row at Sherbondy Hill Cemetery. Ironically, he was one of its founders. (Photograph courtesy of Martin Eichner.)

14

Two

ENDURING BONDS

Judaism has always emphasized the sanctity and the importance of the family. It is the primary center of religious life. In the early years of life in Akron, families lived together with their parents, and often, multiple generations (on both sides) under one roof. Aunts and uncles and their children lived on the same block or within walking distance. Holidays and family events were shared with houses full of relatives. Today that same Jewish family is scattered all over the country. There are very few families whose children all remain in Akron. The family unit is also much more diverse, due to a high rate of intermarriage and same sex partnerships. And yet, the bonds remain. Families still come together for holidays, travel, family "simchas" (weddings, b'nai mitzvah, graduations, and so forth), reunions, and funerals.

And what is a good life without friends? This is a community of caring, concerned, and fun-seeking friends who have long since moved beyond the divisive bounds of old and often misplaced "pride of nationality" of the early settlers. The once derisive terms "Litvak," "Hunkie," or "Pollack" have become humorous epithets. Akron Jews have been blessed by friends and know how to make them. It is a hallmark of the Akron Jewish community.

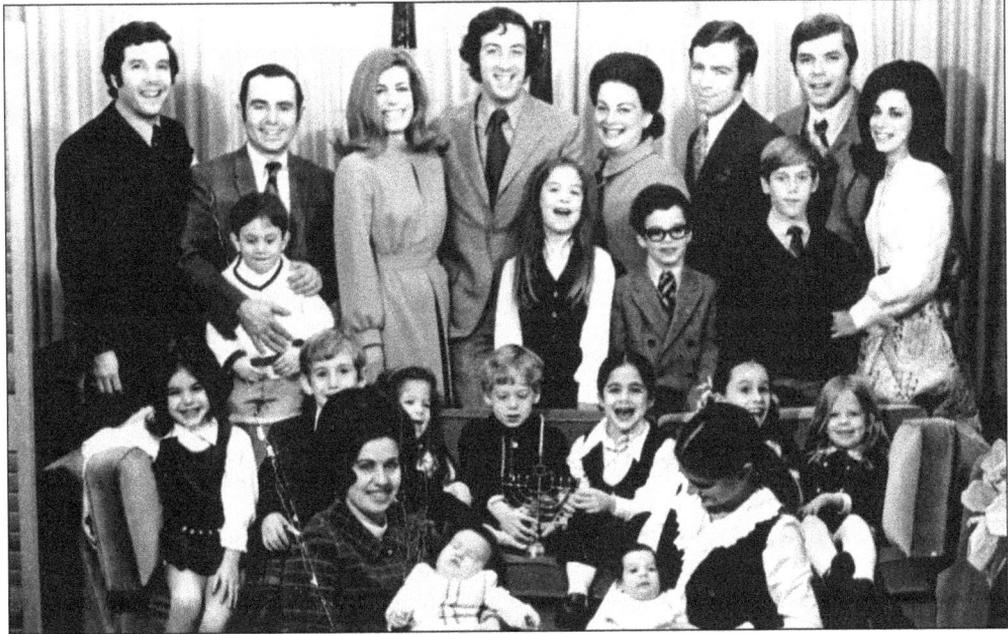

Chanukah provided a great time for friends to gather and enjoy one another's company. This image of the Gourmet Club in 1969 includes, from left to right, the following: (seated) Arlene Rossen with son Michael, and Renee Rose with son Michael; (on sofa) Vicki and Todd Willen, Lauren Myers, David Abbey, Lizzy Rose, Debby Rossen, and Melissa Myers; (first row) Danny Rossen, Carolyn Abbey, Brian Rose, and Brad Willen; (second row) Eddie Rose, Dick Rossen, Sue and Alan Abbey, Susan and Mel Myers, and Stuart and Sybil Willen. (Photograph courtesy of the Gourmet Club archives.)

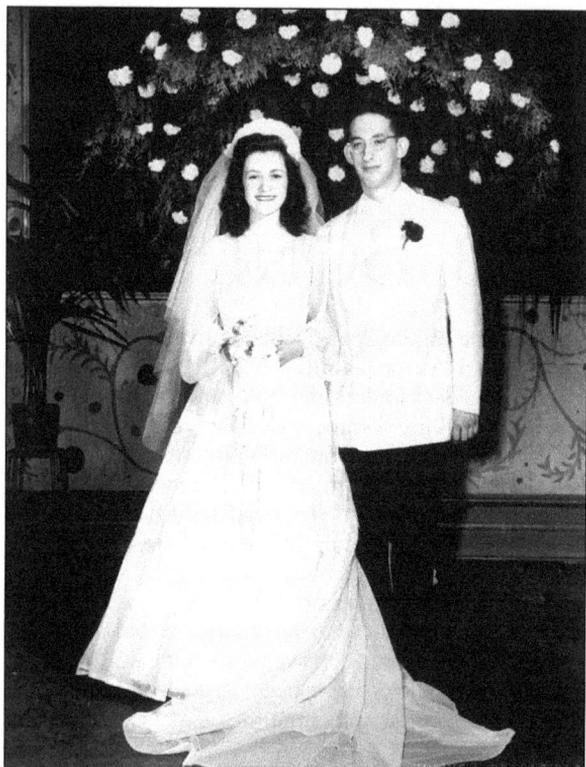

When Ruth Schwartz Sweet and Leonard Sweet served as attendants at the wedding of their best friends, Mary Ann Marks and Stanley Minster, they would not have predicted that their families would merge 56 years and two generations later, when their grandchildren were wed. Mary Ann's generations are represented in these photographs of Akron weddings. The photograph at left was taken when Mary Ann Marks married Stanley Dean Minster on June 8, 1947. In the photograph below, the Minsters' daughter, Deborah Susan, married Richard Alan Zelin on July 1, 1973. (Photographs by Julius Greenfield.)

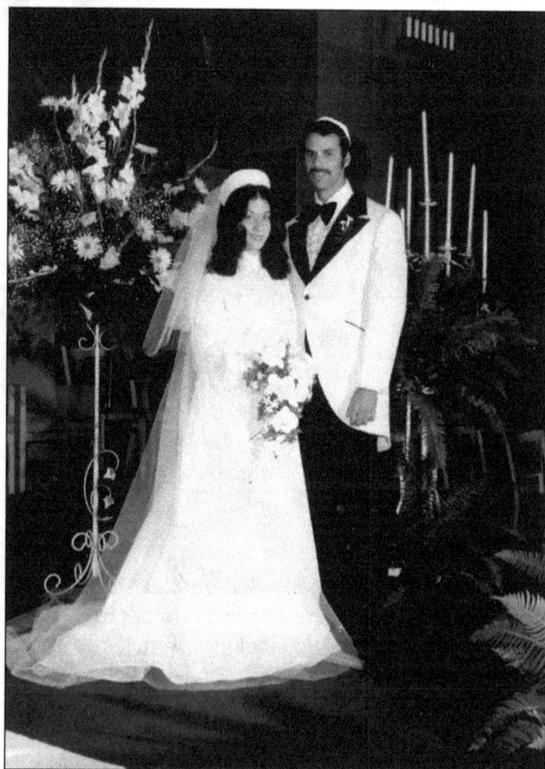

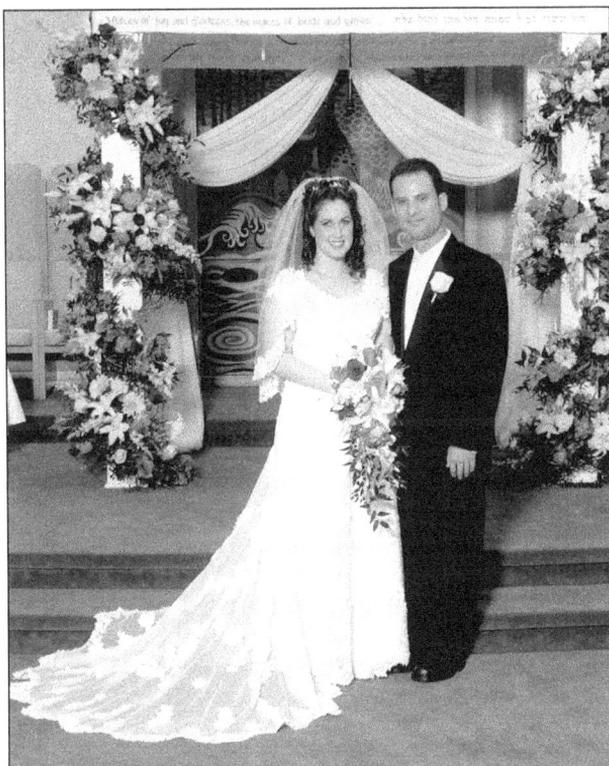

What a joyous celebration when Ruth and Leonard Sweet's granddaughter Erin Kohn was wed to Mary Ann and Stan Minster's grandson Steven Zelin. This photograph was taken at this special occasion on June 15, 2003, when Erin Elyse Kohn married Steven Ira Zelin. (Photograph by David Schoenfelt.)

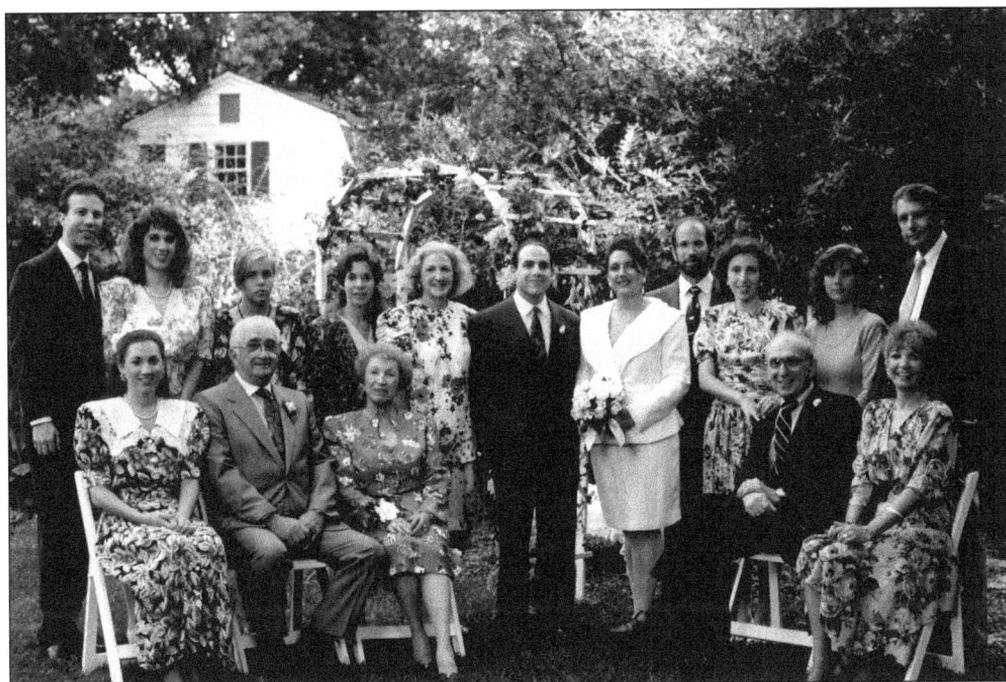

Not all weddings were held in a synagogue or hotel. In the 1990s, the garden of the groom's mother provided a pleasant, less formal alternative. (Photograph by Robert Graetz.)

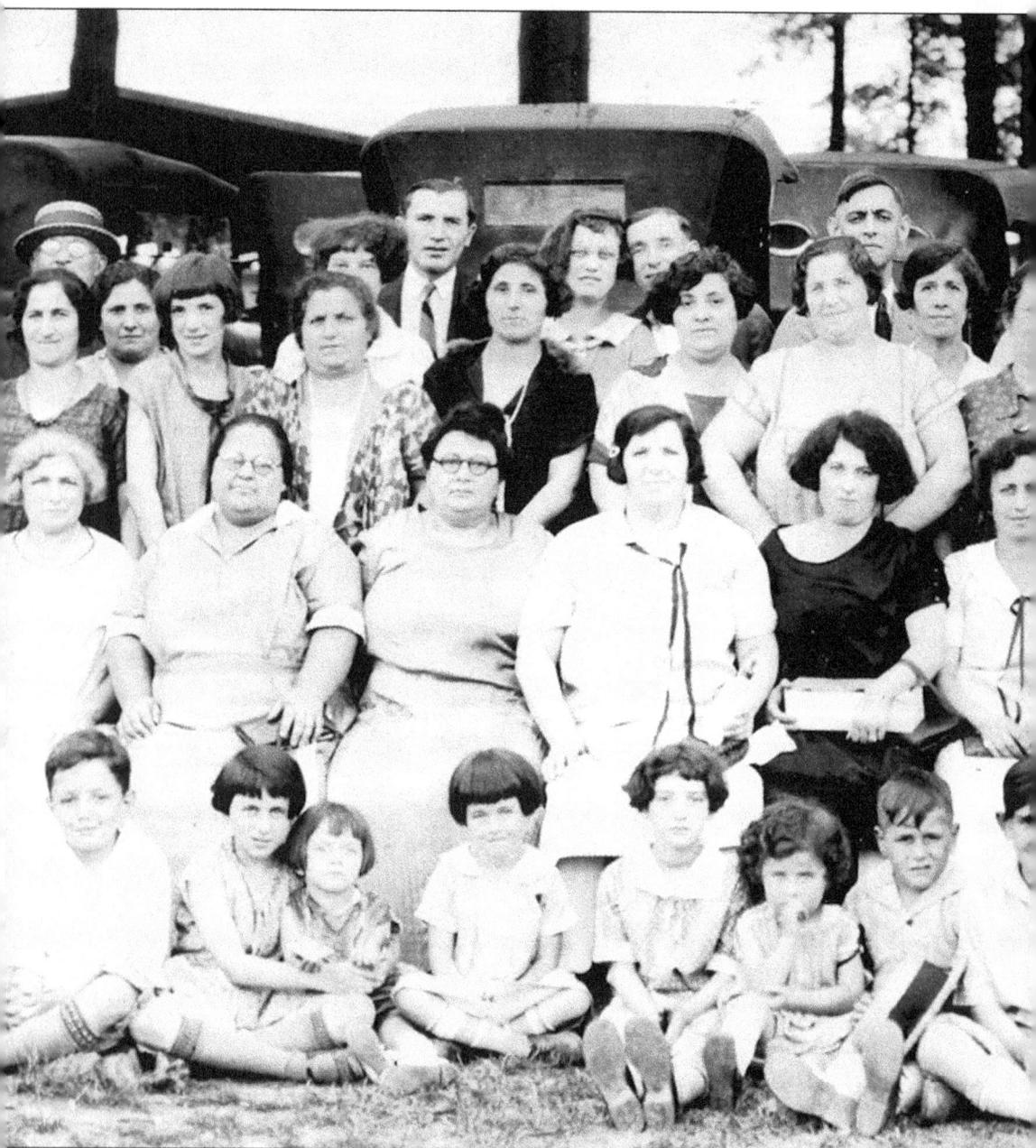

Members of the Ahavas Zedek congregation enjoy the camaraderie of an afternoon picnic in 1925. The wonderful old cars give them the mobility to travel to the country with their children

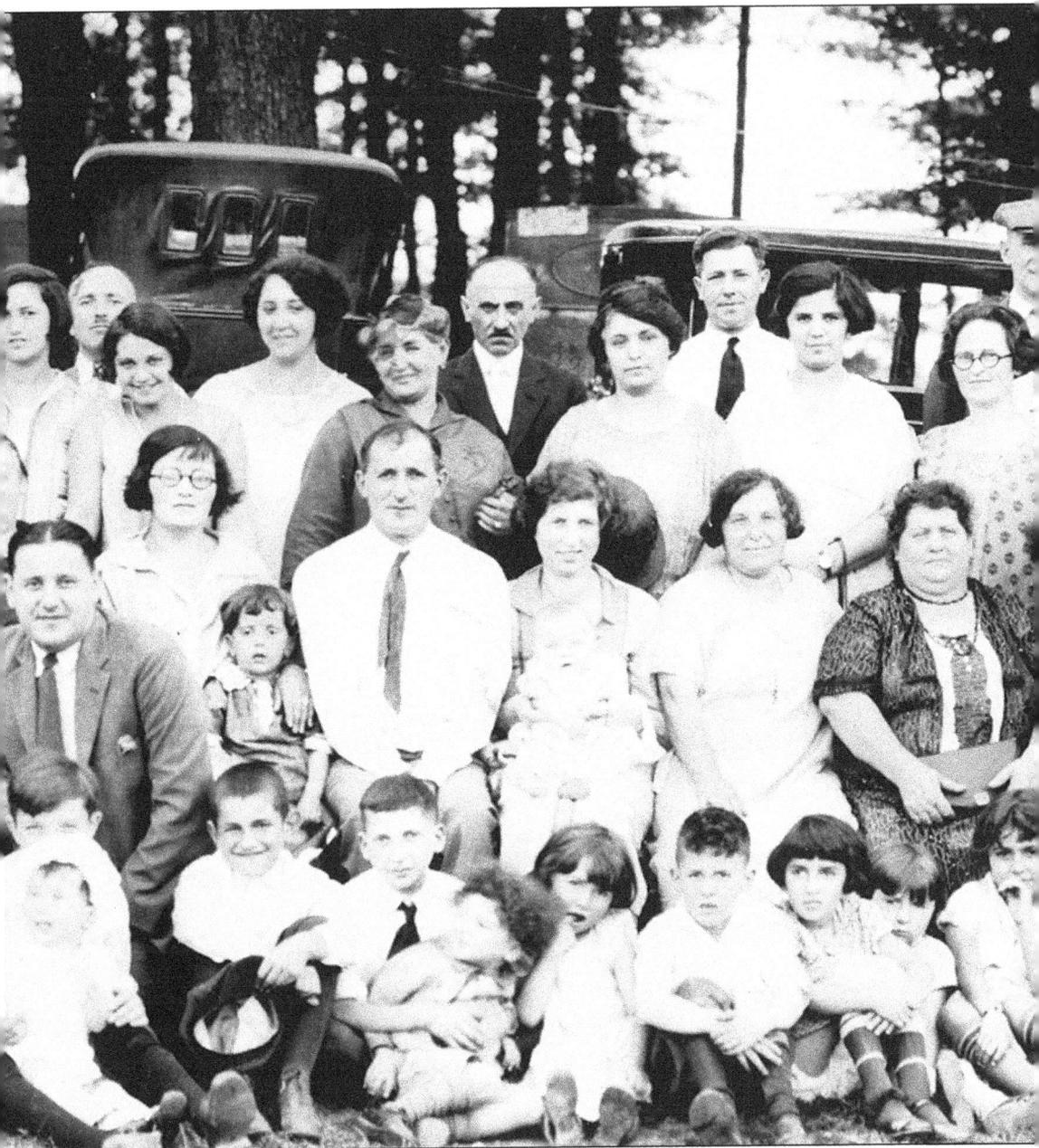

and friends for a holiday.

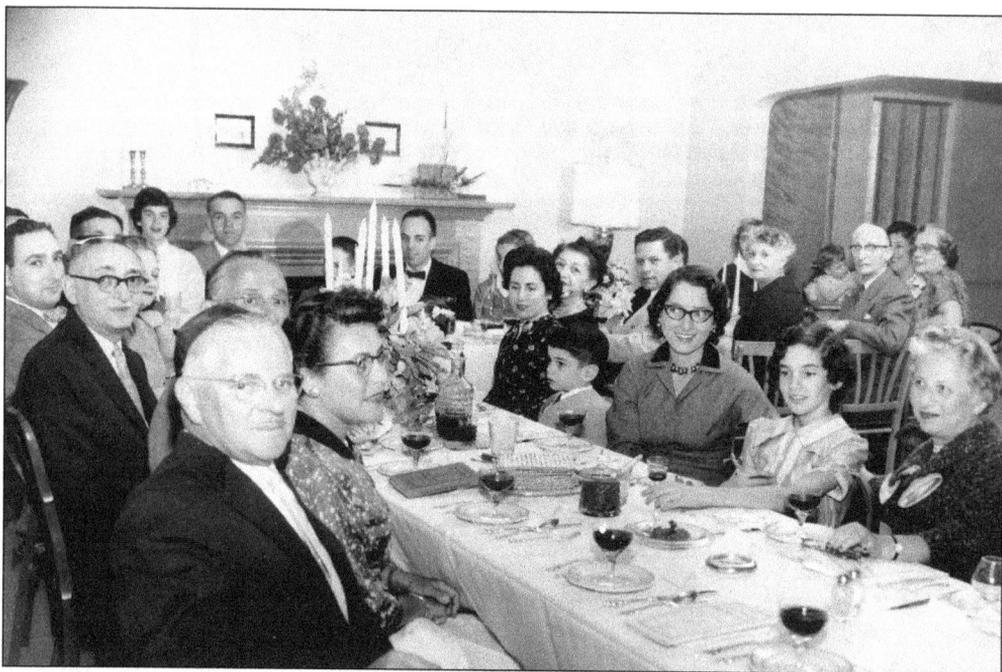

Jewish holidays are time for family. Seated at the holiday table of the Ben Holub family on Roslyn Avenue are the Buxbaums, the Nehrers, and the Shechters. (Photograph courtesy of Jerry Holub.)

Samuel and Rachel Koplin would be very proud of the achievements of their children and grandchildren. Their son Nathan was a prominent judge in Akron. Grandsons Aaron Koplin and S. Robert Waxman and their great-grandson Joel Levenson are ordained rabbis. Seated at their festive table in 1951 are Samuel and Rachel Koplin. (Photograph courtesy of Sandra Levenson.)

Eleanor Friedman serves tea to her sister Beatrice in the dining room of their Beck Avenue home in 1924. (Photograph courtesy of Friedman family.)

Going "downtown" was a treat for mothers and daughters. Lunch at the Garden Grille and a brisk walk to shop at favorite stores is a childhood memory. In this late 1930s photograph, Lois Rubenstein and her mother, Rose, enjoy a day together. (Photograph courtesy of Lois Reaven.)

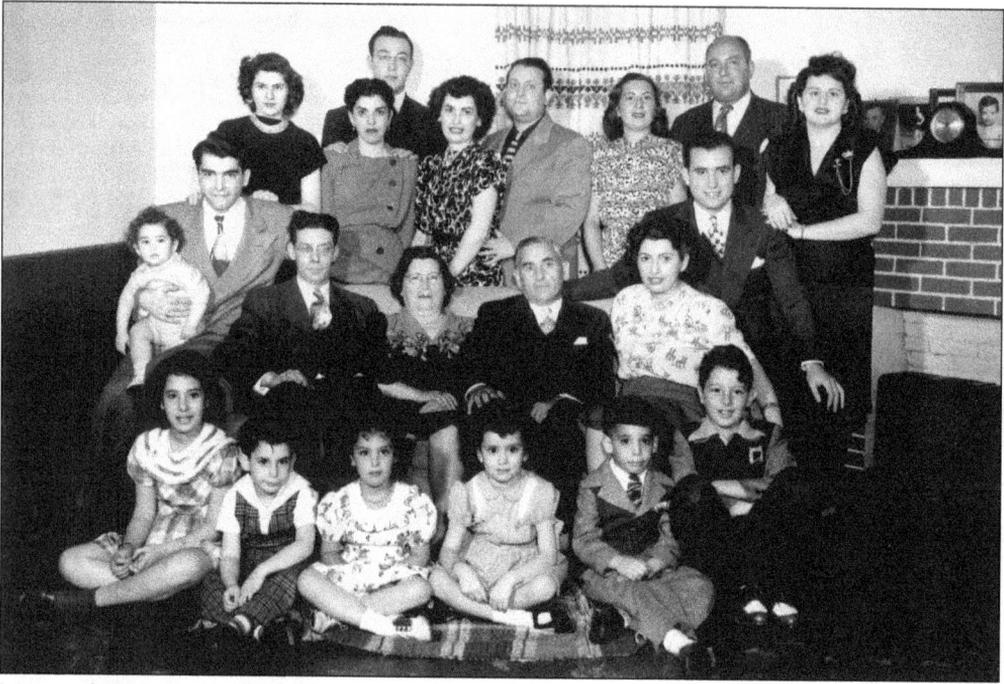

Max and Yetta Rogovy instilled the ideals of living a charitable life into their children and grandchildren. Their son Herman served as president of Akron Jewish Federation, daughter Harriet was president of its Women's Division, and daughter Eva was a leader of Hadassah. A family reunion in 1948 was the occasion for this photograph. (Photograph courtesy of Diane Greene.)

Traditions abound when Joyce and Martin Levin conduct their annual Passover seder. Gefilte fish can be made only in the antique bowl used by Joyce's mother, Alice Backer. Matzah covers and seder plates are made by children and grandchildren. Special wine cups are always displayed. In this photograph, Martin and Joyce are surrounded by their granddaughters. (Photograph courtesy of Joyce Levin.)

At a time when outdoor pools were not prevalent, most teenagers and young families swam at White Pond on Copley Road. This photograph shows a group of friends enjoying the rays.

An annual family reunion has become a popular way for family members who have moved away from Akron to have an opportunity to get together with those who stayed. Four generations of Magilavys, originally all from Akron, now living in 10 different states, are shown here in 1993. (Photograph courtesy of Charles Slikkerveer.)

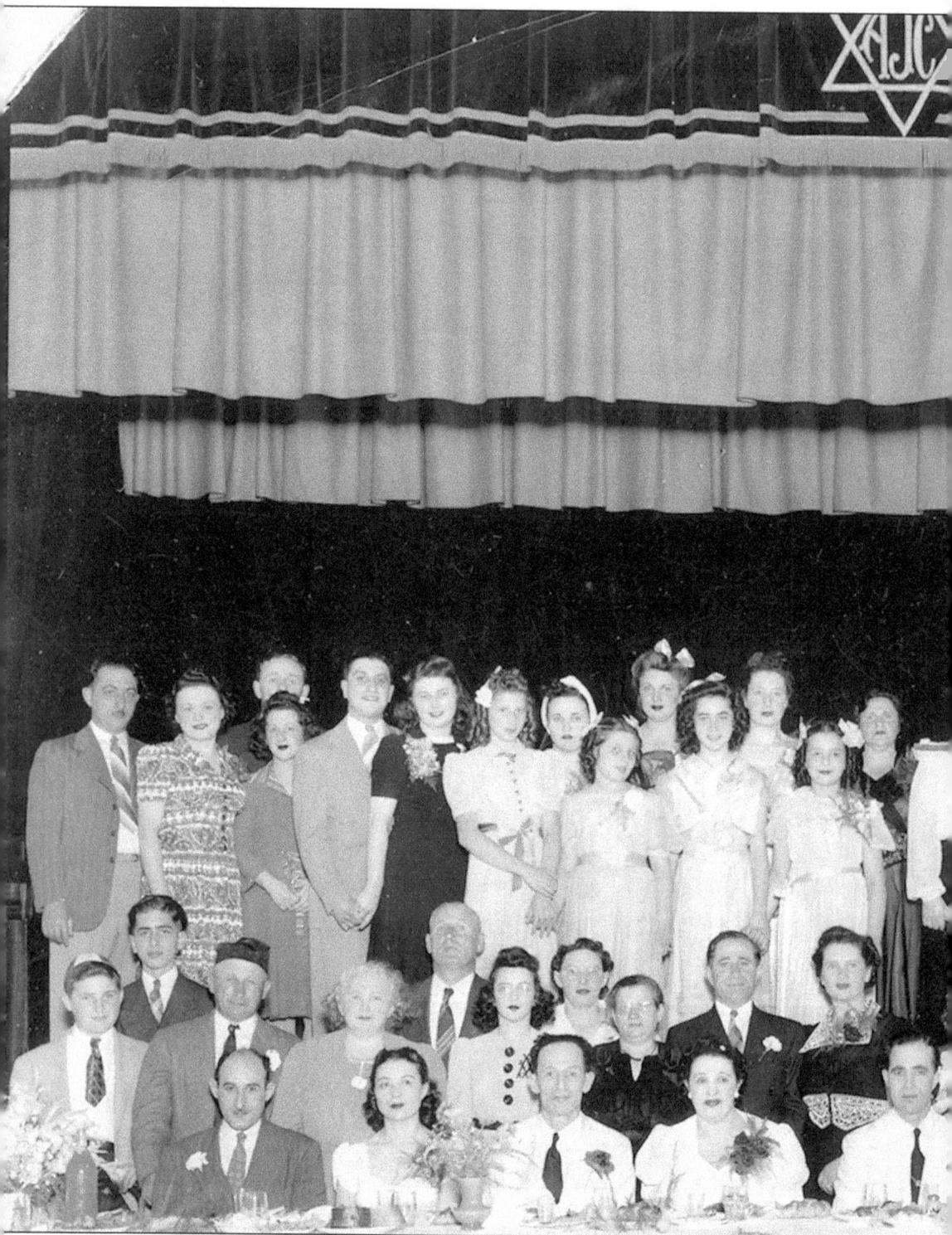

Family and friends gathered to celebrate the bar mitzvah of Harvey Ekus at the Akron Jewish Center in 1941. The entire Ekus family, the Davidsons, the Gertz family, and the Weintraubs

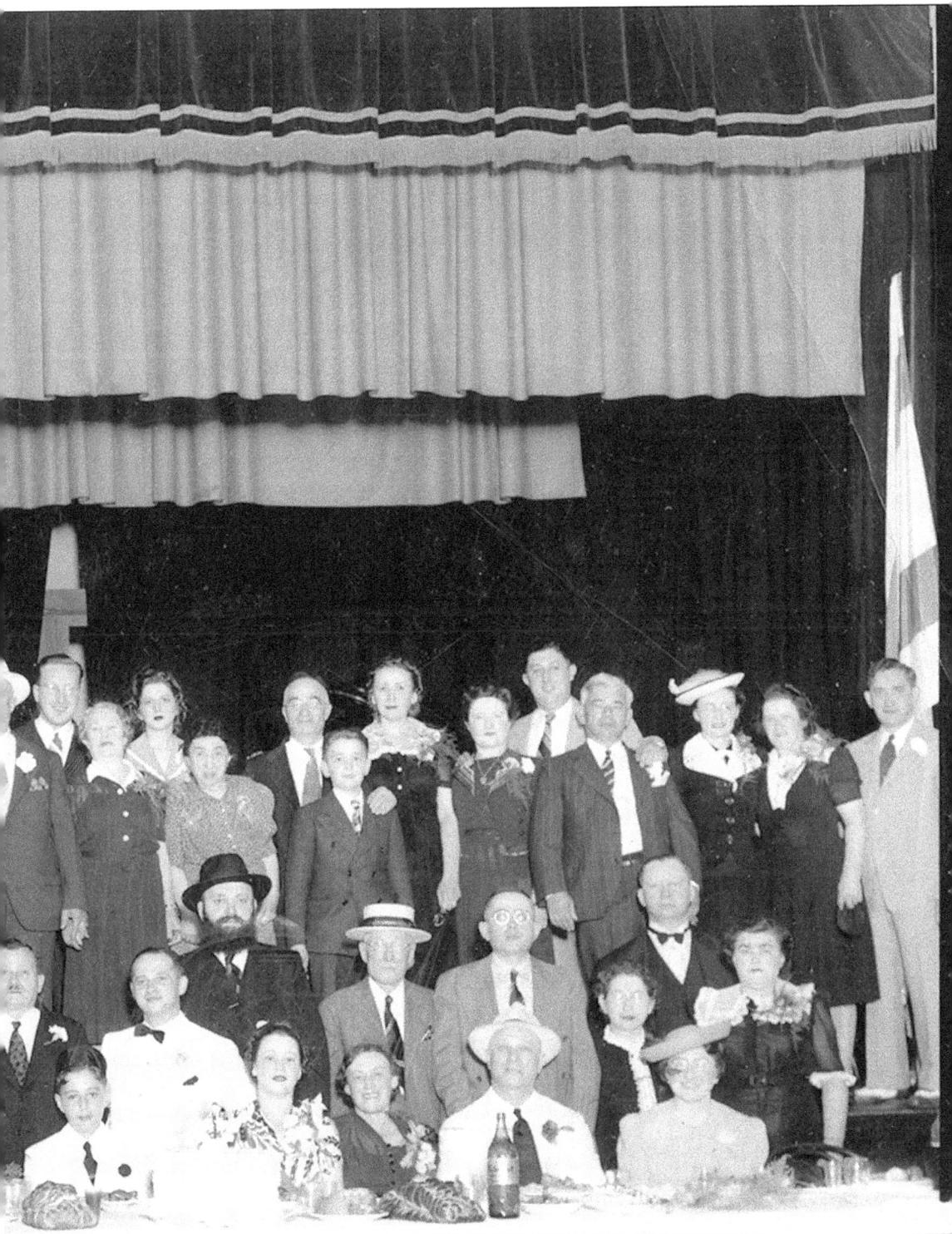

pose before dinner prayers are recited. (Photograph courtesy of Sylvia Davidson Lewis.)

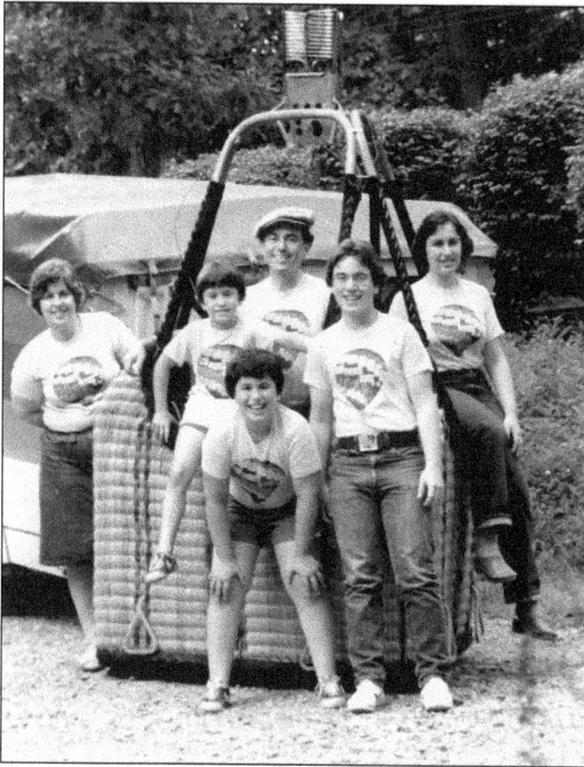

Dick Rossen learned to fly airplanes while a student at Ohio State University, generally a solitary activity. For the past 26 years, he has flown hot air balloons. Ballooning is a colorful sport that encourages friends and strangers to participate in the crewing process. In this 1980 photograph, Dick's family became his crew. They are, from left to right, as follows: (standing in front) Michael and Danny; (seated) Jerry and Debby; and (standing in back) Dick's wife, Arlene, and Dick.

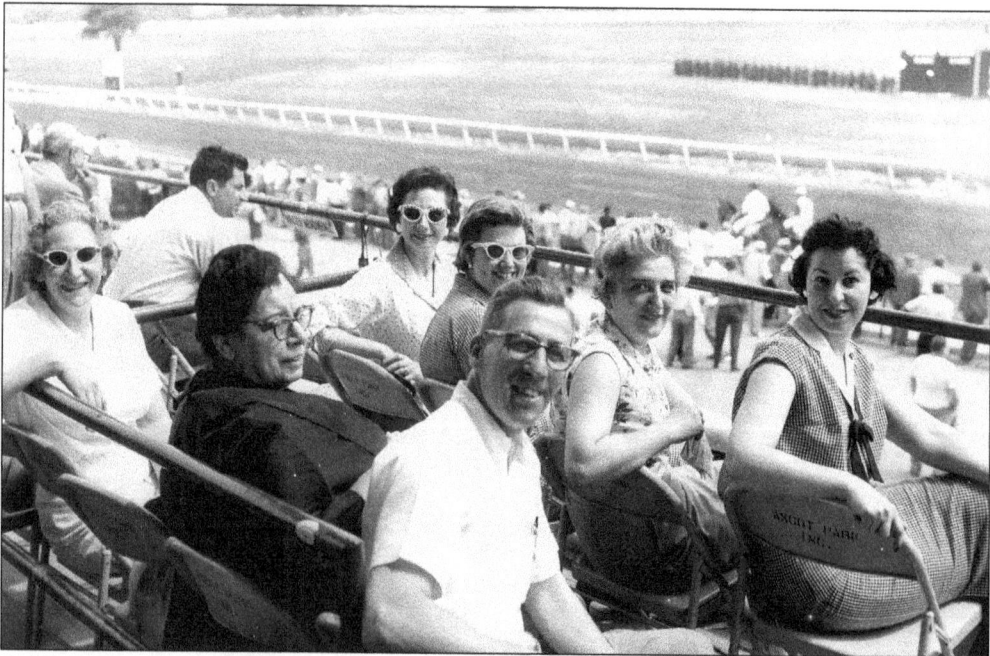

A Day at the Races has been a favorite fund-raiser sponsored by the Akron Art Museum and St. Thomas Hospital. In the 1960s, Ed Kellerman (first row, on right) looks like he picked a winner at Northfield Race Track. To his left, clockwise, are Lil Rosea, Mimi Folb, Rose Dwoskin, Gussie Sussman, Leona Sacks, and Sib Mirman.

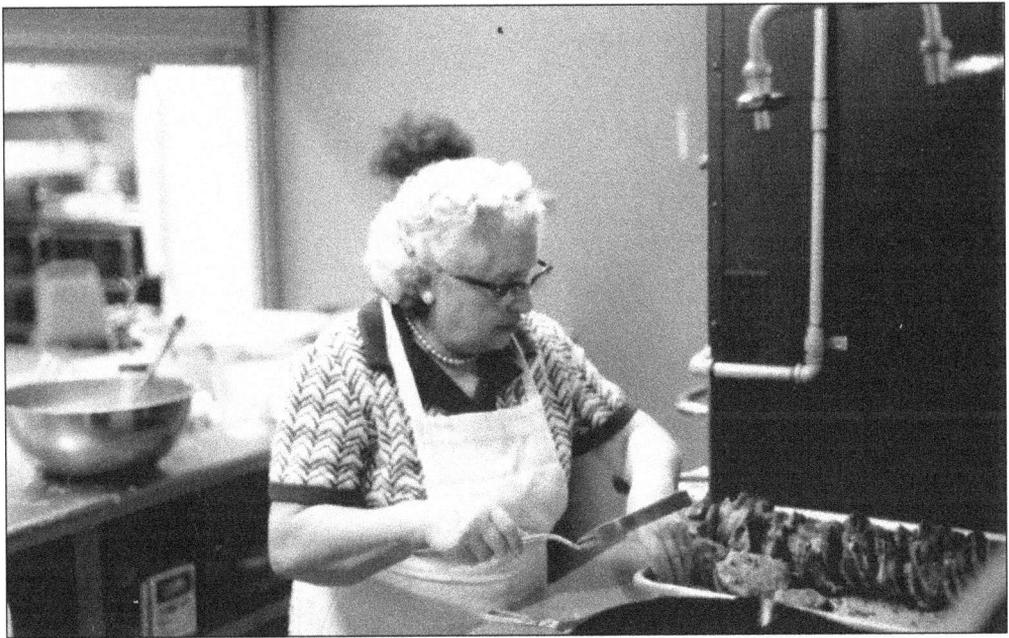

Ruth Polovoi catered b'nai mitzvah, weddings, community dinners, and other special occasions for over 30 years. Her kosher catering service was one of the few available locally. Pictured above is Ruth stirring a large pot. It is assumed to be her "famous" farfel.

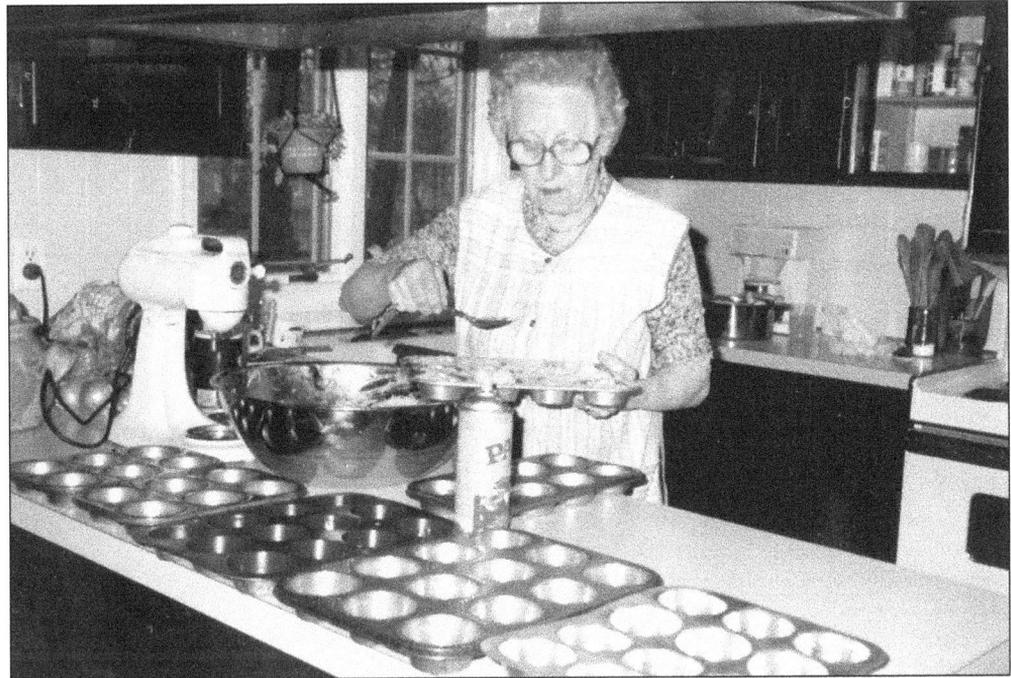

Although not a member of the Jewish community, Marie Skadra was the "Julia Child" of Akron. Her creativity with menus and cooking was remarkable. In her late 70s, she was researching recipes. Women of Akron learned a great deal from Marie. Pictured here is a photograph of Marie preparing dozens of potato kugels. (Photograph courtesy of Joyce Levin.)

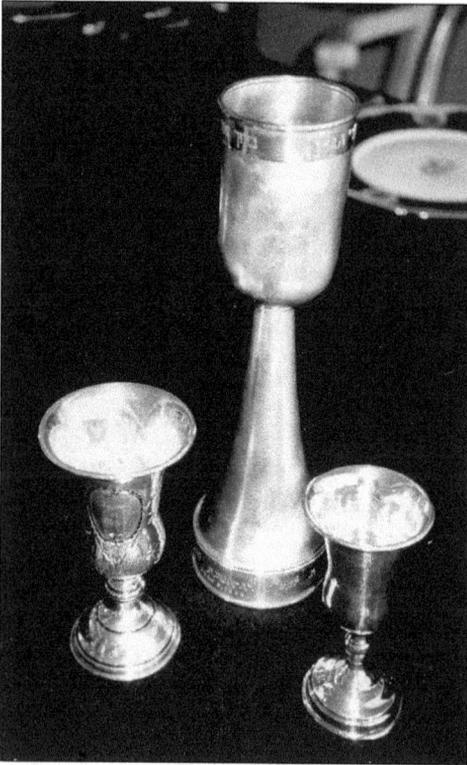

Artist and metalsmith Paula Newman creates beautiful objects that are in the permanent collections of Jewish museums all over the world. The large pewter wine cup in this photograph is proudly displayed in the home of Martin and Joyce Levin with the two smaller heirloom cups from the 1950s and 1960s. (Photograph courtesy of Joyce Levin.)

To become a son or daughter of the commandment (b'nai mitzvah) remains one of the oldest and most important life cycle rituals in Jewish family life. It signals adulthood for Jewish religious purposes, and reflects accomplishment in learning to read Hebrew. Here the bar mitzvah stands in front of the open ark at Temple Israel, preparing to remove one of the Torahs. His proud father and grandfathers assist him by reciting the opening and closing prayers. (Photograph courtesy of the Katz family.)

Over 756 Jewish Akron men served in all branches of the armed services during World War II. All four of Belle Magilavy's sons and her son-in-law, Sidney Sacks, enlisted. In this photograph, from left to right, Manny, a pilot who spent time in a POW camp; Maury, a Marine who survived the Battle of the Bulge; and Dave, a navigator based in India, celebrate their safe return with her in the fall of 1944. Her son Jack and son-in-law returned for Thanksgiving a year later. (Photograph courtesy of Nachelle Whitlow.)

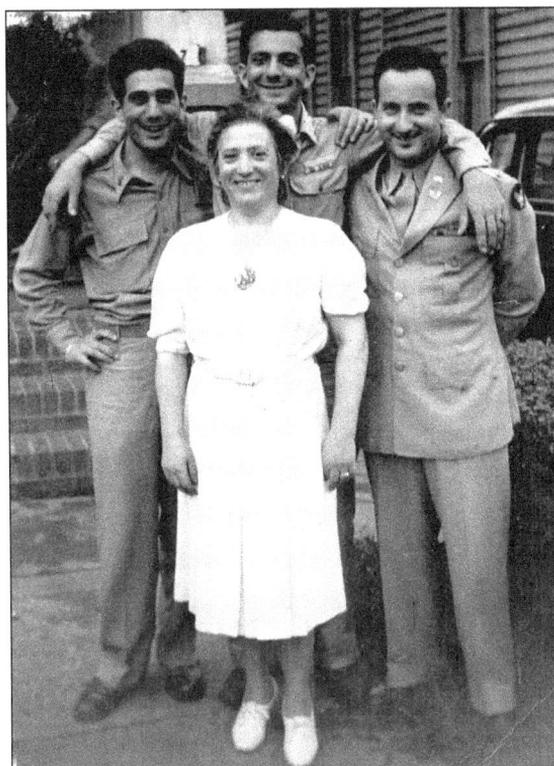

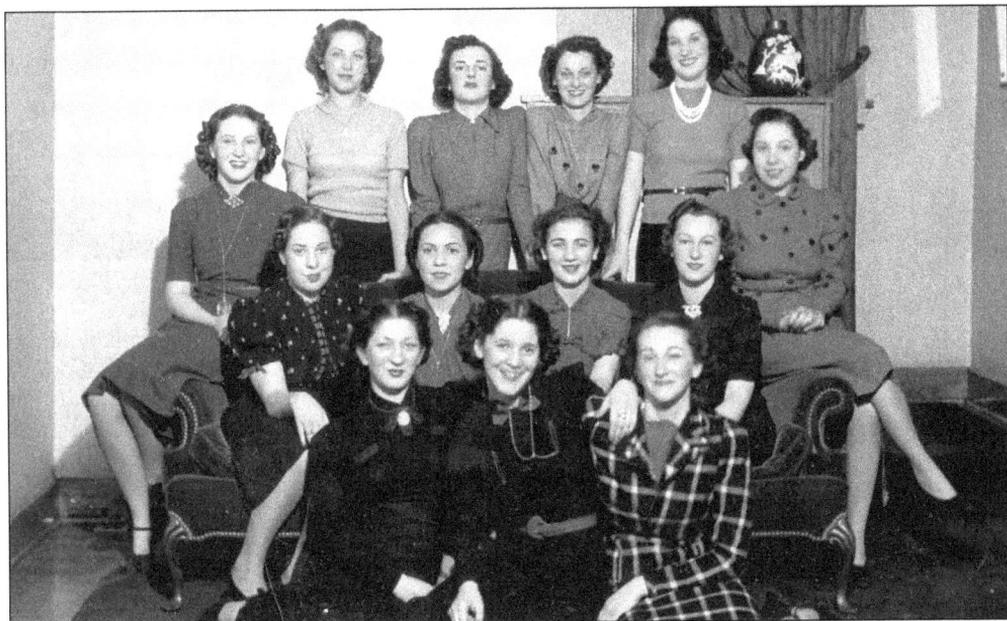

Friends gather for a formal picture. In this photograph are, from left to right, the following: (first row) Corrine Wolloveck, Shirley Unger Koren, and Pheen Rossen Berns; (second row) Sylvia Winer, Florence Mendelson, Ann Kaplan Brody, and Fritzie Cohen Trigger; (third row) Charlotte Katz Finn, Tibey Rudy Swedler, Lola Berger, Sis Lichtman Perilman, Libby Millstein Ginsberg, and Gert Winer Luck.

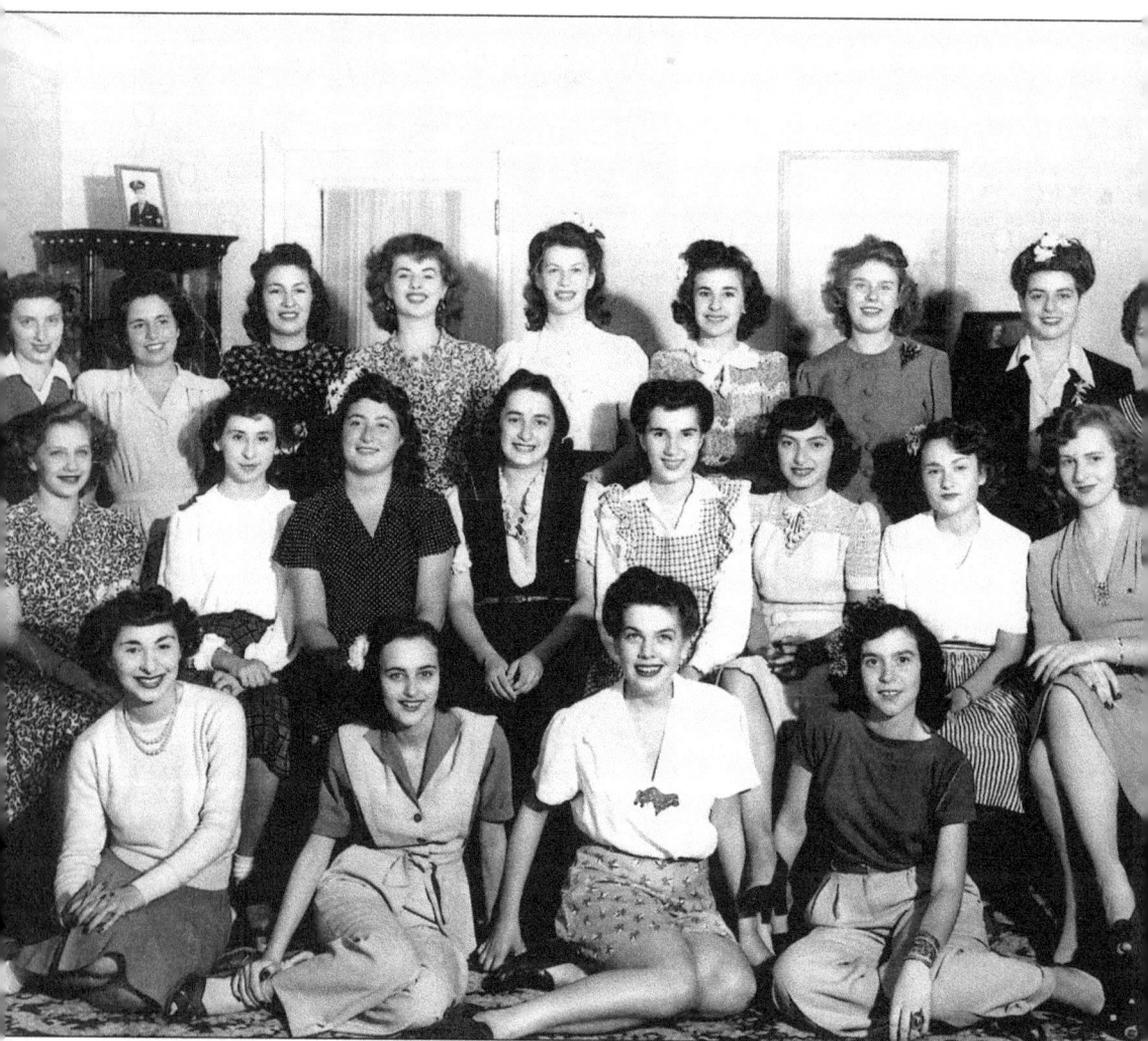

This group of young friends called themselves "the Gincs"—Girls Incorporated. This 1943 photograph includes, from left to right, the following: (first row) Charlotte Havre, Reva Sabetay, Alice Kohler, and Gloria Margolis; (second row) Margie Koplin, Miriam Liberman, Anita Ostrov, Connie Garson, Shirley Shwartz, Jewel Garson, Isabel Snyder, and Phyllis Wollins; (third row) Bernice Garson, Harriet Buxbaum, Anne Louise Weinberg, Joyce Holland, Mimi Fladen, Esther Liberman, Helene Shultz, Betty Ostrov, and Louise Rosenberg. (Photograph courtesy of Libby Rosenblatt.)

Three

ENLIGHTENED PATHWAYS

Education and knowledge have been essential elements for Jewish people throughout the ages. From their European roots, the settlers brought these values to the United States and formed Jewish schools. In Akron these schools met after "regular" public school at various sites throughout the community.

The Talmud Torah was the oldest established educational institution, founded in 1909. Children attended four afternoons a week and Sunday morning. Mr. A. Fox and Dr. Isadore Fish are remembered as teachers from the late 1930s and 1940s. It was the main source of Orthodox Jewish education. It was a tedious test of an elementary school child's endurance.

The Farband and Workman's Circle organized schools for the children of their members. These also met after public school and Sunday. Most of the subjects at these schools were taught in Yiddish, the language of Eastern European Jews. It was not a "text book" language, so much of the teaching was conducted by lecture and repetition. Phillip Kolko is fondly remembered by his students at the Farband, and Mr. Dorn was an early teacher at Workmen's Circle School.

Temple Israel had a school from its beginning, and Beth El formed a school in 1952. In 1965, the concept of Jewish day-school education came to Akron with the formation of the Hillel Academy (now known as the Lippman Jewish Community Day School.) Additionally, the Akron Jewish Community High School was established in 1976. This after-school program has grown to 80 students from Akron and Canton.

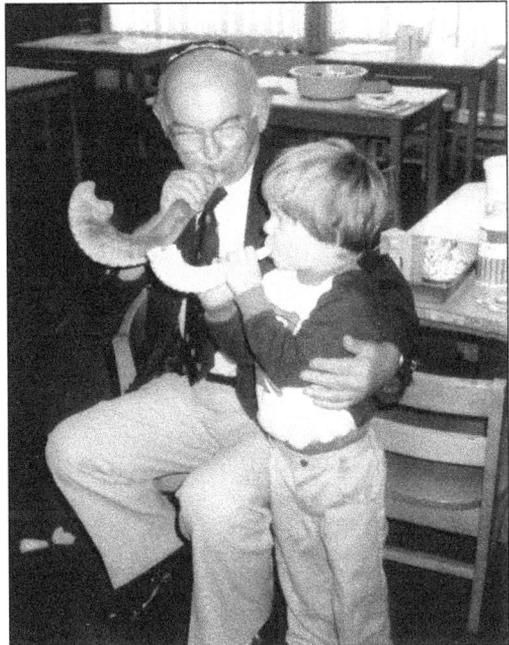

In this photograph, Rev. Phillip Salzman is fulfilling the commandment of teaching children the rituals of Judaism with the blowing of the shofar (rams's horn).

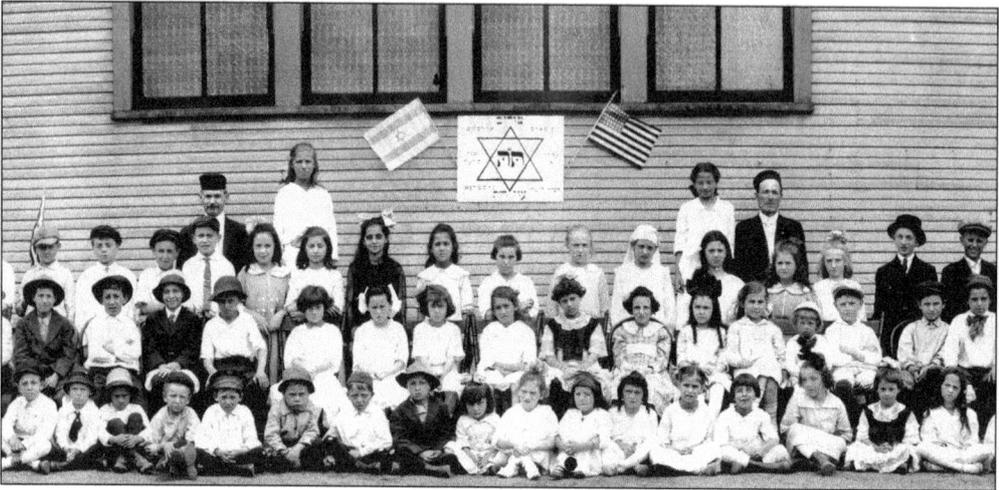

The Talmud Torah at the corner of Wabash and Wooster Avenues provided one of the first coordinated religious education opportunities for youngsters ages 6 to 14. Support was provided by all traditional "orthodox" congregations and private individuals. Pictured here are students and teachers in 1918 (above) and 1922.

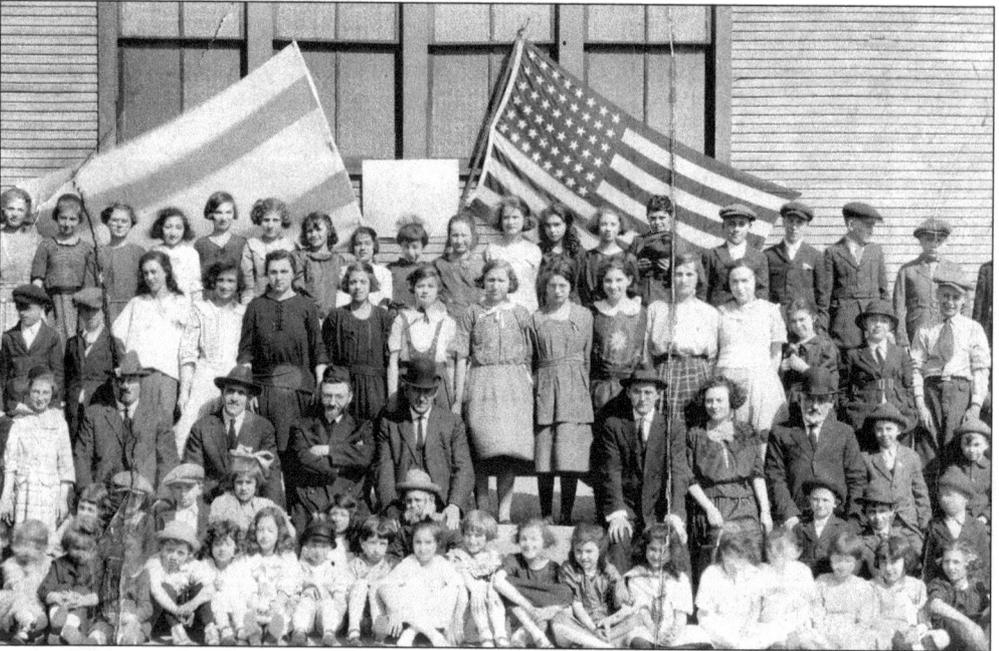

The Workman's Circle, at 1916 Raymond Street, had an after-school Jewish school. This photograph is the 1929 graduating class with teacher Mr. Dorn. From left to right, they are as follows: (first row) Eve Goldner, Ethel Bloom, Mr. Dorn, Rose ?, and Sylvia Waitskin; (second row) Joe Deutchman, William Whitehouse, Jack Lipsitz, Nate Glazman, Abe Pliskin, and unidentified. (Photograph courtesy of Joe Deutchman.)

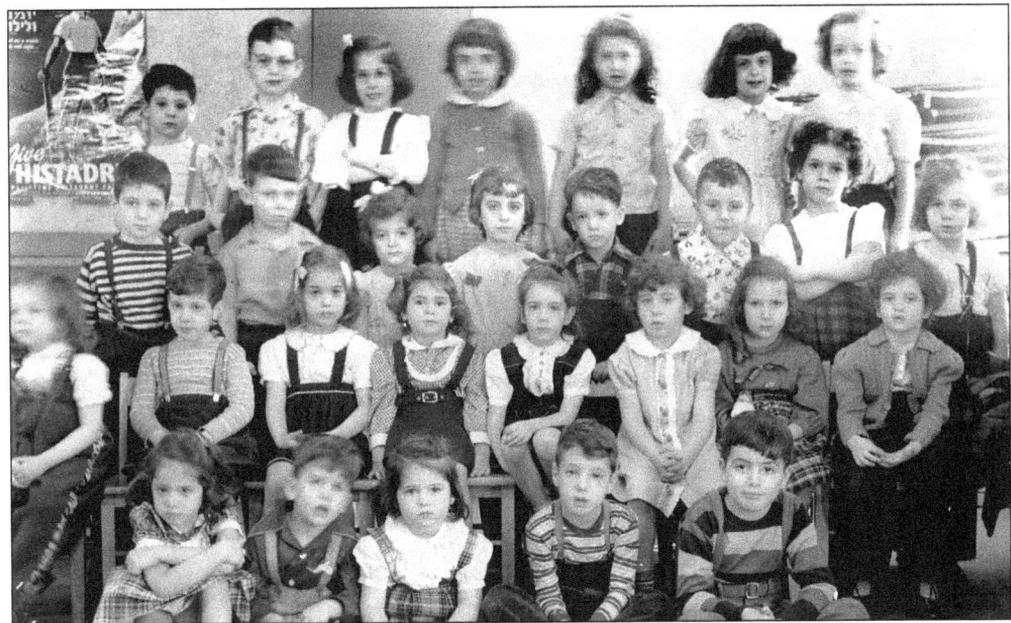

This is a photograph of Farband's kindergarten class of 1949. Identified are, from left to right, the following: (first row), two unidentified students, Rita Meltzer, Sandy Allison, and Jordan Hahn; (second row) unidentified, Phillip Corey, Sandy Dean, Barbara Zapilar, unidentified, Nancy Golden, Sandra Waxman, and Karen Kropko; (third row) Howard Allison, Jack Weinberg, Andrea Wolfand, Marilyn Berloff, Gary Kodish, Paul Haberman, Phyllis May, and Susan Lieberman; (fourth row) Gary Podlish, Mike Rozen, Joan Frederick, Florence Newman, Harriet Slonsky, Sally Schrero, and Harriet Kropko. (Photograph courtesy of Sandra Levenson.)

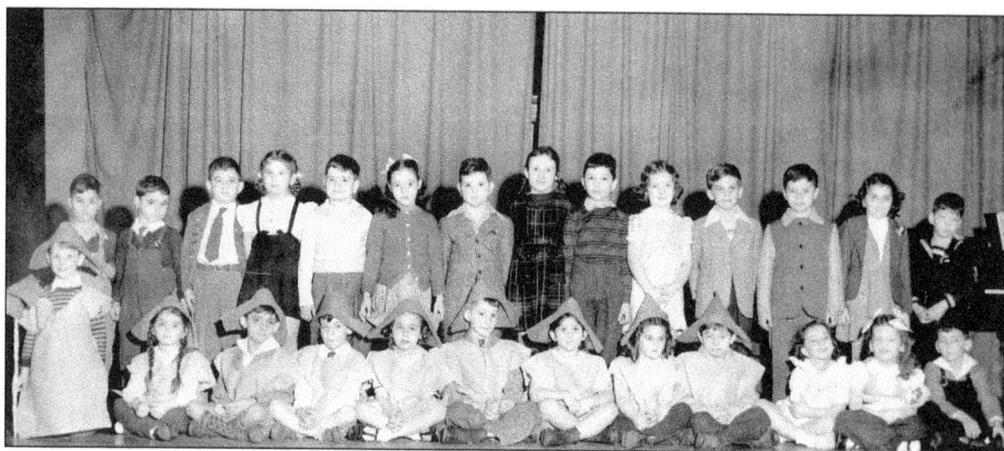

Chanukah is time for celebration of miracles and light. Jewish religious schools staged plays and programs for the children to commemorate the holiday. These Talmud Torah Sunday School plays were performed in 1944. Children who are identified in the photograph above are the following: (first row) Nicki Magilavy, Melvyn Mermelstein, Marvin Gardner, Madelyn Goldberg, Harriet Lasoff, Susan Albert, and Steve Manes; (second row) M. Levitatz, Marvin Shapiro, Bob Lesowitz, Norman Danzig, Faye Nobil, Lee Shapiro, Sid Lesowitz, Bob Sholiton, Marvin Rosenthal, and Bunny Magilavy. The photograph below shows, from left to right, Burton Subrin, Jerry Gardner, Charlie Stein, and Sherman Friedlander as Macabees.

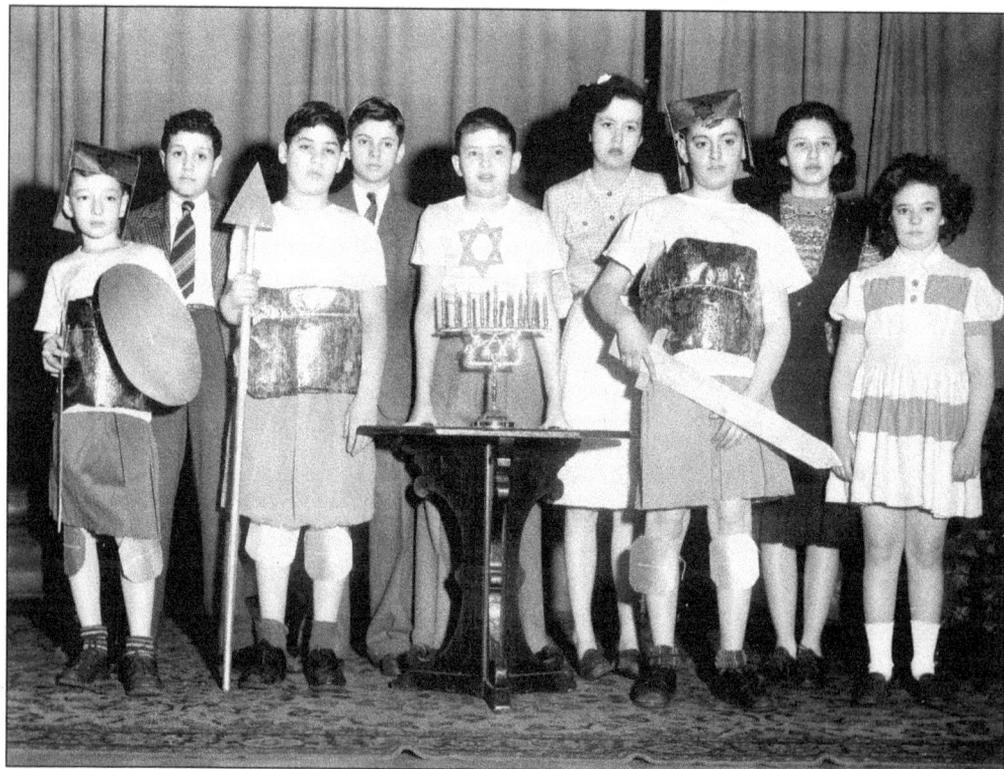

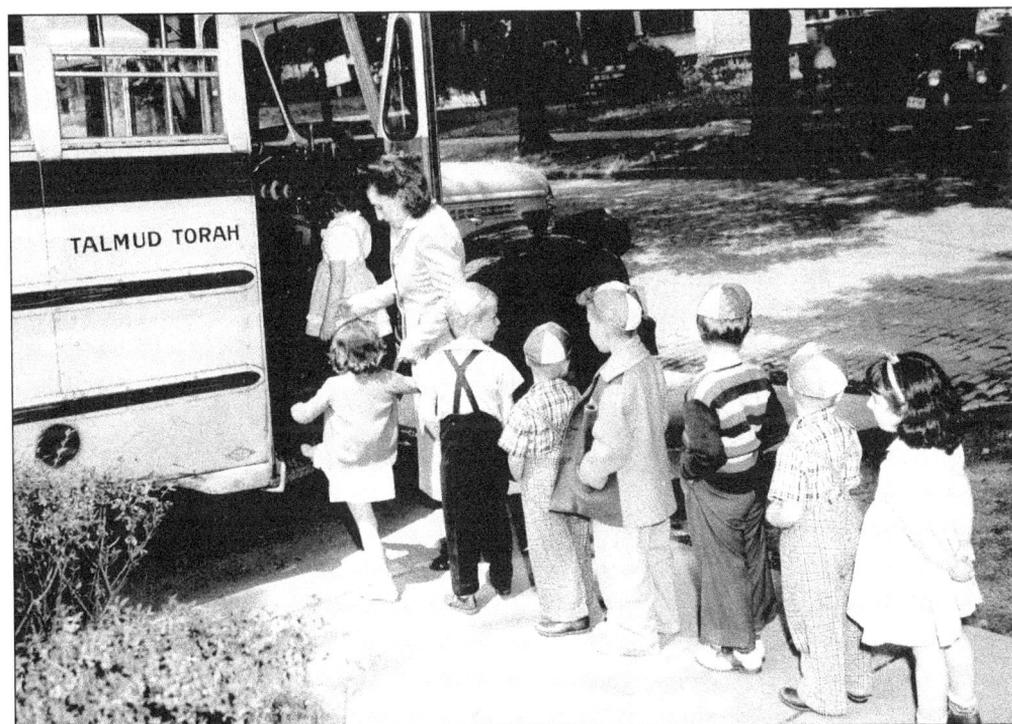

During the 1940s and 1950s, the Talmud Torah bus provided after-school transportation to children at Rankin Elementary School. During this period, the religious school was housed in the Balch Street Akron Jewish Center. This photograph shows the children boarding the bus at Rankin School. (Photograph by Julius Greenfield.)

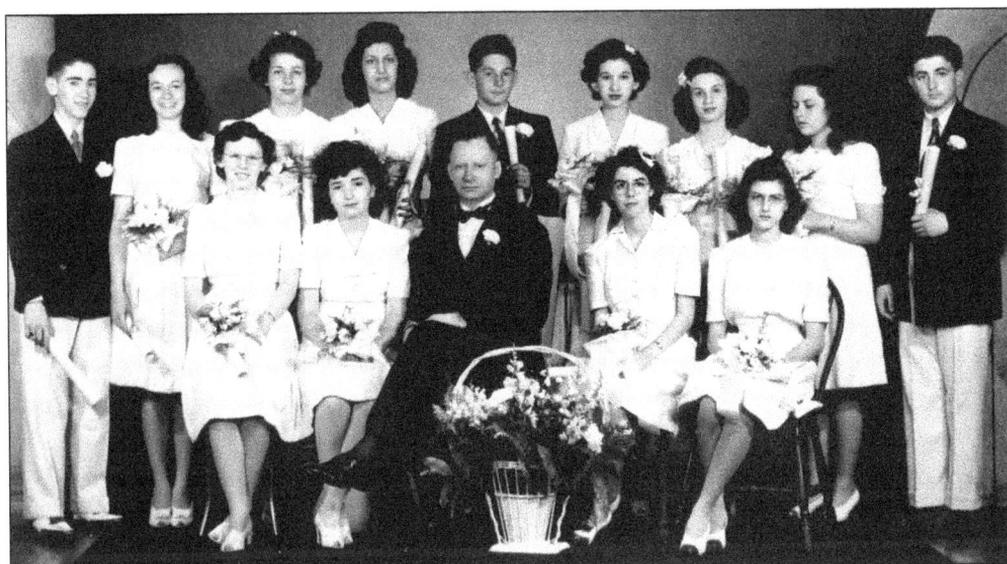

Rabbi Stampfer served Anshe Emeth congregation in the 1940s. This photograph of the confirmation class of 1945 includes, from left to right, the following: (seated) unidentified, Shirley Gardner, Rabbi Stampfer, Naomi Mack, and Elaine Sabetay; (standing) Danny Weinberger, Dorothy Feir, two unidentified girls, David Schneir, Janet Hirsch, unidentified, Marian Rossen, and Jerry Schneier.

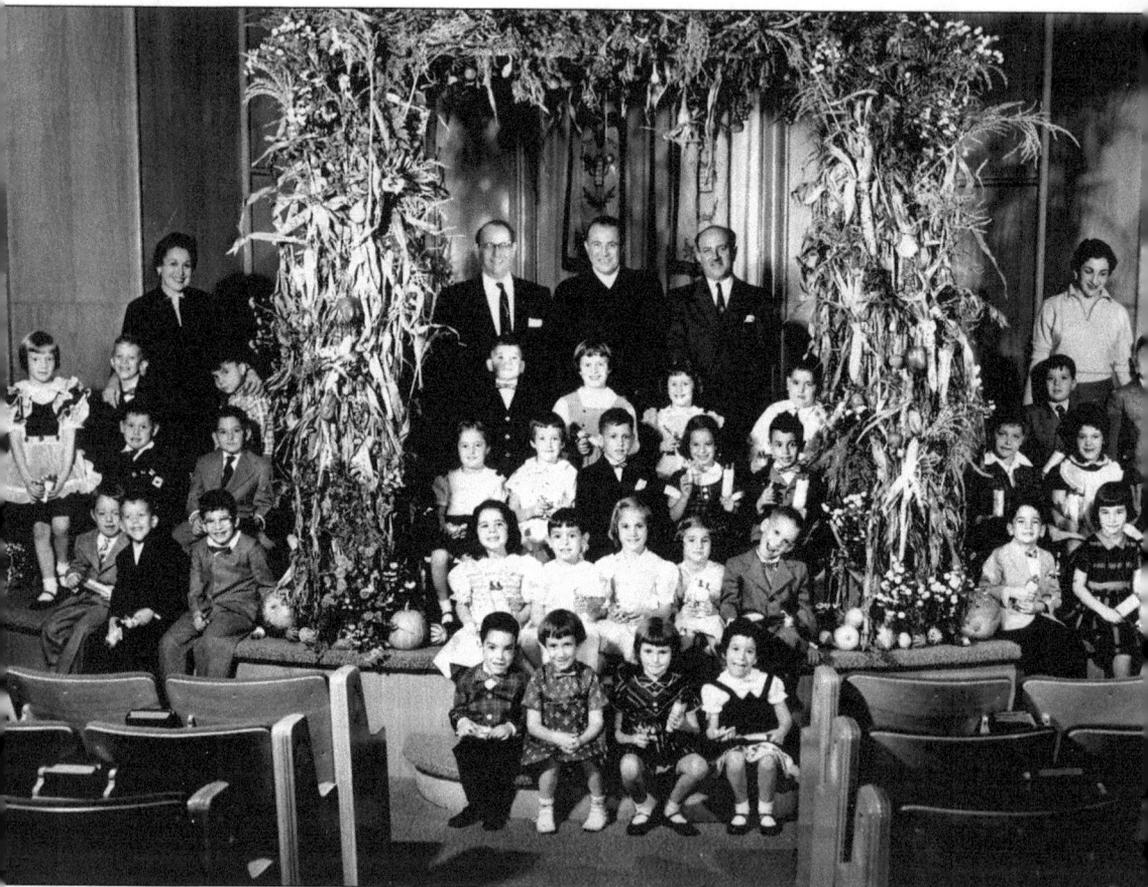

Education has always been a top priority for Jewish people, and Temple Israel's members were no exception. Temple's religious school began the first year of Temple's existence, 1865, and the first confirmation took place five years later. Rabbi Morton Applebaum is shown with his first consecration class in 1953, together with Leonard Berman, the principal of the Sunday school, and Judge Nathan Koplin, the president of the congregation. Harriet Clayman, shown to the left of the sukkah, taught this class for many years. This photograph includes David Sands, Sherry Solomon, Janet Reingold, Betty Topper, Sydney Kaplan, Suzanne Moss, Marilyn Pliskin, Mark Moorstein, Marilyn Sass, Betsy Stern, Ron Weiner, Steve Shector, and Susan Oseroff. (Photograph courtesy of the Temple Israel archives.)

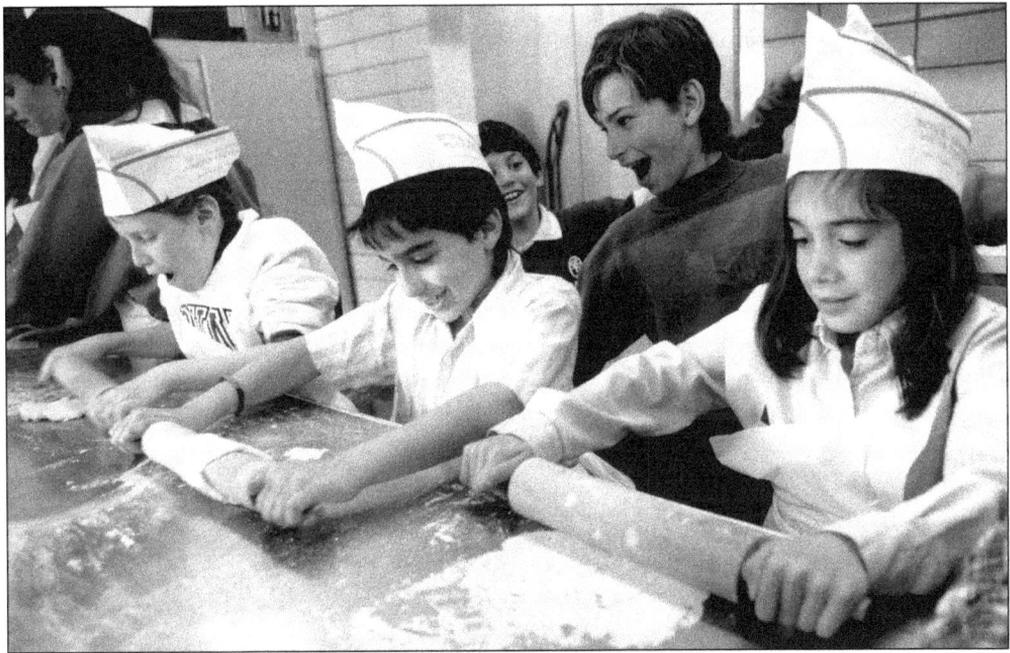

Children at the Lippman Day School are afforded unique learning experiences. From left to right, Michael Cohen, Ben Zarouk, and Rebecca Minc are pictured rolling out unleavened dough to make their own matzohs.

Hillel Academy opened in 1965 as Akron's first Jewish day school. This group of kindergarten students with teachers Pam Lewis and her brother Daniel Lewis includes, from left to right, the following: (first row); Eric Gerber, Julie Shapiro, Rachel Goldstein, Carley ?, and Nancy Newman; (second row); three unidentified students, Marcella Kanfer, and Aaron Stile; (third row); Ellie Aaronoff, Paula Newman, David ?, Kim Shapiro, and Janine Castor (Photograph courtesy of the archives of Lippman School.)

From left to right, Cathy Baer, Susan Lockshin Kattan, an unidentified mother, and Laurie Freedman are feeling a mixture of anxiety and relief as they drop their toddlers off at the AJC nursery school for the first day of "school."

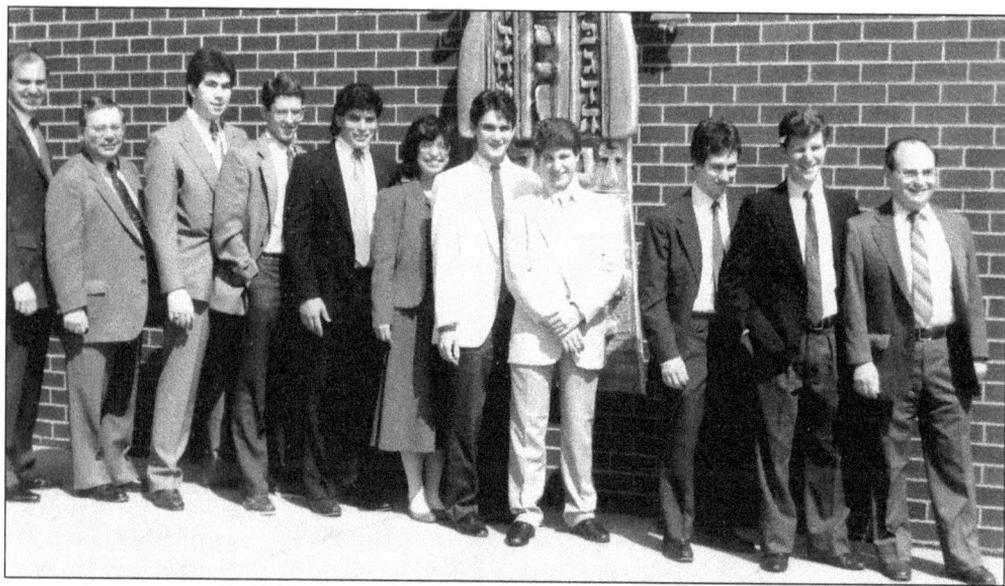

Akron has sustained a Hebrew high school since 1976. A challenging curriculum attracts teenagers with special interest in continuing Jewish education through their high school years. This graduation picture includes adult lay leaders and teachers with the graduates. From left to right, they are Joe Kanfer, Stan Bard, Jay Levin, Shachar Torem, James Gloth, Alyet Torem, Robert Fish, Arnold Stux, Todd Kotler, Bill Levenson, and Herb Hochauser. (Photograph courtesy of Sandra Levenson.)

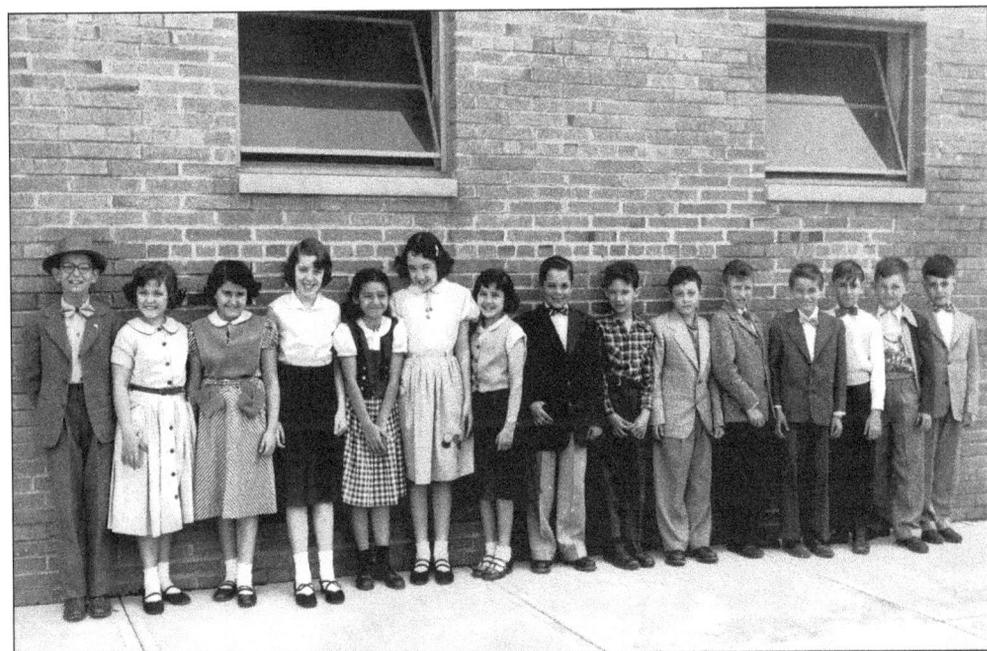

Jackets and ties for the boys and dresses and "Mary Jane" shoes for the girls were normal Sunday school attire. Students in line at the Beth El Academy in the early 1950s are, from left to right, Michael Steinreich, Dianne Rubin, Rita Harris, Francine Myers, Aroline Liff, Joan Sipelow, Pattie Reiser, Michael Sher, Robert Groonis, Sheldon Ocker, Marvin Goldstein, Gerald Goldstein, Larry Goldberg, Jerry Salzman, and unidentified.

Post–World War II immigrant resettlement issues were addressed by the entire Jewish community. Opportunity for employment was the motivation to learn English. This photograph shows one of the many classes held at the Akron Jewish Center in the late 1940s.

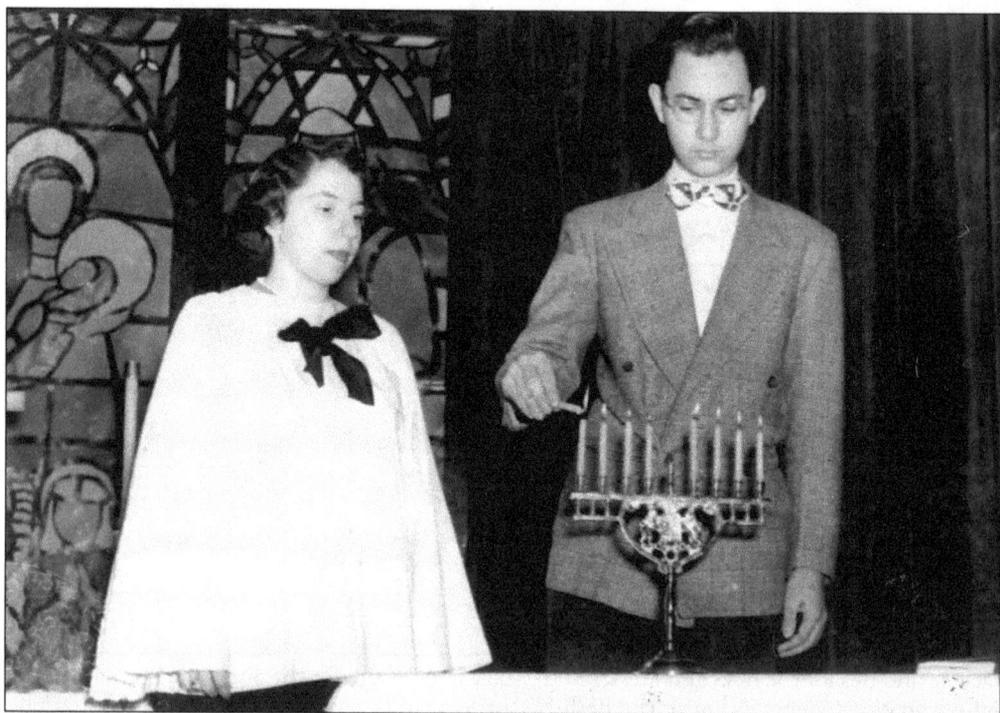

In the late 1940s and 1950s, most Jewish students attended Buchtel High School on Copley Road. Prior to that time, most attended West or South High School. This photograph shows Evelyn Slavin and Emory Geller as they light the eighth candle on the Chanukah menorah at the Buchtel High School holiday program in 1951.

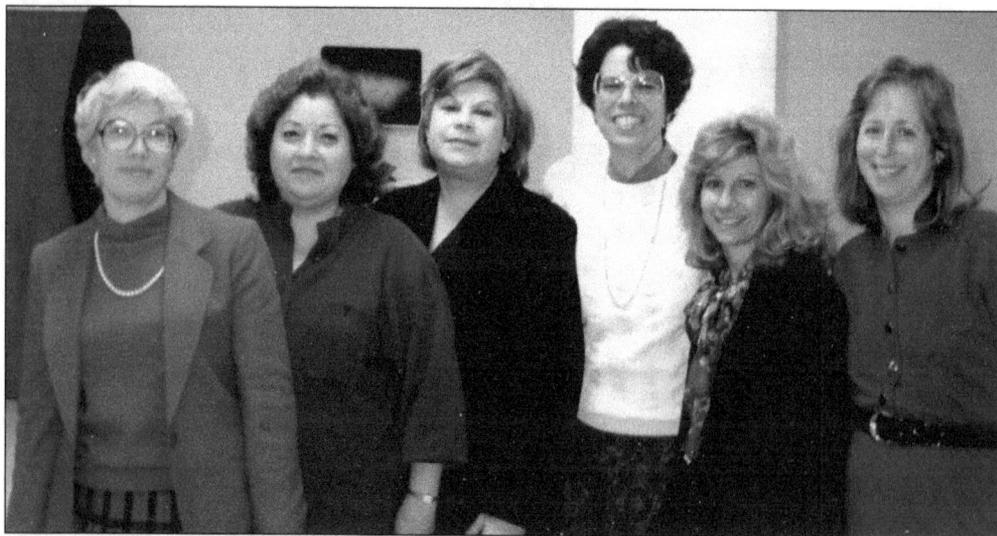

In the early years, Jewish educators were usually rabbis or learned men, who came with degrees from European Jewish educational institutions. With the changing times and egalitarian privileges, women began to receive degrees in Jewish education from American institutions. Pictured in 1996 are Akron's teachers and principals, who formed the Council of Jewish Educators. Shown here, from left to right, are Susan Spector, Rhoda Kamens, Jessica Cohen, Esther Cohen Hexter, June Seidel, and Sarah Bricklin. (Photograph courtesy of Esther Cohen Hexter.)

Four

HEART OF COMMUNITY

In the 1920s, a group of Akron's Jewish leaders determined to open an institution that would attract the entire Jewish community without regard to ethnic origins or religious preference and be affordable to all. In September 1929, the dream became a reality when the Akron Jewish Center opened at 220 South Balch Street, on land used by the Anshe Emeth congregation. For generations of youngsters and adults, the AJC was a second home. An extensive array of Jewish organizations, social clubs, special events, sports tournaments, religious schools, and theater groups called the AJC their home. The Balch Street location was easily accessible by bus, bike, or foot to a majority of Akron's Jewish population through the 1960s. Many remember walking from West Exchange Street to Maple Street on the way to club meetings, rehearsals, or basketball games and stopping at the Krispy Kreme Donut Shop for a warm, glazed donut. In 1973, the AJC moved to a much larger property on White Pond Drive, where it has continued to grow. AJC membership is open to all residents of Akron, and for 75 years, this beloved institution has been a magnet for children and adults of every race and creed. The following pages reflect a sampling of programs offered throughout the years.

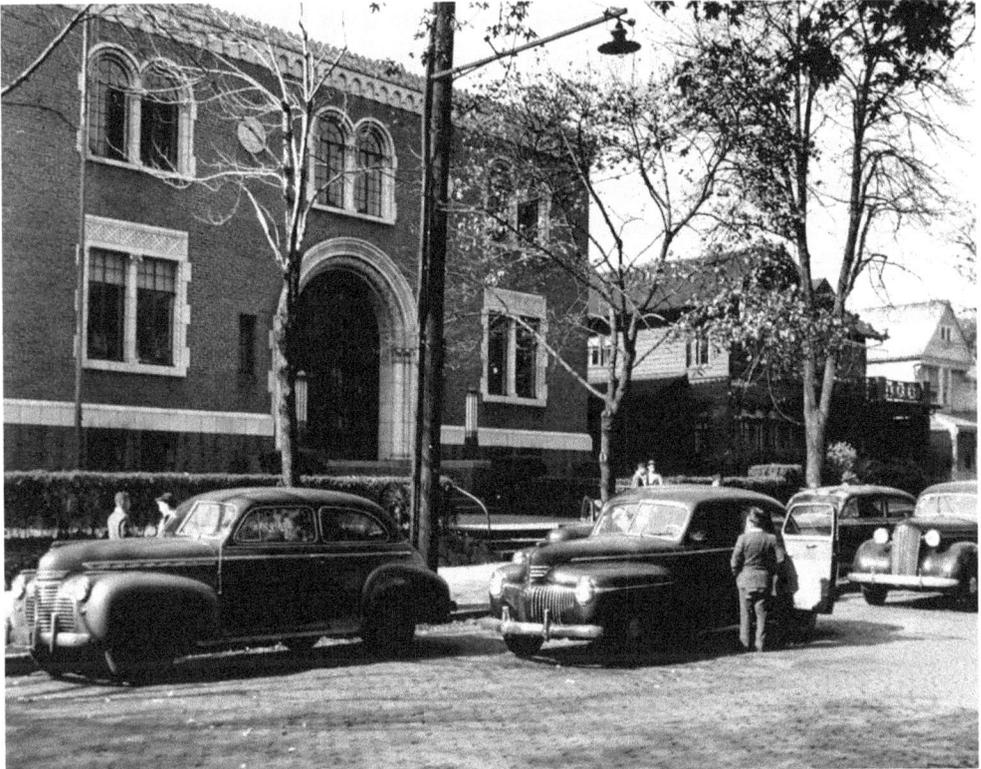

This photograph shows the AJC as it was in the 1940s.

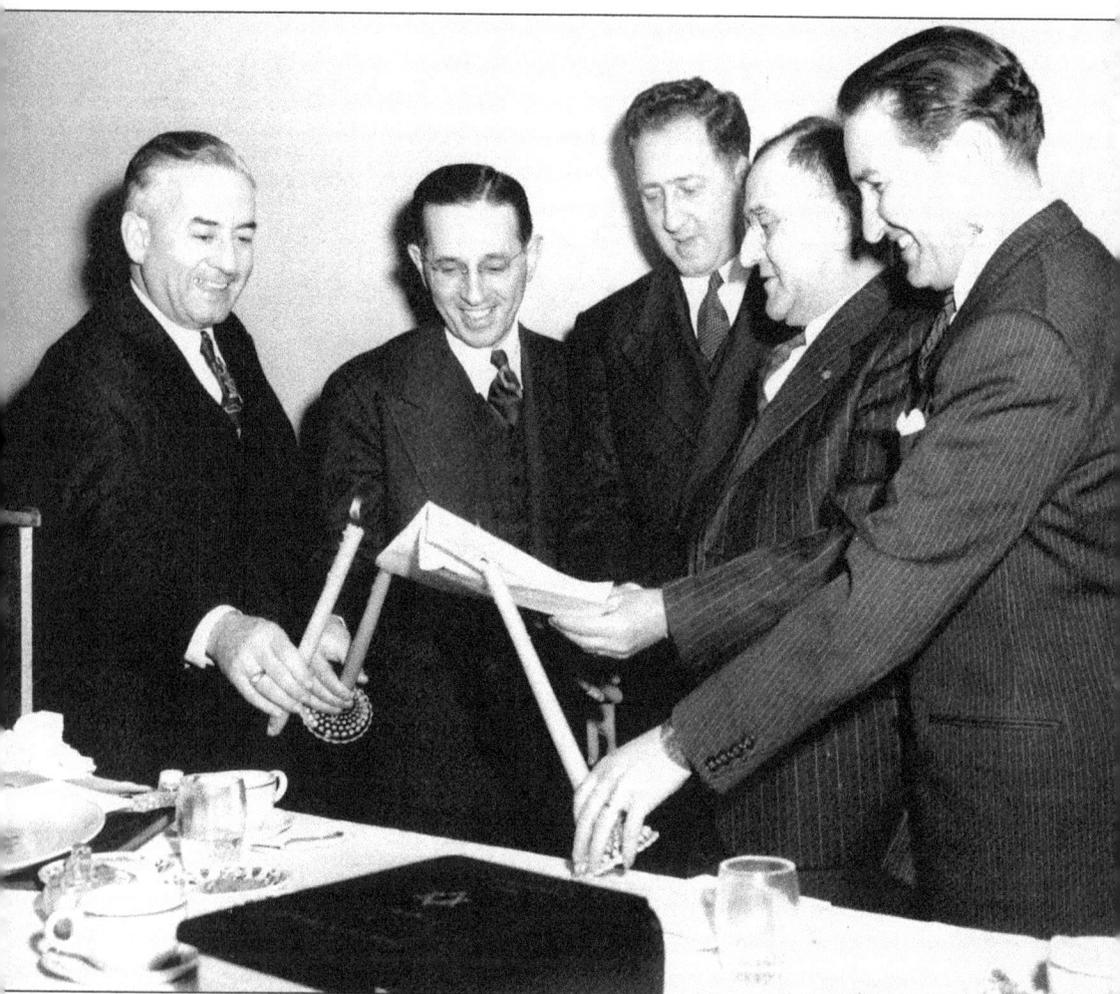

Seen here are five delighted trustees in the ceremonial burning of the Akron Jewish Center's mortgage at the 13th annual meeting, December 6, 1942. From left to right are Charles Schwartz, Albert Buxbaum, Julius Darsky, Sam Friedman, and Alex Schulman.

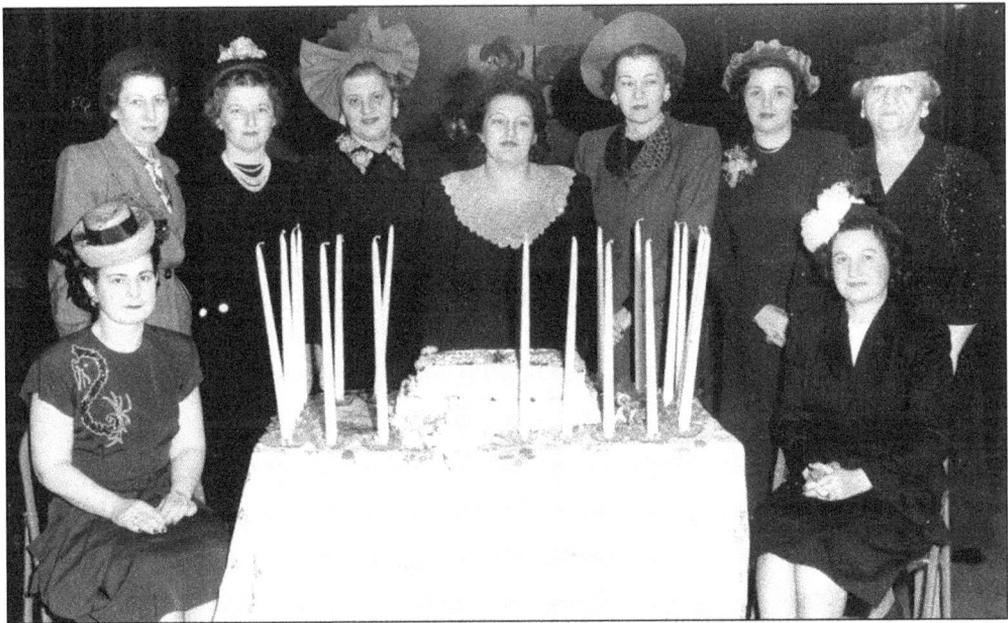

A strong, active auxiliary was a mainstay from the very beginning of the AJC's life until the present day. They sponsor and support a multitude of programs for the membership as well as the community at large. The Balch Street Auxiliary past presidents sit for their 18th anniversary in 1948 and include, from left to right, Ada Goldman, Rose Myers, Gertrude Subrin, Dora Newman, Tillie Gordon, Jeannette Bershon, Alice Backer, Sarah Rivitz, and Ada (Sol) Sacks. (Photograph by Victor Zinn.)

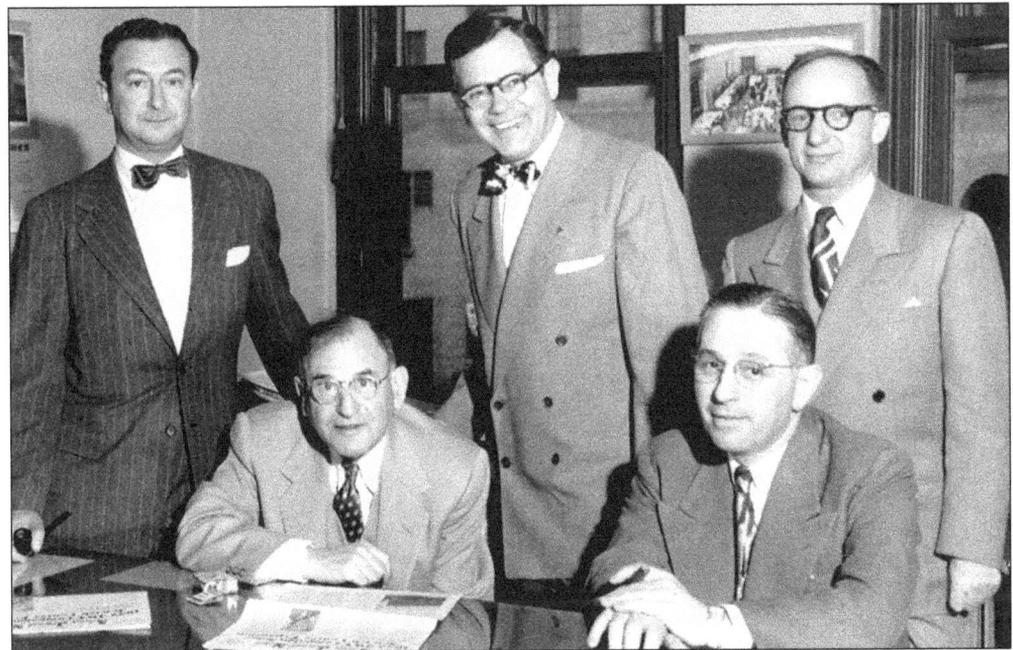

With the community's support, the dream of a first-class gymnasium became a reality when the Balch Street AJC expanded. This 1952 photograph shows, from left to right, planners Irving "Babe" Bennett, Sam Friedman, Charlie Sacks, Al Buxbaum, and Nathan Pinsky.

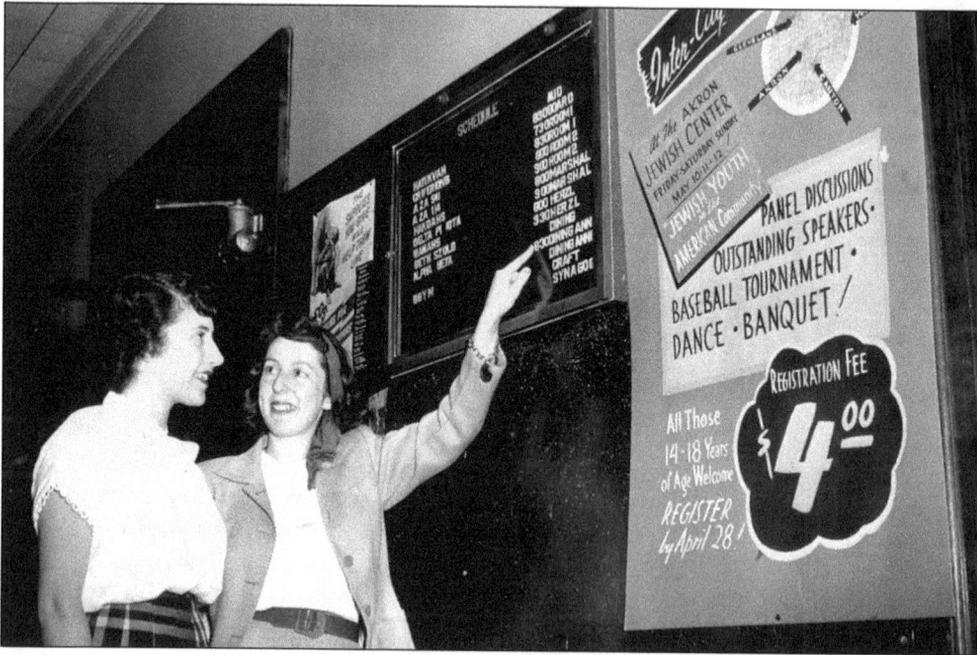

The AJC held regular intercity conferences for senior high club members, giving them an opportunity to meet, socialize, and compete in sports with youths from the Canton, Cleveland, and Youngstown Centers. This photograph, taken in the late 1940s, shows a poster advertising one of the conferences.

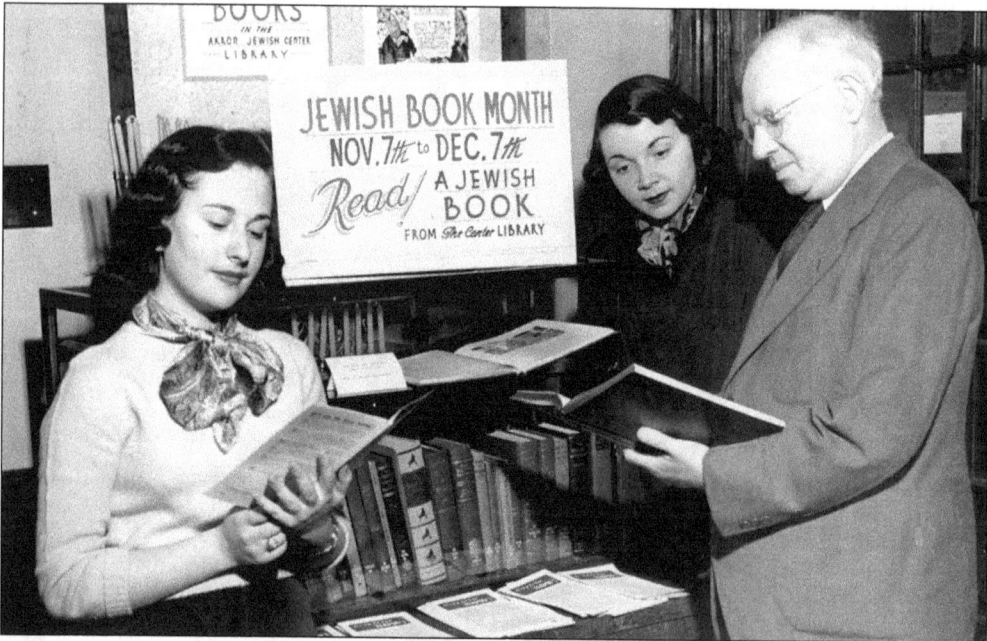

The Balch Street AJC library offered members of all ages an opportunity to sample Jewish writers and themes. At the 1947 Book Fair, Rabbi David Alexander (from Temple Israel) shows a new purchase to Irene Serelson while an unidentified young woman looks over a brochure. Even though the library has disappeared, the book fair remains a popular event.

44

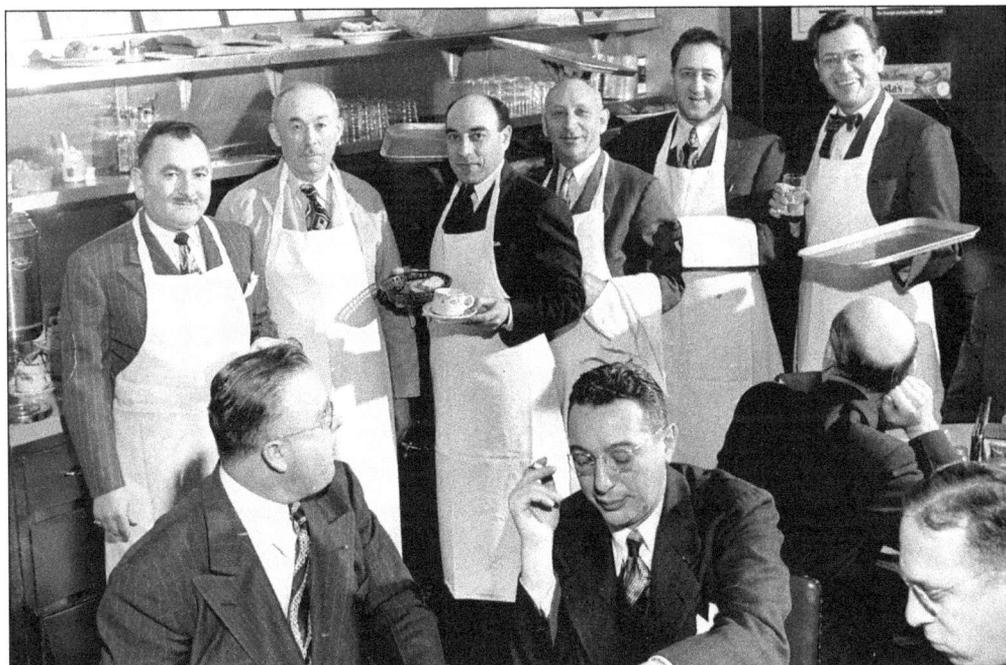

Leaders of the AJC turned the tables at the 1949 annual meeting by acting as waiters. Servers, from left to right, are Nate Roseman, Nate Ackerman, Leslie Flaksman, Max Schneier, Julius Darsky, and Charlie Sacks.

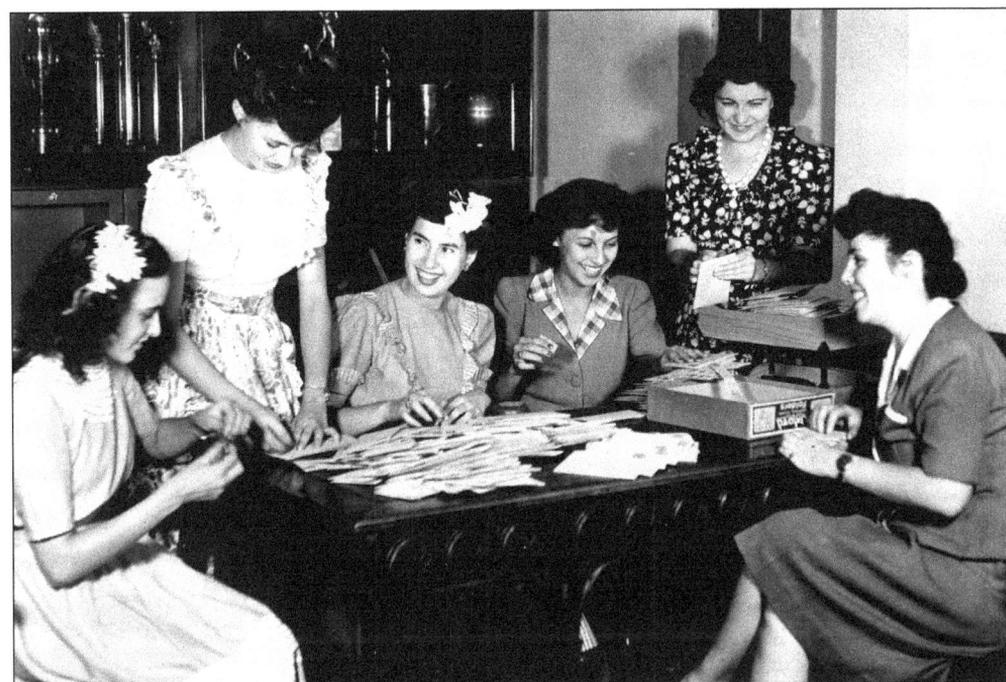

A cheery note from home brightened the days of the servicemen and women from Akron, who served in World War II. From left to right, Reva Sabetay, Dorothy Gruber, Dorothy Shankler, Leona Morris, Shirley Schneiderman, and an unidentified woman mail letters in 1944.

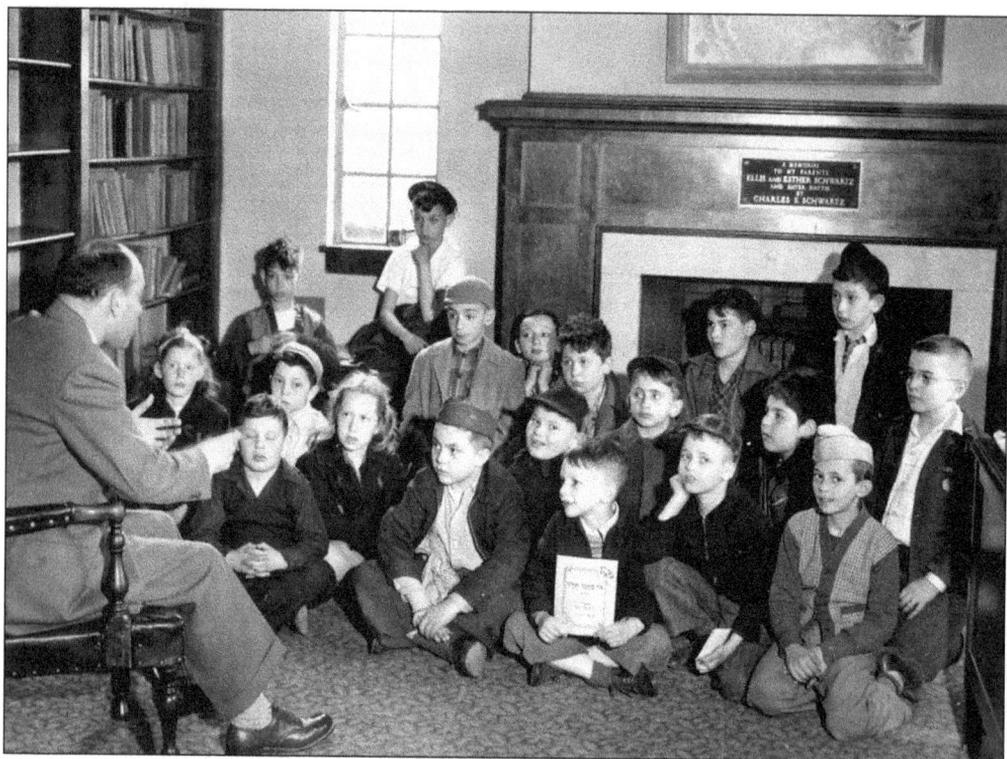

AJC executive director Leslie Flaksman has the rapt attention of his audience as he tells a story in the library in 1945.

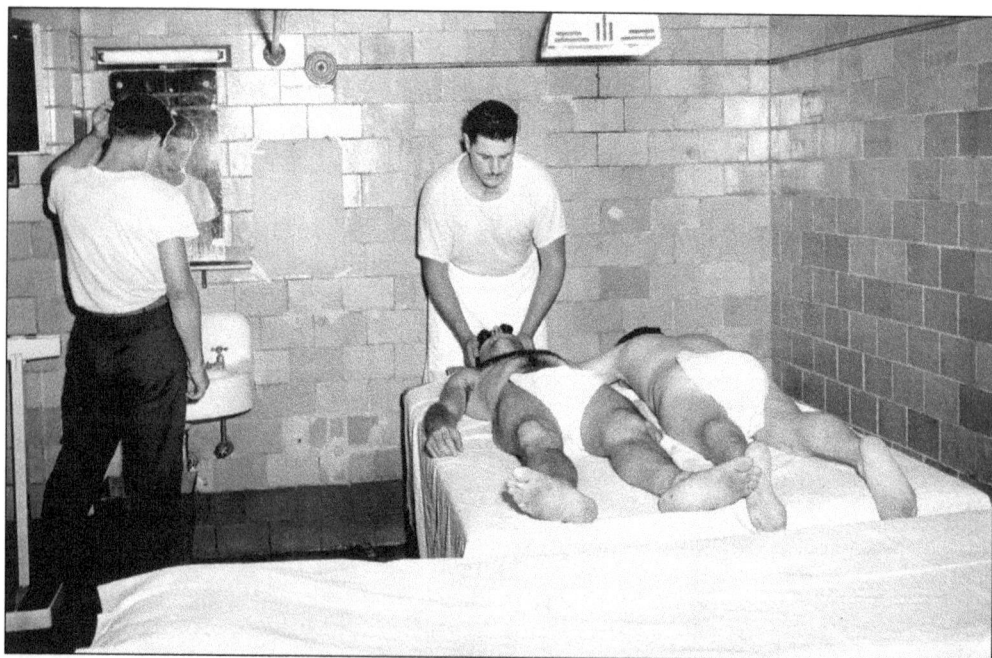

The old health club was never fancy, as this old photograph clearly shows. However, the massage was legendary and the steam room, a real "mechiah."

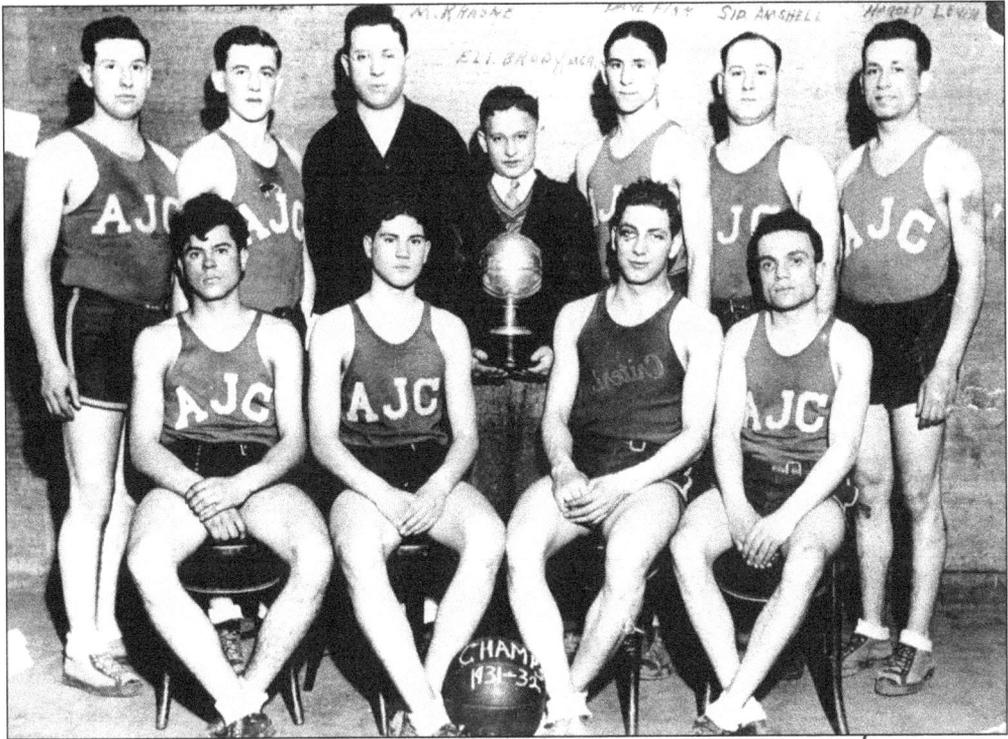

The 1931–1932 AJC basketball team was considered one of its best. In this photograph are the players and athletic director. From left to right are the following: (first row) Max Podlish, Art Shapiro, M. Bleiman, and Phil Dienoff; (second row) Al Bleiman, Morrie Mendelson, M. Krasne, manager Eli Brody, Dave Finn, Sid Amshell, and Harold Levin.

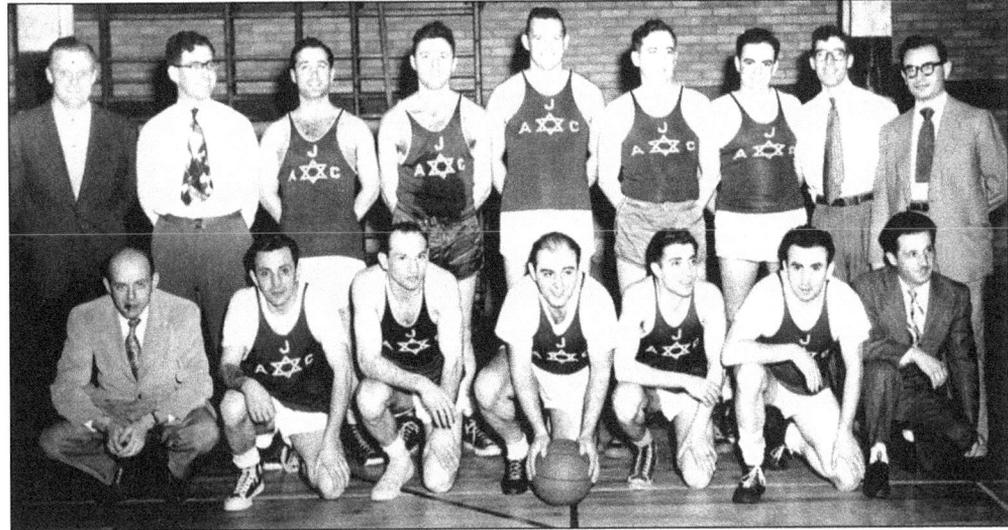

In 1949, the Macabees fielded a competitive intramural basketball team. This photograph includes team players and managers. From left to right are as follows: (first row) Duke Goldstein, Harold Rosenthal, Jack Manes, Al Seenberg, Sol Aidman, Sid Rosenthal, and Max Katz; (second row) coach Ben Roth, Sid Eichner, Lou Stile, Ed Nobil, Mort Leeper, Morry Mendelson, Vic Rofsky, Ed Kellerman, and Leonard Sternberg.

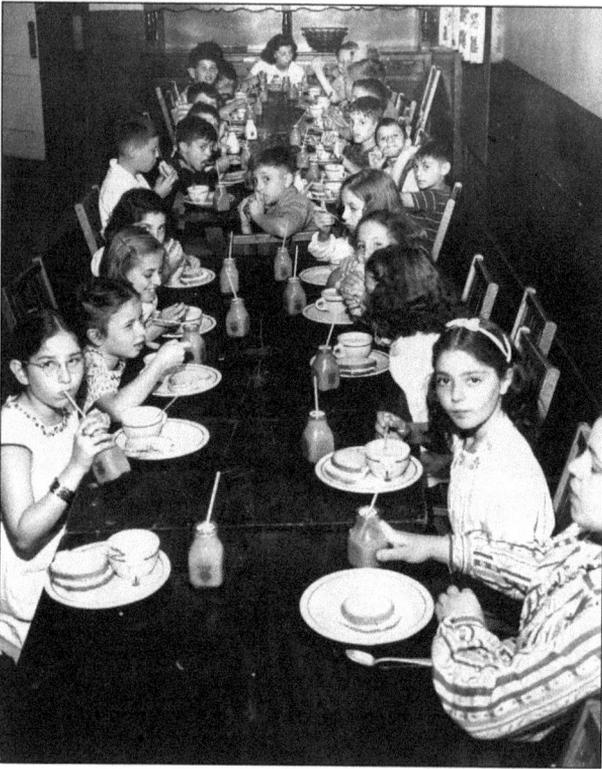

Those who attended the home camp at the AJC's property on West Exchange Street remember having to walk back through the alley to the main AJC building for lunch. Former campers can still smell the chocolate milk that was served daily. This photograph from 1949 shows counselor Reta Narotsky watching her charges.

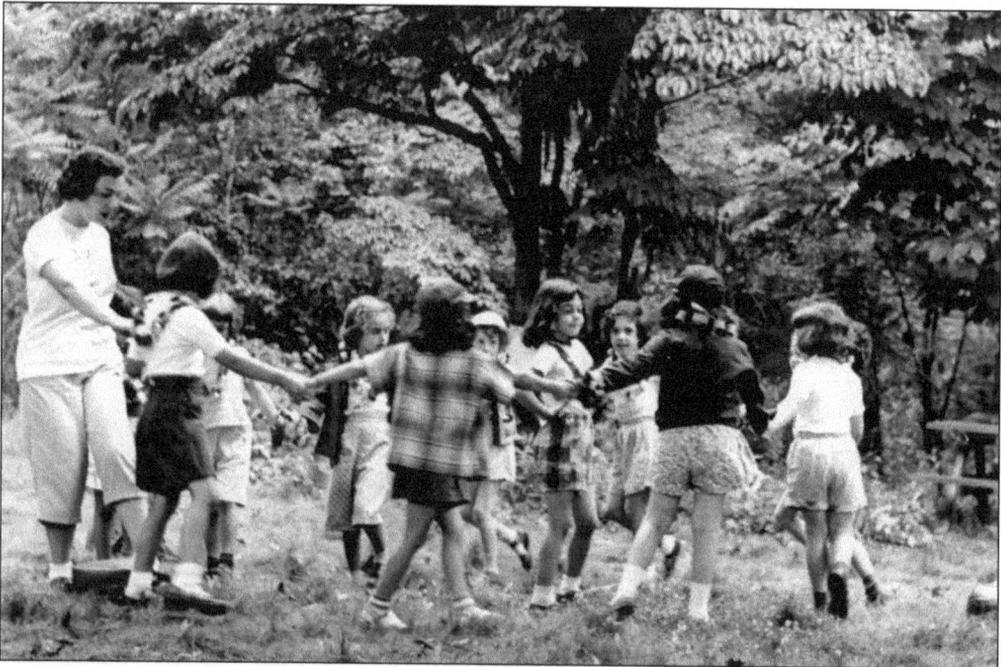

London Bridges was one of the games played at the AJC's home camp on West Exchange Street. Carolyn Narotsky keeps her campers busy in this 1951 photograph.

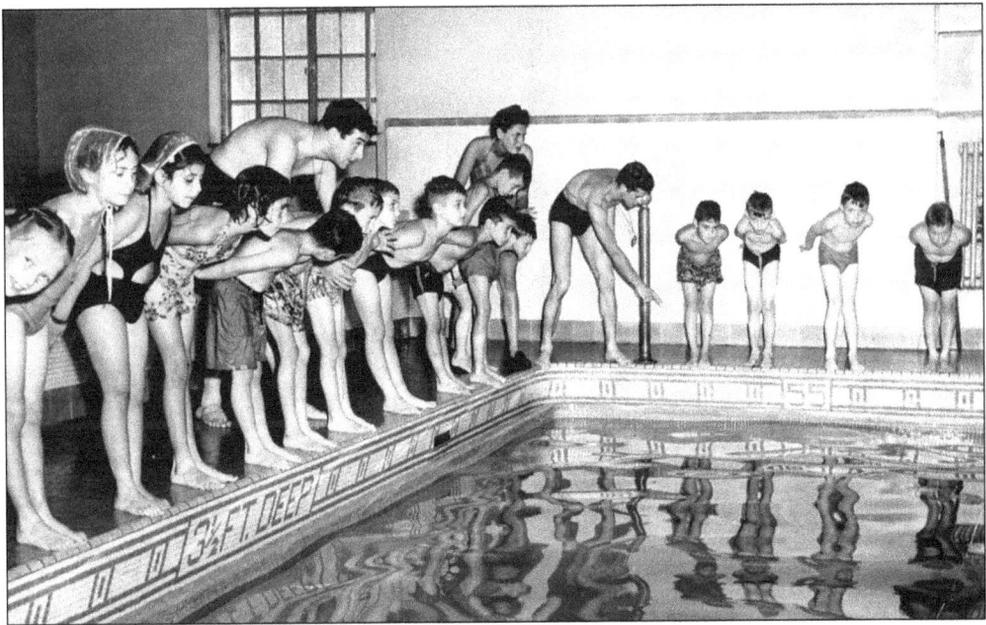

How many learned to swim at the old AJC pool? A mainstay has been the Red Cross–certified lessons. Several generations of youngsters have taken advantage of those lessons still offered at the White Pond AJC's indoor and outdoor pools. Waiting to jump in to practice the flutter-kick at the Balch Street pool in the 1940s are the Tadpole Swimmers. (Photograph by F. Gordon Cook.)

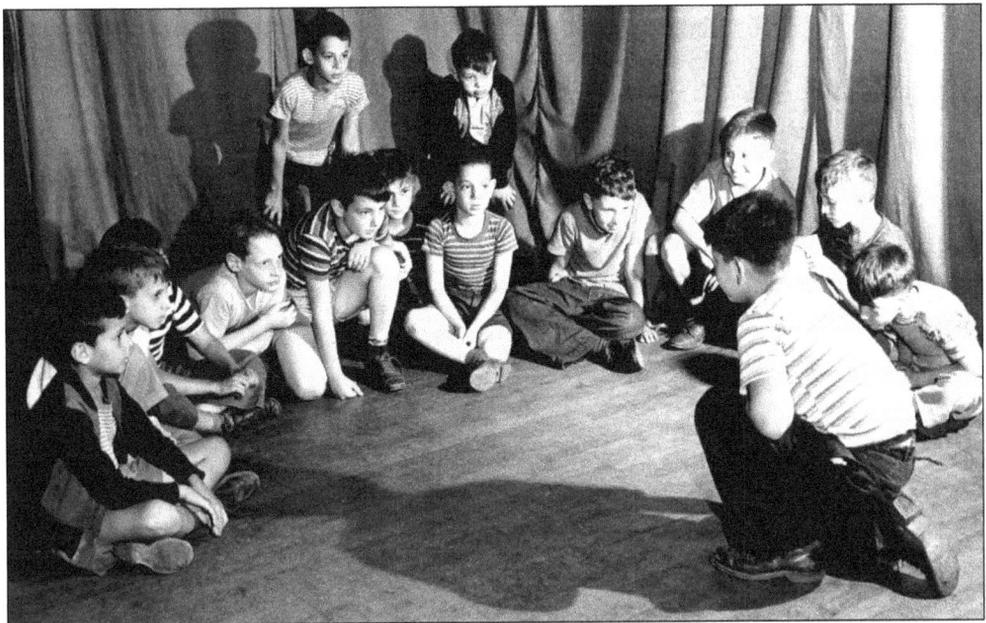

The AJC children's programs always attracted a crowd. The home camp introduced kids not only to crafts, baseball, and swimming but also to drama, which was mostly improvised. A good story caught the imagination of Bill Hartstein, Eugene Lieberman, Manny Mazur, Marvin Rosenthal, and among others, who look eager to perform on the AJC stage. (Photograph by F. Gordon Cook.)

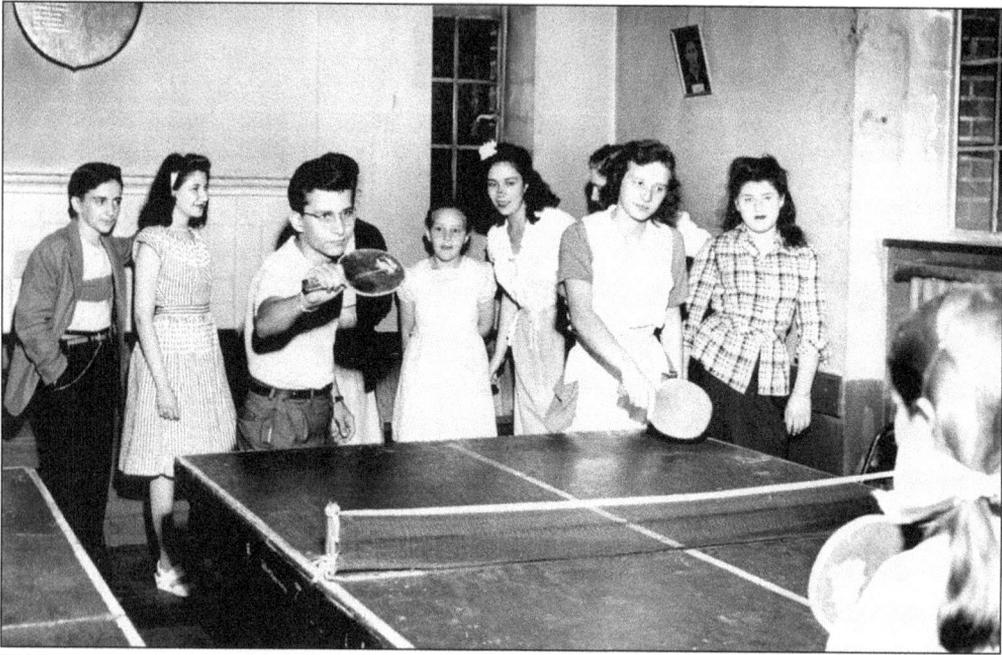

Table tennis was a popular and serious pastime at the Balch Street AJC in the early 1950s. Here Ray Federman and Roz Raipstein are engaged in a doubles match. Intently watching the action along the back wall, from the left to right, are Max and Sue Rothal, Beverly May, Betty Simon, and Shirley Chapman.

Winning prizes at the Akron Jewish Center annual Purim Carnival was not too difficult, as parents manned the booths and expected winners. In this 1947 photograph, Ann Merklin tries a game of chance. Onlookers identified include Pinky Rosenthal, Joe Katz, Morrie Katz, Stan Migdal, Bob Shapiro, Miriam Palachek, and Lourie Ekus.

After club meetings were over, it was time to get together for snacks and dancing. In the 1950s, teens learned to jitterbug, as well as slow dancing. Believe it or not, many happily married couples began dating in the Senior Lounge. Max Rothal (with the key chain) looks very cool. (Photograph by F. Gordon Cook.)

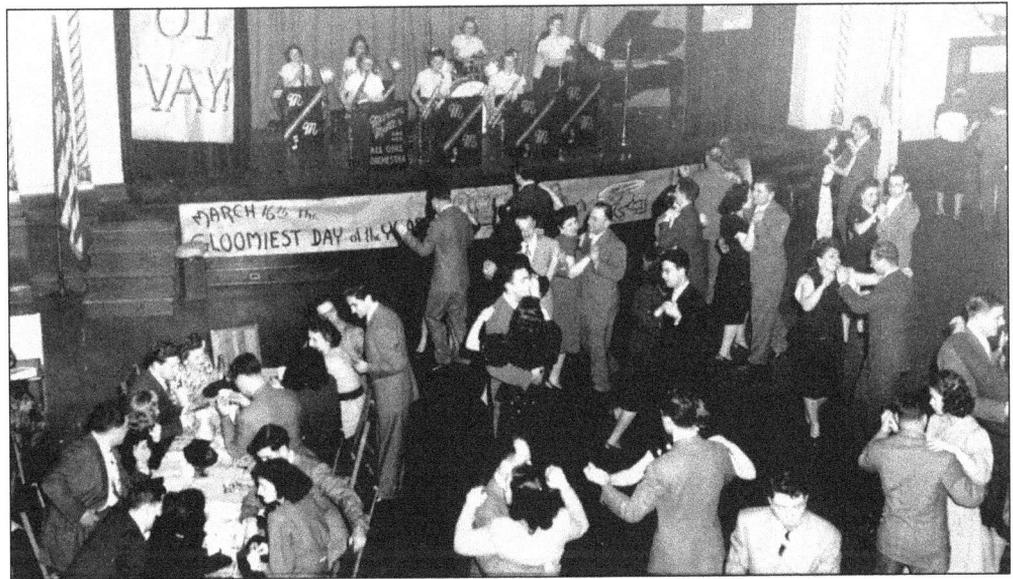

The AJC's future was seriously challenged in 1947 when bankruptcy threatened to close the building. Fortunately, the community responded by an amazing show of support and a variety of fund-raising events, including the "Oy Vay" Ball held in the AJC auditorium on March 16, 1947, which renewed its fiscal health.

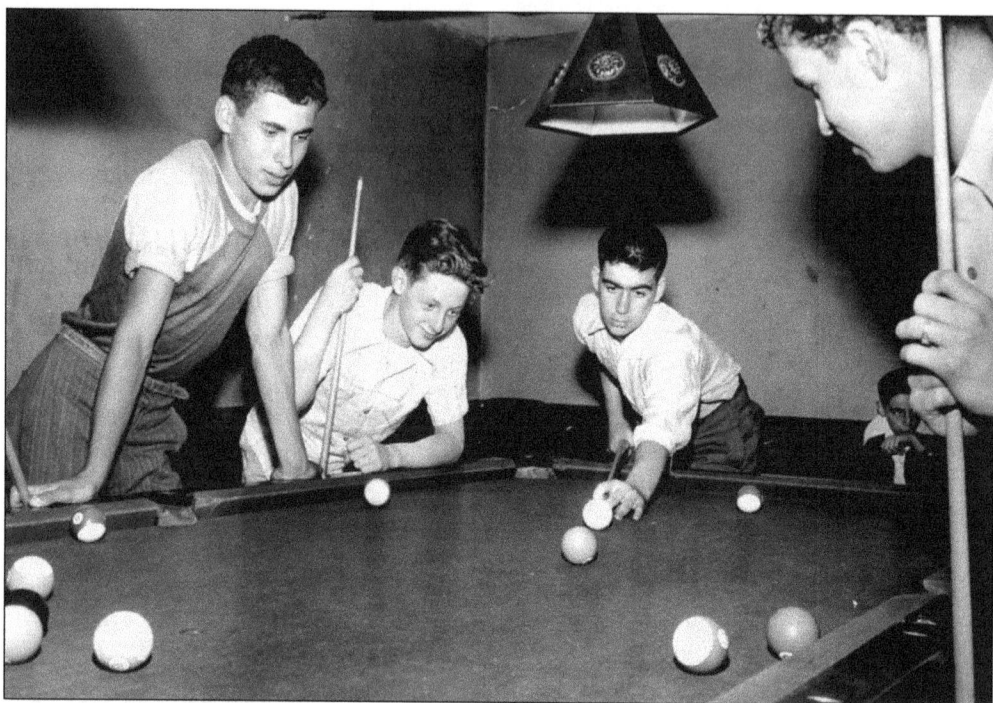

The AJC's pool tables were very popular in the 1940s and offered young men and women the opportunity to learn a sport usually found only in bars. Identified in this photograph, from left to right, are Nate Gould, Don Kaufman, and two unidentified men.

The holiday of Purim provided entertainment for all ages. In this picture, taken in 1946, teenagers try their hand at games of chance at the annual Purim Carnival held at the Balch Street Akron Jewish Center.

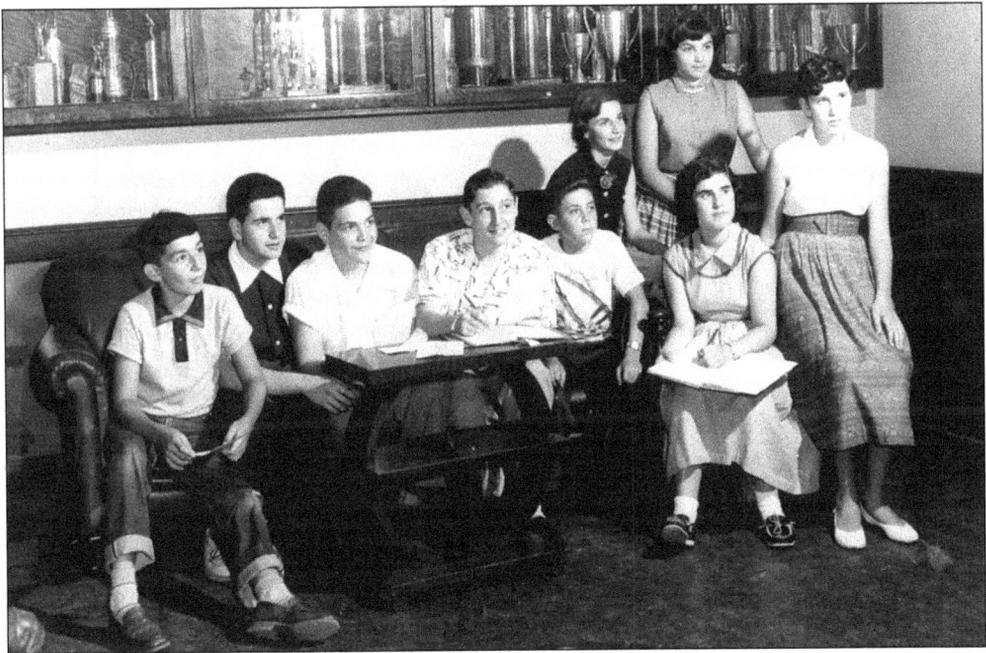

Freshmen and sophomore members of Senior Council planned group activities for their age group in the AJC trophy room in the early 1950s. From left to right are Alex Kushkin, Lee Shapiro, Sid Lesowitz, Marvin Pliskin, Jack Lieberman, Phyllis Kodish, unidentified, Nicki Magilavy, and Rita Garman.

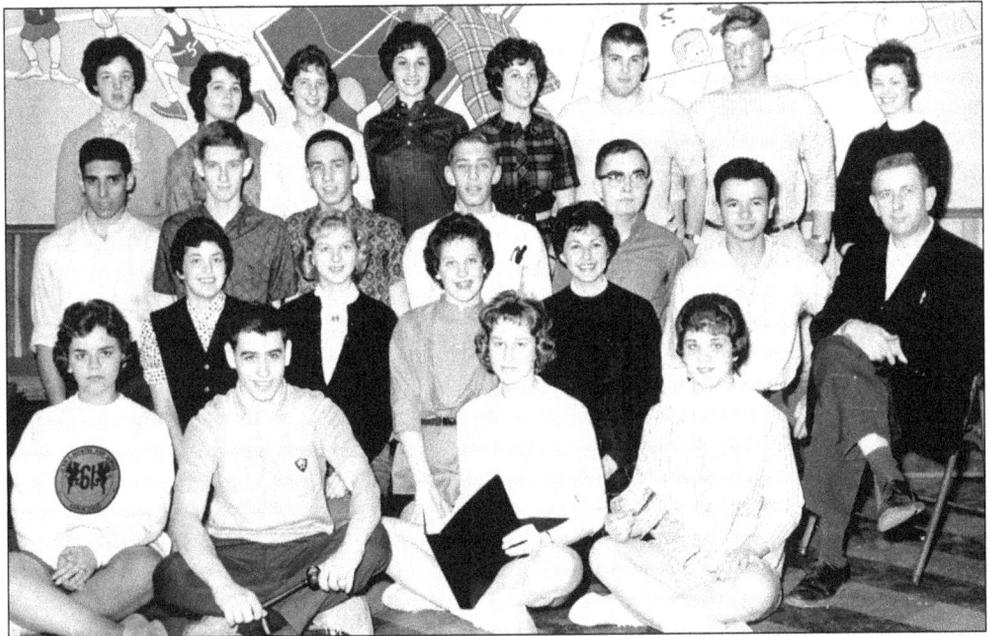

High school members of the AJC met for club meetings and Senior Council meetings on Wednesday nights. B'nai B'rith, AZA, the Buckeyes (Junior and Senior), Cavaliers, C-teens, PDG, and DVV were popular in the 1950s. Senior Council was made up of representatives from each club to plan sports and social events. This picture is from the late 1950s.

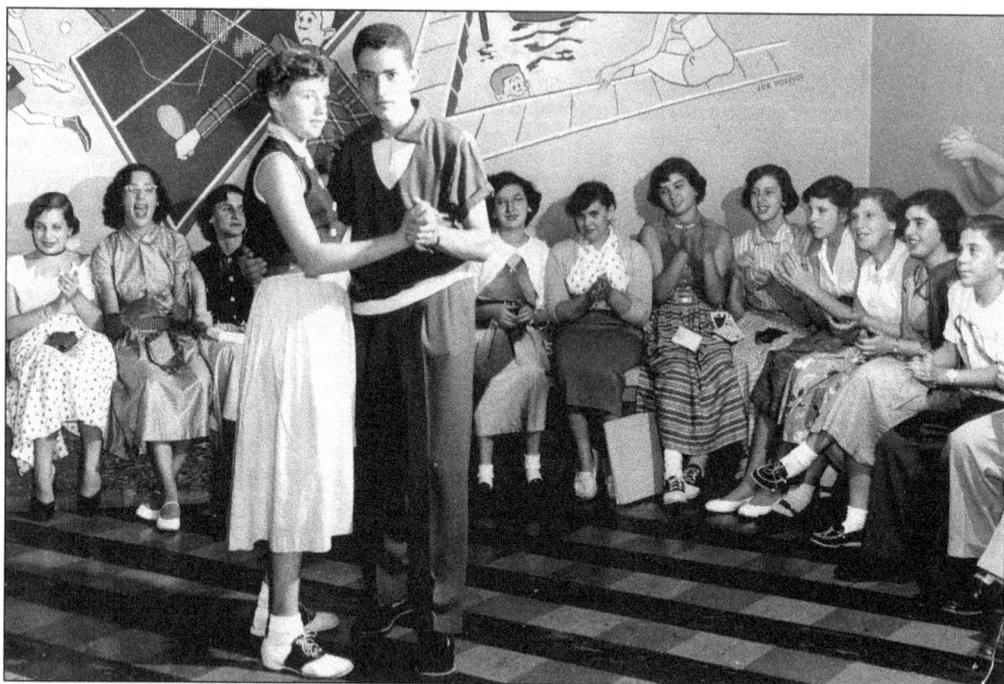

In the 1940s and 1950s, the AJC played a pivotal role in teenagers' social life. Every week they gathered in the Senior Lounge for dancing, talking, and simply hanging out. In this 1955 photograph, Harriet Recht and Aaron Koplin try a slow dance. Watching in the background, from left to right, are Marilyn Mirman, Joyce Backer, Phyllis Kodish, Rhea Axelrod, Lenore Schultz, Nicki Magilavy, Margie Slonsky, Rita Garman, Cookie Wolinsky, Arlene Cohen, and Jack Lieberman. (Photograph by Vic Zinn.)

A great way for young teens to get acquainted and have fun was a Junior Council–sponsored square dance in 1951. These preteens were serious about learning to do-si-do and other square dance steps.

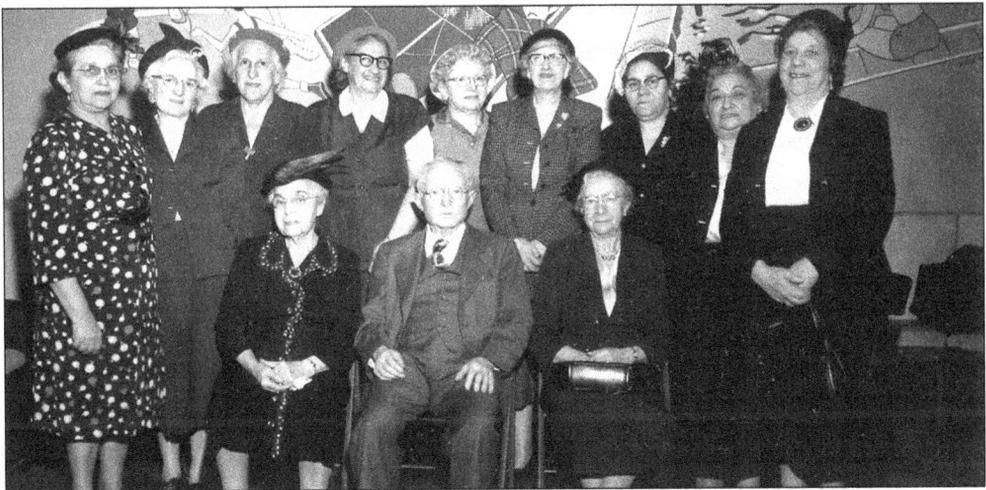

The AJC provided older adults with activities and day trips. Posing in the 1950s in the youth lounge on Balch Street are senior citizen women surrounding Aaron Ocker. From left to right are the following: (first row) Goldie Shorin and unidentified; (second row) Ida Schultz, Regina Beck, Katherine Schmaltz, ? Yudell, Fannie Kreitzbert, ? Grossman, Rose Weisberg, ? Berman, and Raie Laurence.

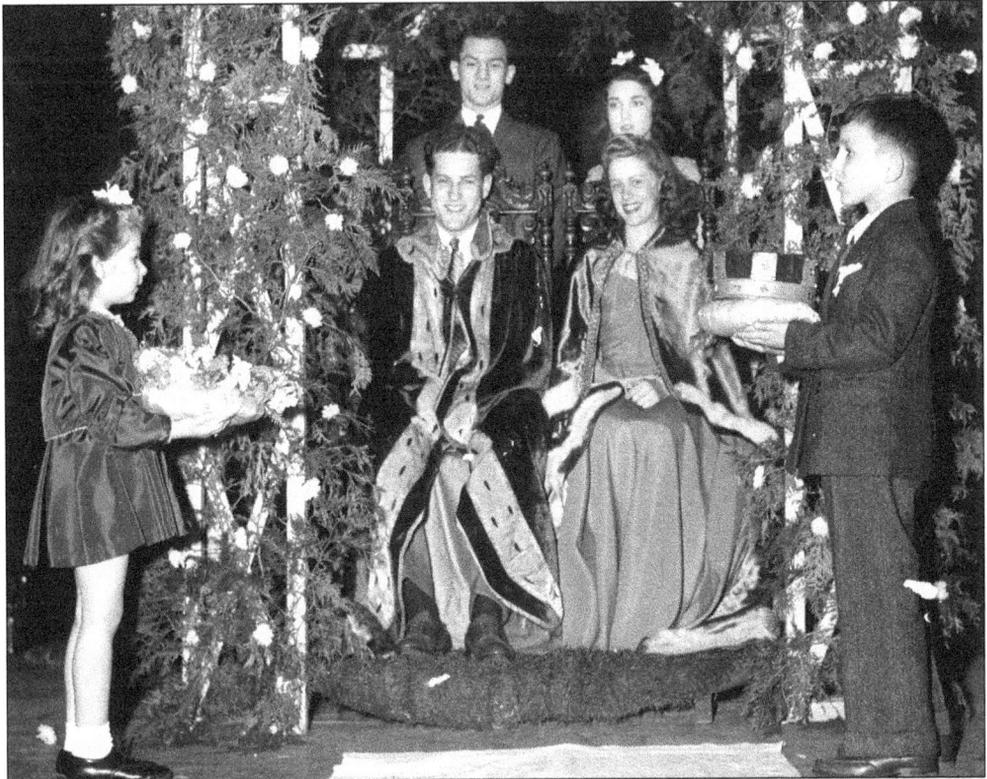

The AJC youth and young adults crowned a king and queen annually for the Purim Ball. In this 1942 photograph, Herb Rudy and Helen Shecht are honored. Their teen attendants are Jack Manes and Micky Folb. Young crown bearers are Joan Leibowitz and Bernard (Berel) Leff.

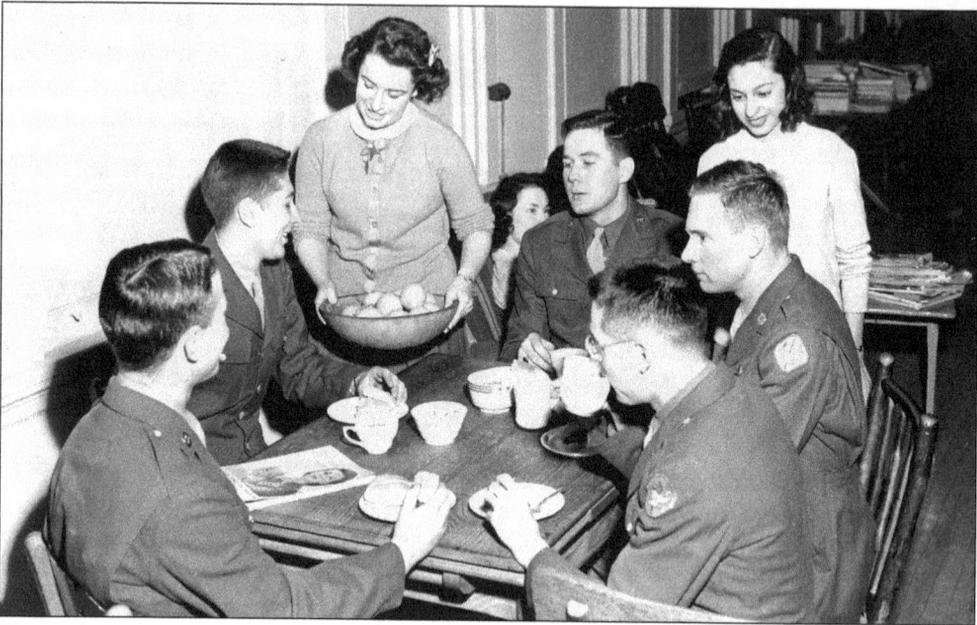

Playing hostess to the military men stationed at the University of Akron during World War II are Mona Lee Rose (left) and an unidentified woman.

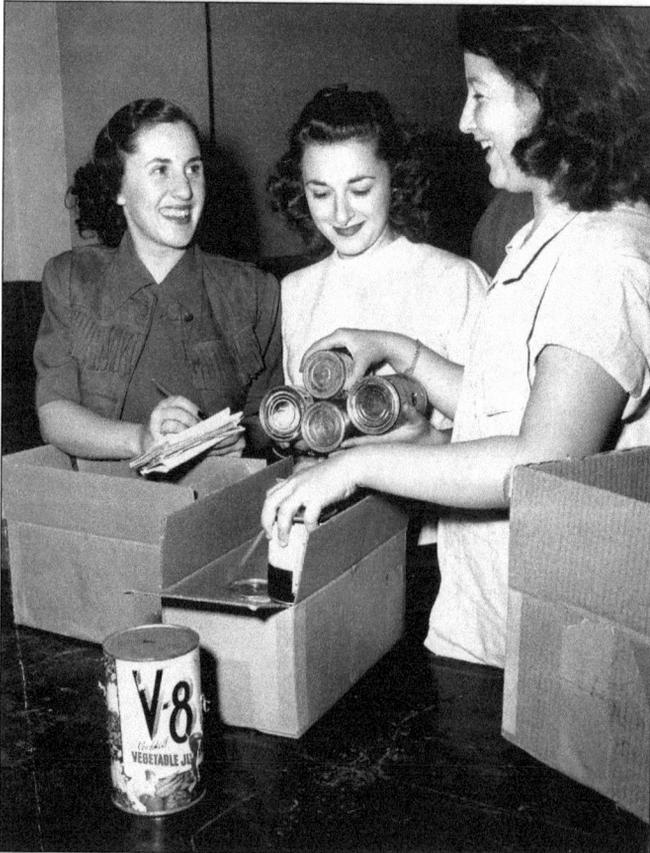

Packing food for the needy in 1947 are, from left to right, Miriam Schwartz, Edith Haberman, and Barbara Weinstein.

Murray Glauberman was in every way a big man, with an even bigger heart. Together with his family, he founded Maalco Products, a successful packaging company. Murray loved the AJC, and for years, he not only enjoyed the facilities, but as president of the AJC's board in the early 1970s, he oversaw the raising of funds for the construction of the White Pond Drive complex.

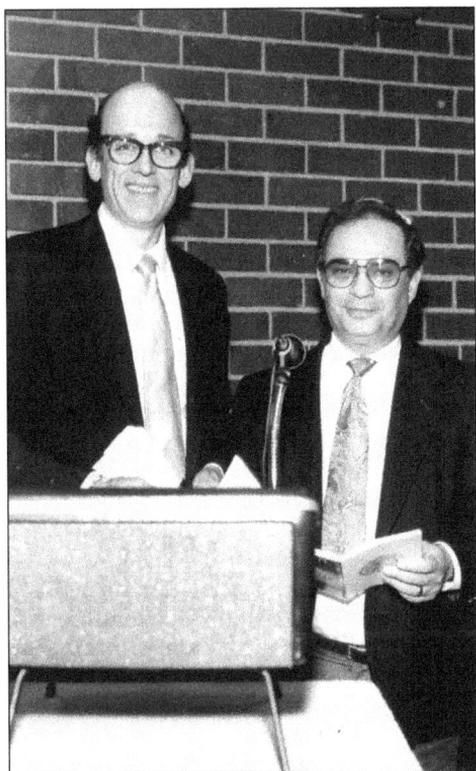

Sheldon Saferstein (left) and Shaw Jewish Community Center executive director Hy Tabachnick share the podium at a community function.

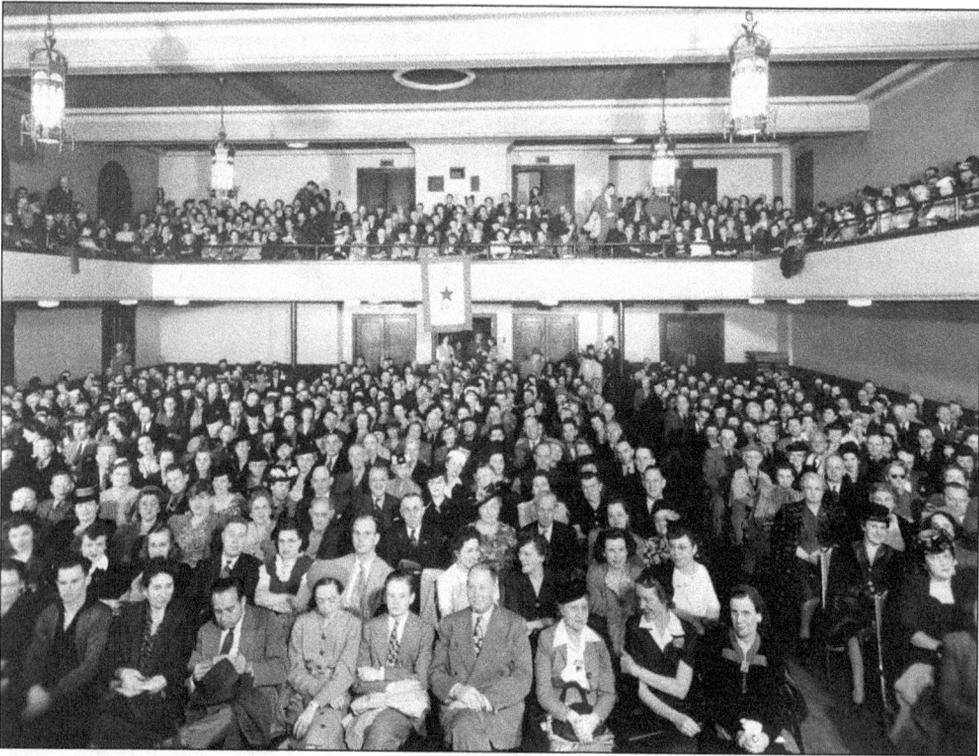

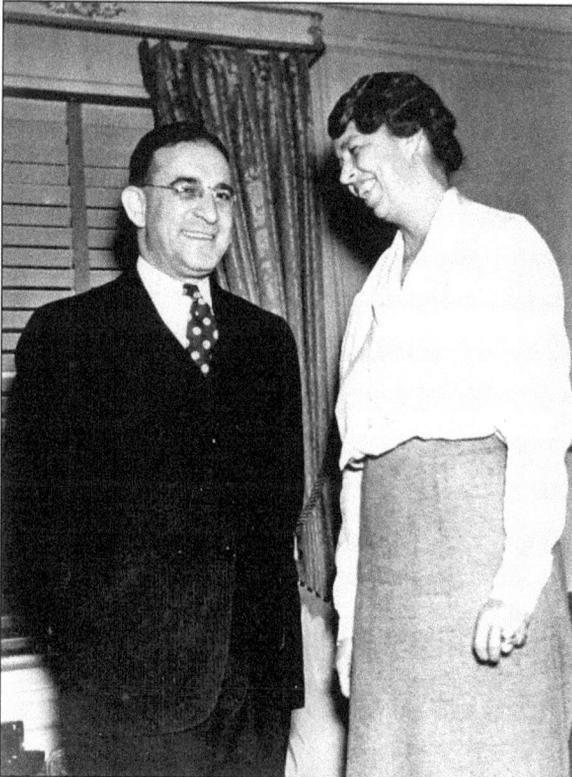

The AJC sponsored an annual series of speakers in the 1930s and 1940s that brought nationally known individuals to the Akron community. Among them were Will Rogers, Sen. Wayne Morse, Margaret Bourke-White, Robert Taft, Rabbi Abba Hillel Silver, Mrs. Paul Robeson, and Telford Taylor. In the 1950s, the series was moved to radio and, later, to television, where it continues to serve the Akron community today. A full house at the AJC's Balch Street auditorium is pictured above, with audience members raptly listening to the evening's lecture in the 1940s. At left, Eleanor Roosevelt is seen with Hy Subrin, one of founders of the Akron Civic Forum. She spoke to an overflowing and welcoming crowd in 1937 at the Akron Armory, since the AJC's auditorium could not accommodate the number of tickets sold. (Photograph courtesy of the University of Akron Archives.)

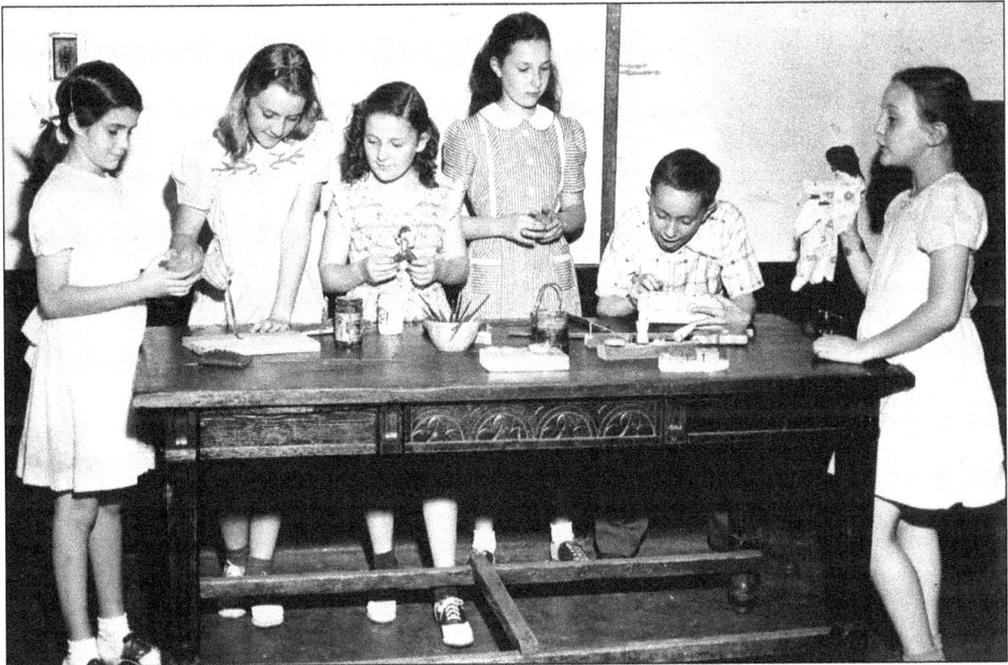

The Balch Street AJC has always offered creative programming for youngsters. The photograph above shows a group of young girls working on a project around one of the AJC's beautiful multipurpose wooden tables. These tables evoke memories of countless hours spent learning to work clay, finger paint, weave, and other new skills, not least of all was making new friends.

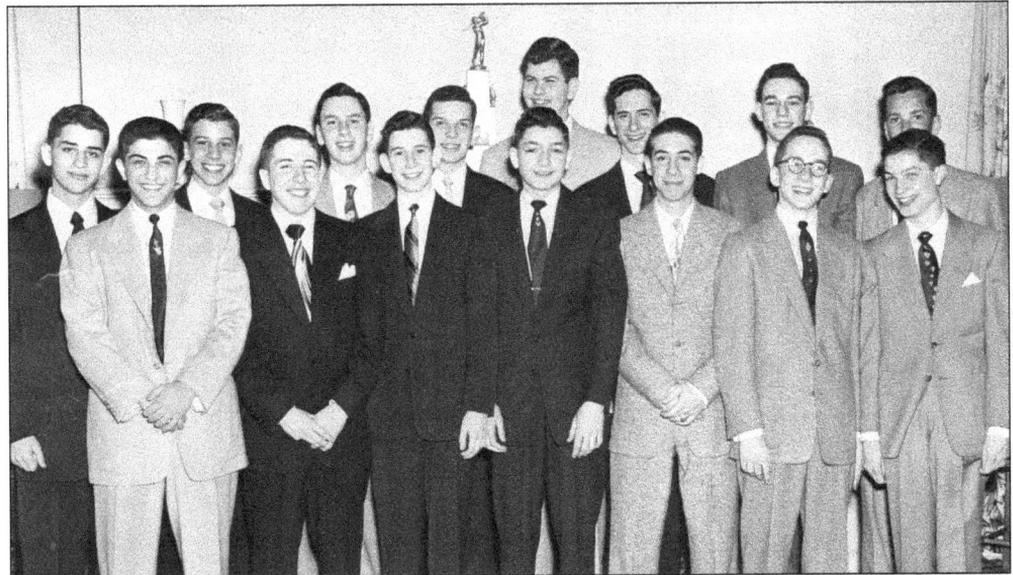

This photograph shows the Junior Buckeyes, a group of young men whose friendships began in 1948 and continue almost 60 years later. They played (baseball, poker) together and studied together. From the Junior Buckeyes, five became doctors, two dentists, three lawyers, and three businessmen. The Junior Buckeyes were encouraged to form as a result of the friendship of their older brothers in the Senior Buckeyes: Don Stone, Allan Leavitt, Burt Subrin, and Larry Perelman. (Photograph by Stan Marks.)

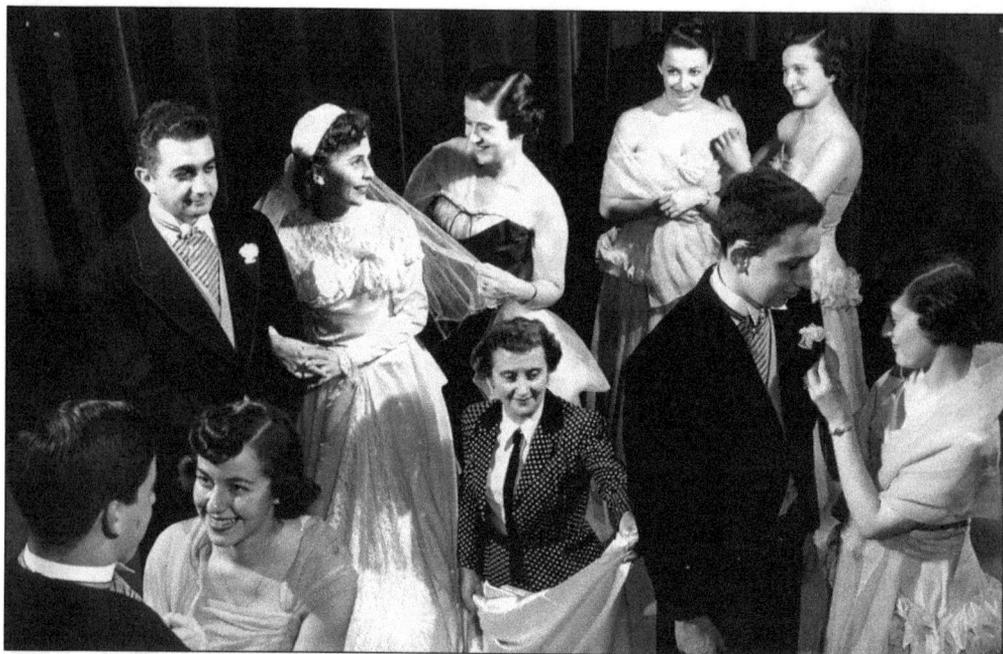

The Center Theater Guild provided the community with live productions of Broadway plays at the Balch Street AJC. Sasha Rose, the first director, and, later, Esther Berloff successfully directed local actors to mostly rave reviews for 13 seasons beginning in 1947. *Father of the Bride*, starring Jack Magilavy and Bea Rabb, was one of those hits.

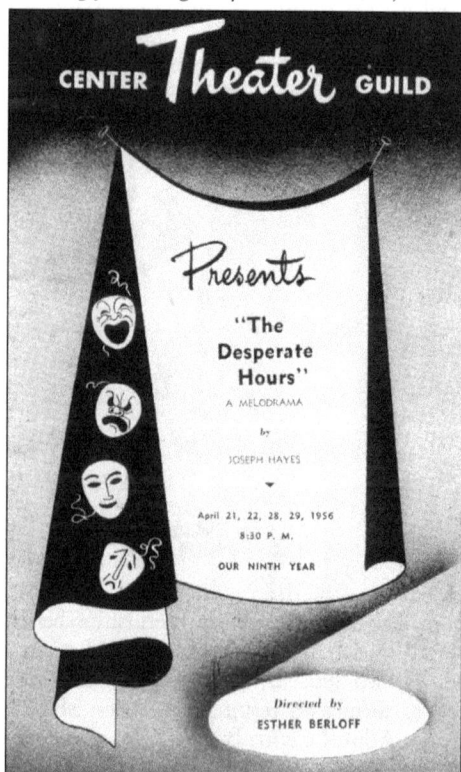

CENTER *Theater* GUILD

Presents

"The
Desperate
Hours"

A MELODRAMA

by

JOSEPH HAYES

April 21, 22, 28, 29, 1956
8:30 P. M.

OUR NINTH YEAR

Directed by
ESTHER BERLOFF

Shown here is a playbill for *The Desperate Hours*.

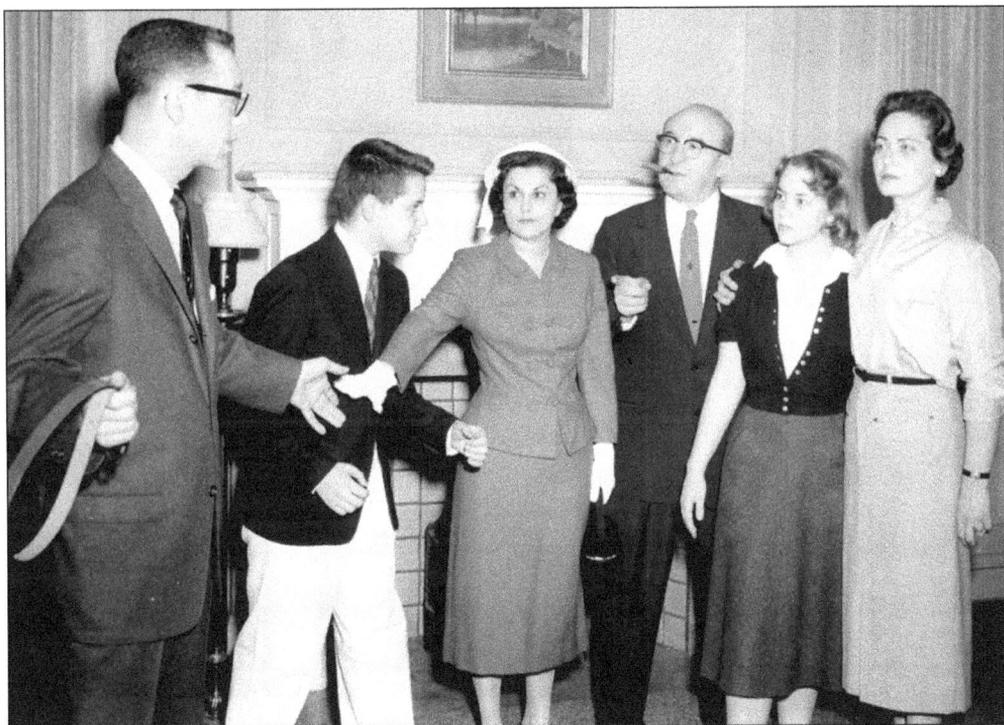

The Center Theater Guild presented *Anniversary Waltz* in 1957. This scene includes, from left to right, Bob Graetz, Joe Berman, Charlotte Essner, Sam Weidenfeld, Mary Beth Weinstein, and Mary Myers.

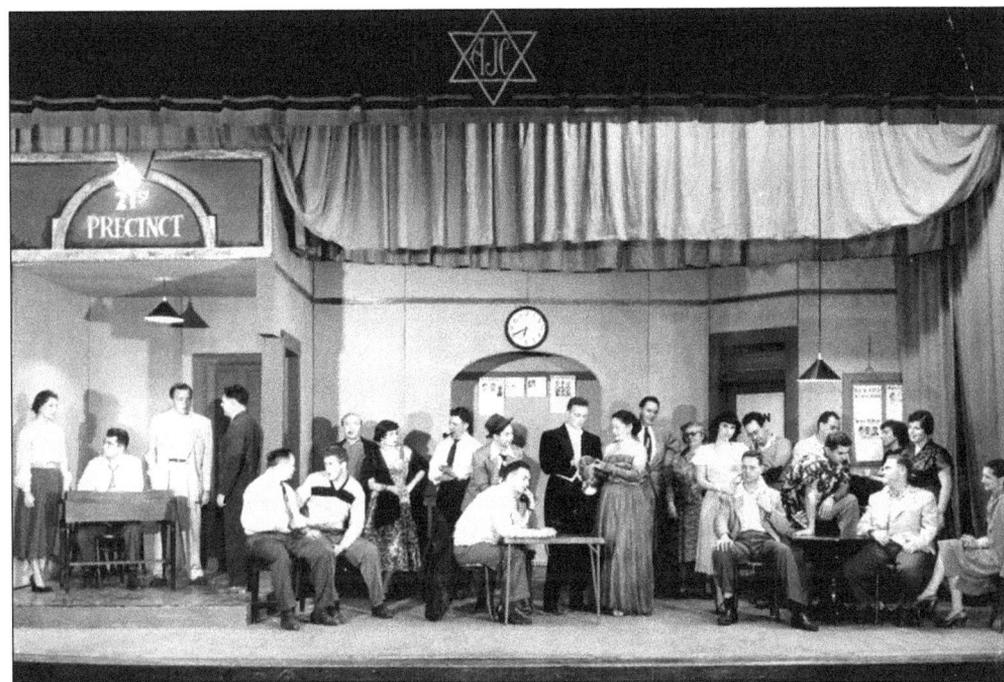

A cast photograph from *The Detective Story* is pictured here.

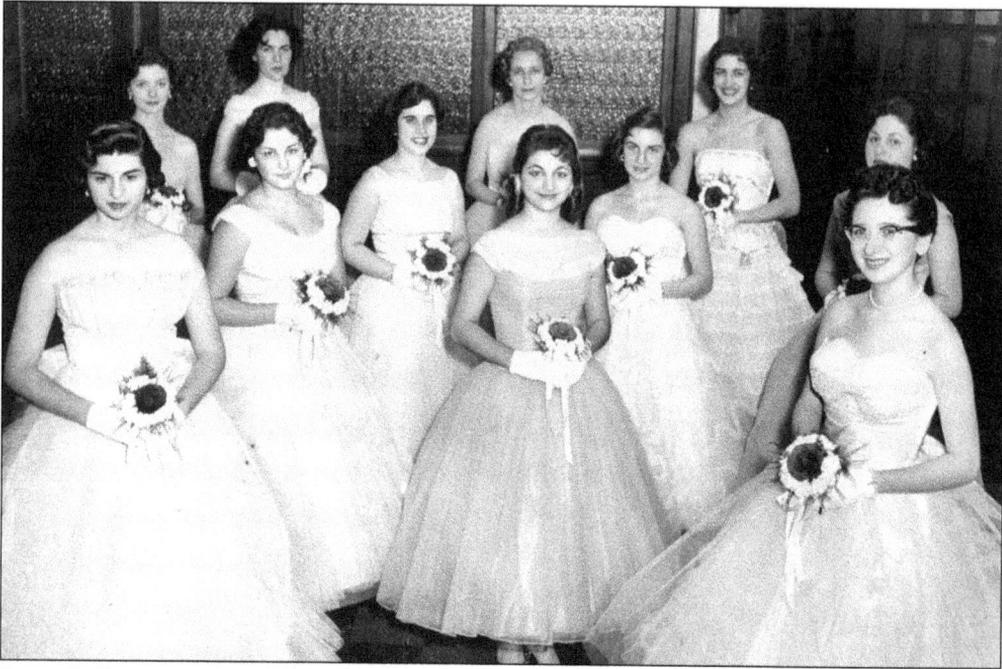

Purim Ball is unique to Akron. Beginning in 1956, all high school senior girls have been invited to participate with their fathers (or male relative). Beginning each Sunday in January and continuing weekly until spring, fathers and daughters practice intricate dance steps that are performed for ball attendees. It is a special bonding time. At the ball, each girl is magically presented as a Queen Esther for the evening.

Choreography of the Purim Ball dance starring fathers and daughters has always been professionally designed. Eleanor Rudick and her sister Geraldine Stein began the tradition. This photograph shows more recent choreographers Sandi Moses (left) and Fran Lieberman, who have devoted many hours to the success of Purim Ball.

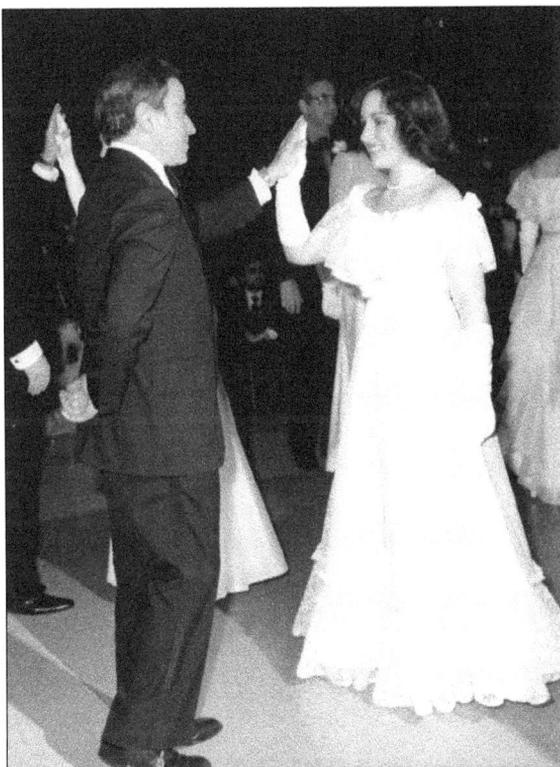

Debra Rossen represents the second generation of Queen Esthers at the annual Purim Ball in 1981. In this photograph, Debra and her father, Dick, perform to the song "Fascination." (Photograph courtesy of Debra Rosenthal.)

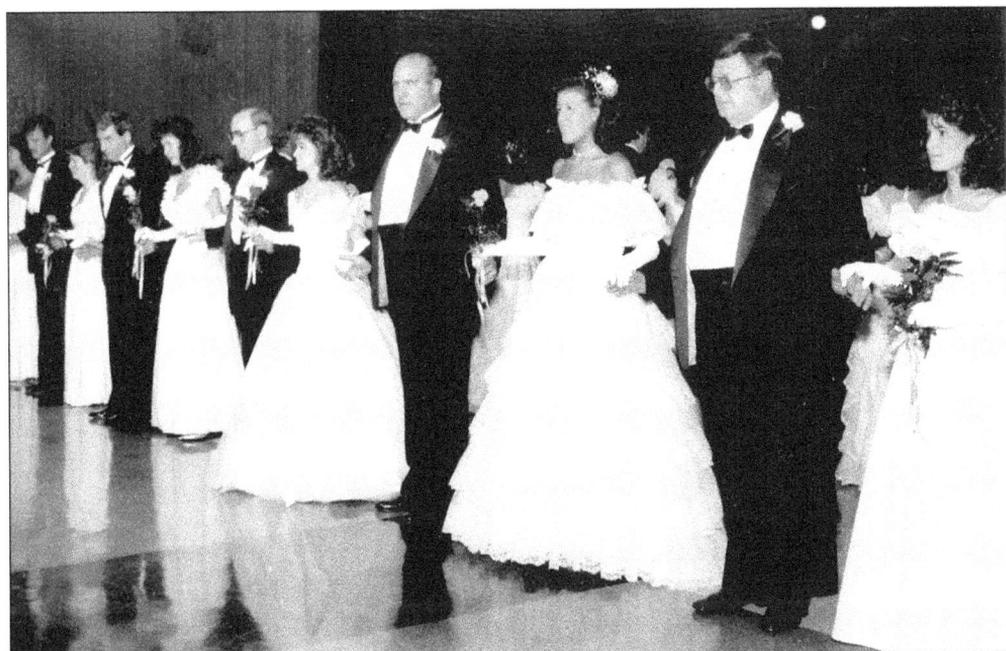

Girls and their fathers line up to begin their dance. In this 1987 photograph, the senior high school girls are, from left to right, Amy Berid, Joy Feibelman, Joy Levin, Michelle Oppenheimer, and Lisa Shapiro.

The Center Auxiliary began sponsoring Women's Day in the spring of 1956 under the chairmanship of Sasha Rose, pictured above (second from the left) with Dr. Norman Auburn, president of the University of Akron (on the right) and other speakers participating in the all-day program. This event was open to all Akron women. Through the years, celebrity keynote speakers included Joan Crawford, Carl Rowan Jr., Ann Eaton (wife of Cyrus Eaton), and Akron's own R. W. "Johnnie" Apple Jr., shown with Lourie Rapport on the left. Apple, a reporter for the *New York Times*, had to leave in a hurry to cover the breaking news of the Watergate break-in.

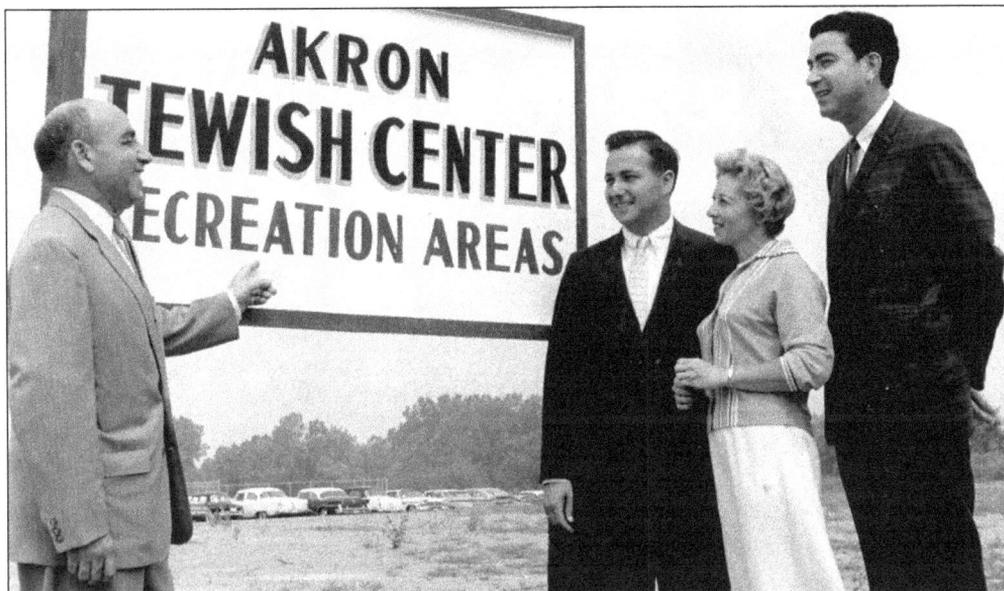

By 1960, it was clear that the Balch Street AJC needed to expand again. Max Wyant and the Sacks family contributed to the dream of a new complex by purchasing property on White Pond Drive. From left to right, Leslie Flacksman, Mel Sacks, and his mother, Irene, along with AJC president Jack Saferstein, happily look to the future.

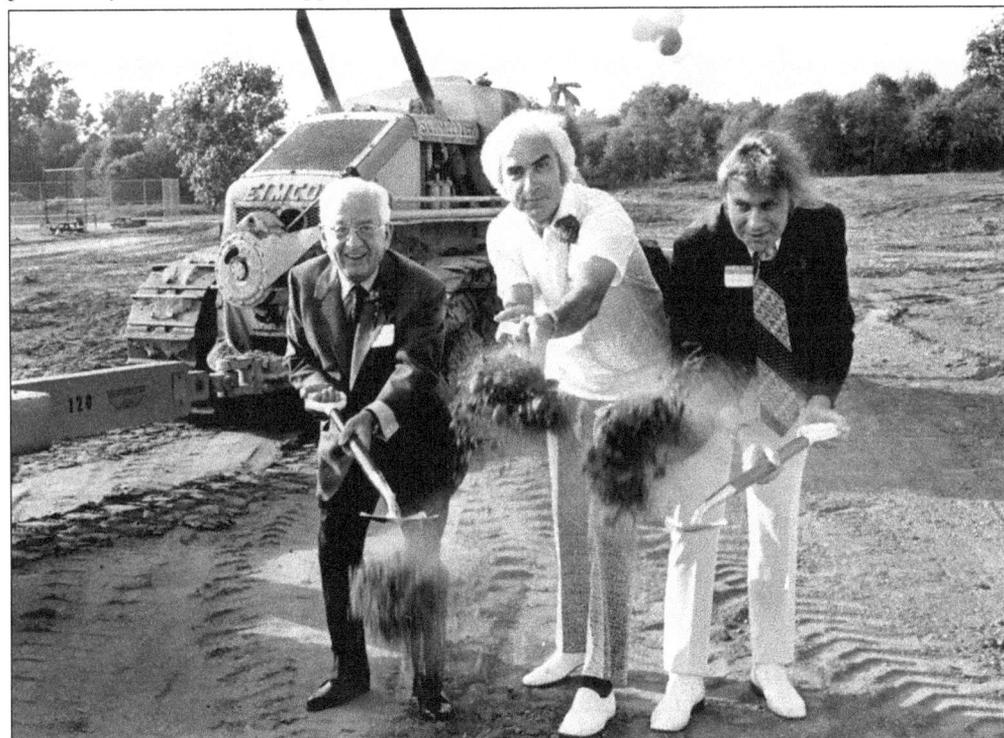

Charles Schwartz, Jack Saferstein, and Murray Glauberman, from left to right, join in the first dig as past AJC presidents. Saferstein and Glauberman served as cochairmen of the Building Fund for the White Pond Drive AJC in 1963.

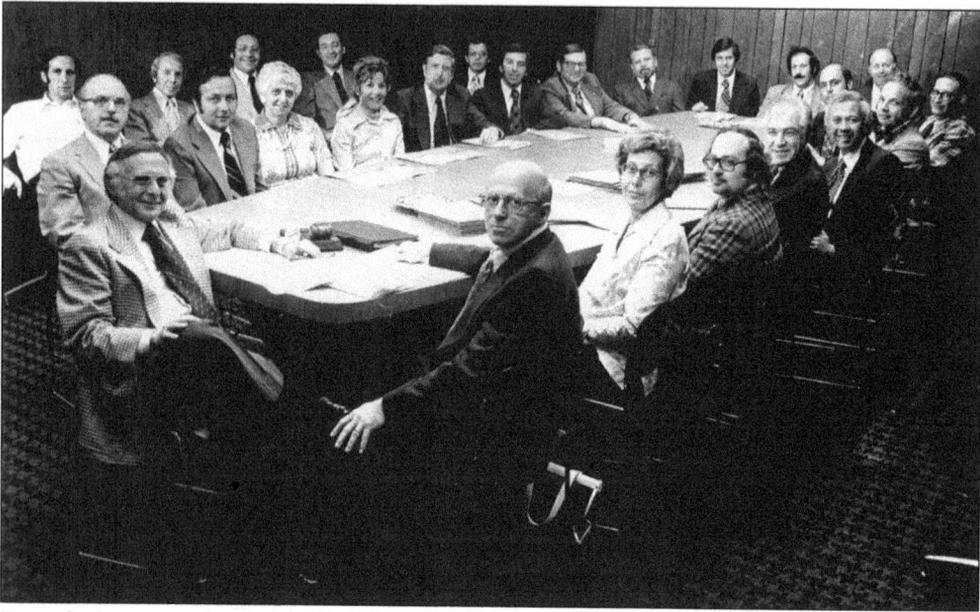

From the beginning until today, the AJC trustees have been the cream of the community. Shown in the board room of the newly opened White Pond AJC are the trustees for 1973–1974. Clockwise around the table, they are president Stan Bober, Jack Lederman, Mel Sacks, Sarah Orlinoff, three unidentified, Ted Marks, Walter Philips, Fred Vigder, unidentified, Marv Shapiro, Milt Wiskind, Stan Minster, Bob Stone, Jerry Goldstein, unidentified, Harvey Sterns, Gloria Deutchman, and Hal Lebovitz. Along the wall are David Friedman, Bernie Rosen, Dave Lockshin, and Irv Kaplan. (Photograph by Julius Greenfield.)

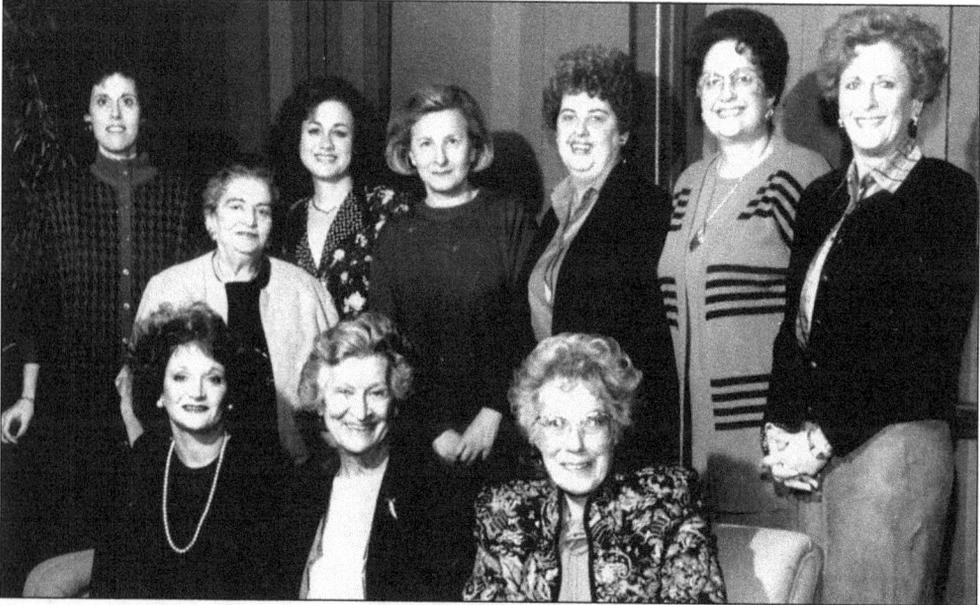

Jewish Center Auxiliary past presidents got together at the White Pond Shaw Jewish Community Center. From left to right, they are as follows: (first row) Esther Bober, Elsie Kodish, and Gloria Reich; (second row) Lynne Weinberger, Jenne Meltzer, Patti Nemeroff, Carole Giller, Maxine Gertz, Patti Vigder, and Francine Freedman.

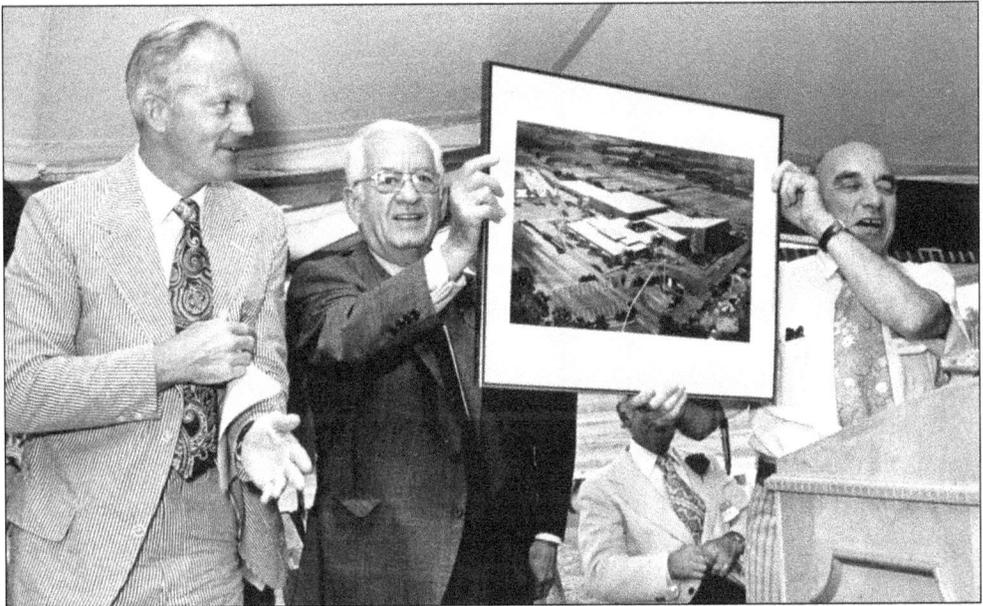

The White Pond Drive AJC was completed in 1973. In this photograph, from left to right, Congressman John Seiberling, Charlie Schwartz, and Leslie Flaksman enjoy showing the architectural photograph of the finished complex.

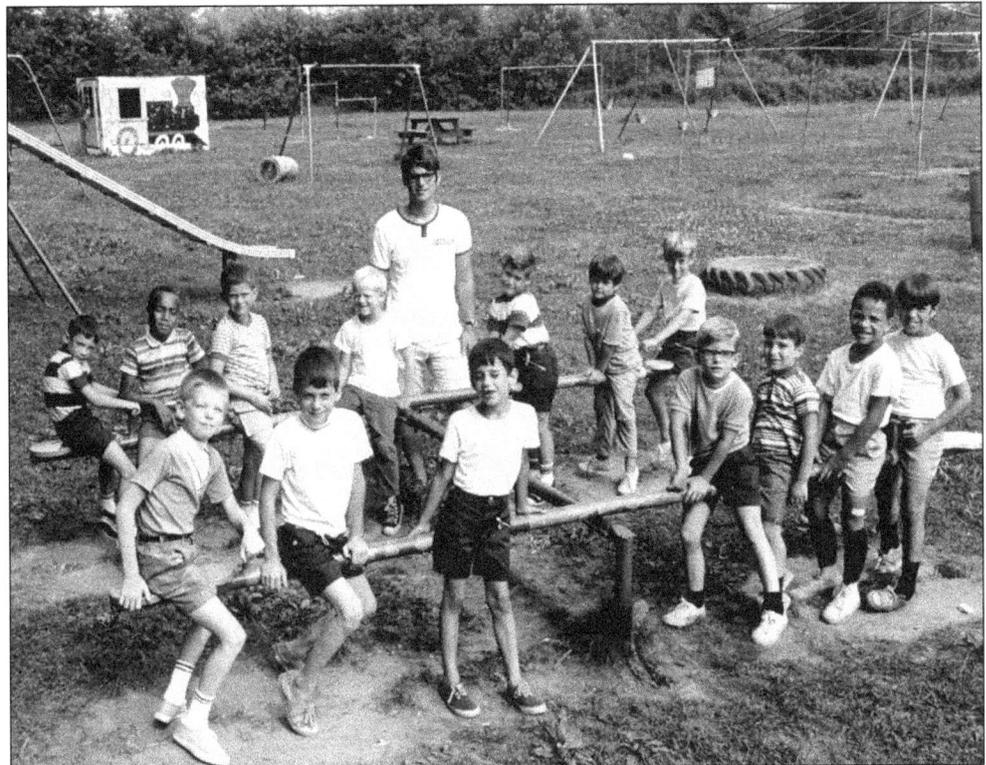

The White Pond Drive AJC included grounds for a day camp. Here the children play in a relatively underdeveloped area.

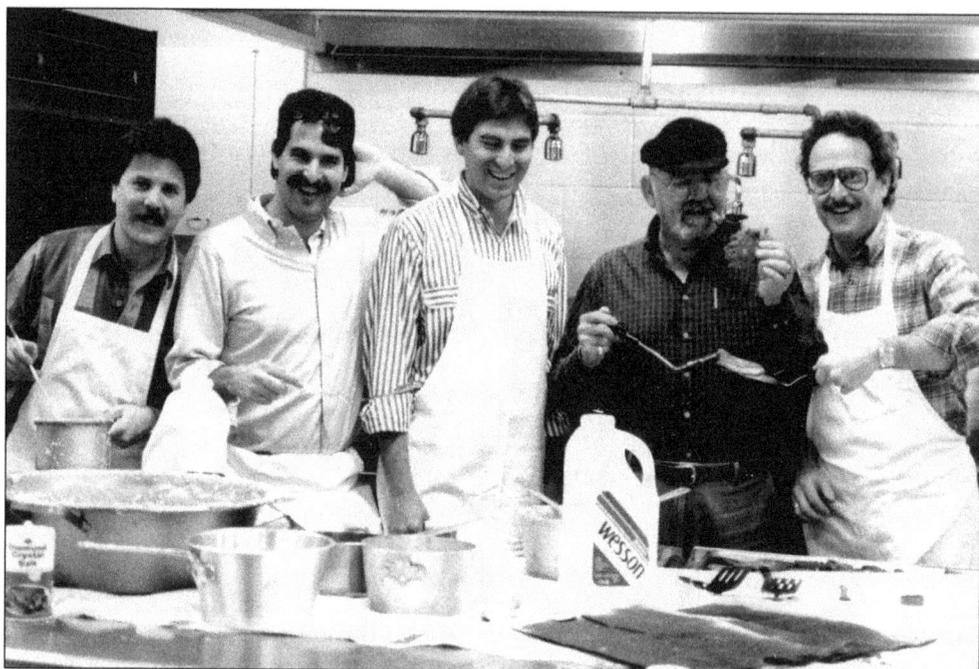

It is a myth that Jewish men do not know their way around a kitchen. These fellows made some fine-tasting latkes for a Chanukah party at the AJC.

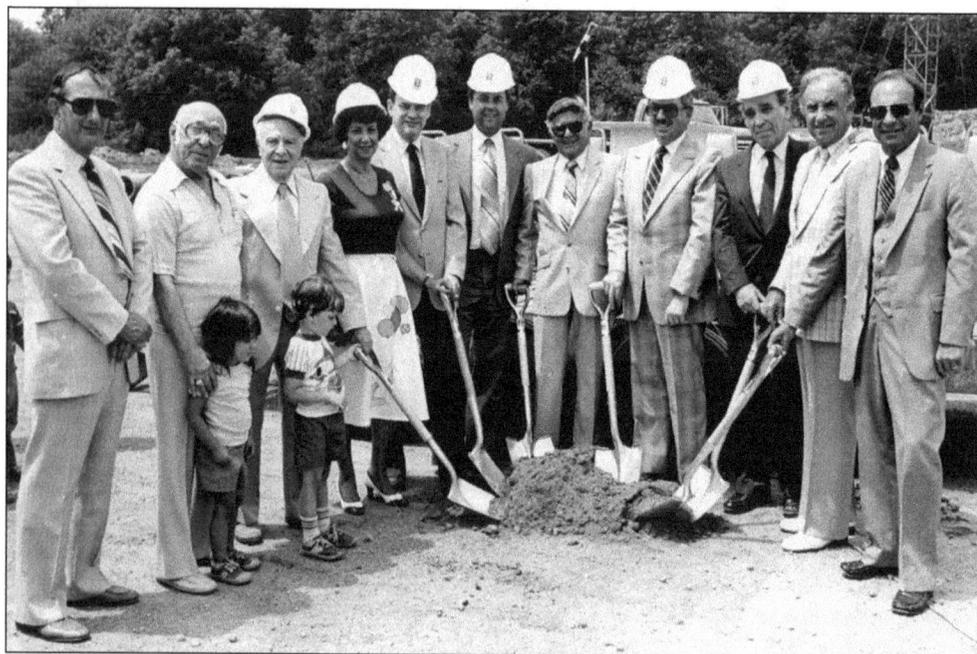

In 1981, construction began for an apartment building catering to senior citizens on the grounds of the White Pond AJC complex. Shown at the groundbreaking are members of the AJC board, as well as a few active seniors. From left to right are Stan Minster, two unidentified men and their grandchildren, Lila Marks, Ted Schneiderman, Marvin Shapiro, Stanley Bober, Stan Schneiderman, unidentified, Herman Rogovy, and Marvin Manes.

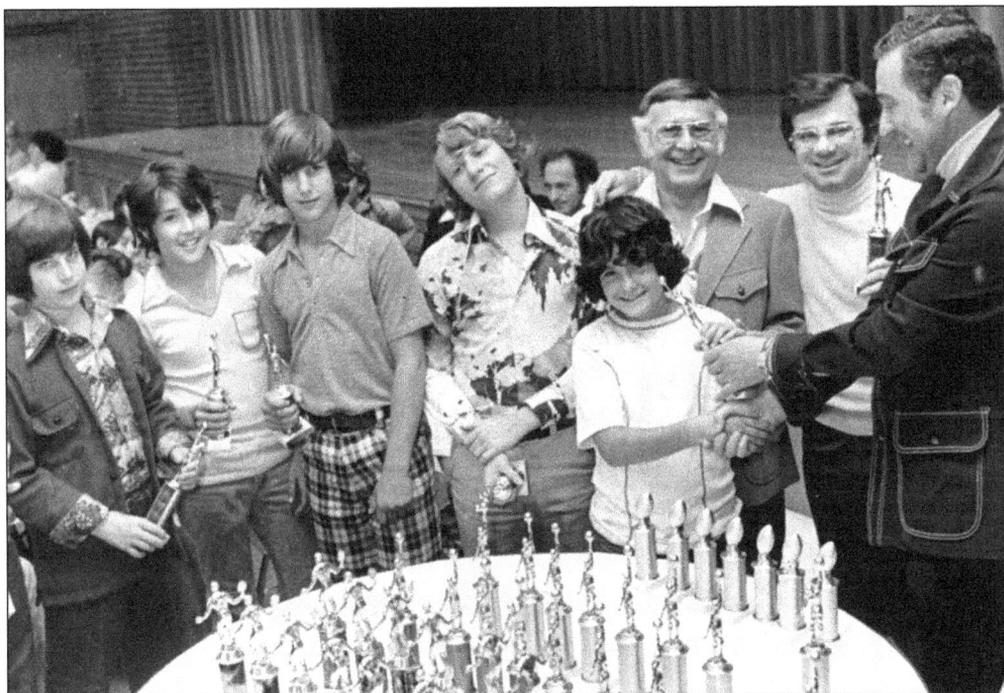

The Shaw Jewish Community Center honors its sports champions and Hall of Fame inductees at an annual dinner. This photograph from 1975 shows Irv Kaplan (far right) awarding trophies to young athletes, while Stan Bober (left) and Mort Stein await their turns. (Photograph by Julius Greenfield.)

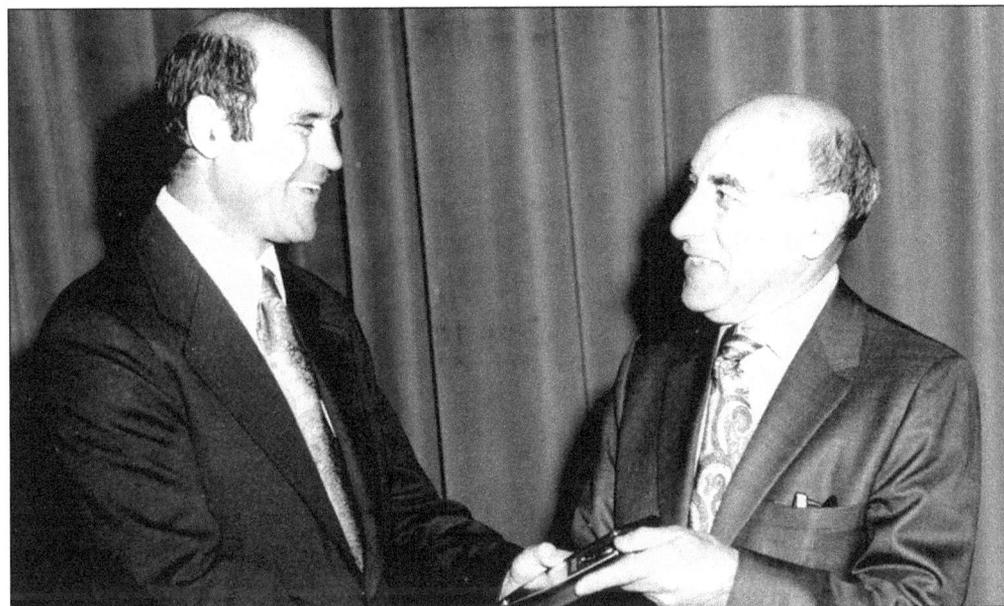

The Jewish Sports Hall of Fame celebrates the achievements of Akron's outstanding Jewish athletes. From the 1930s through the 1960s, the AJC's men's basketball team was legendary. Art Shapiro receives his plaque from Leslie Flaksman, signifying his induction into the Hall of Fame for his accomplishments in basketball.

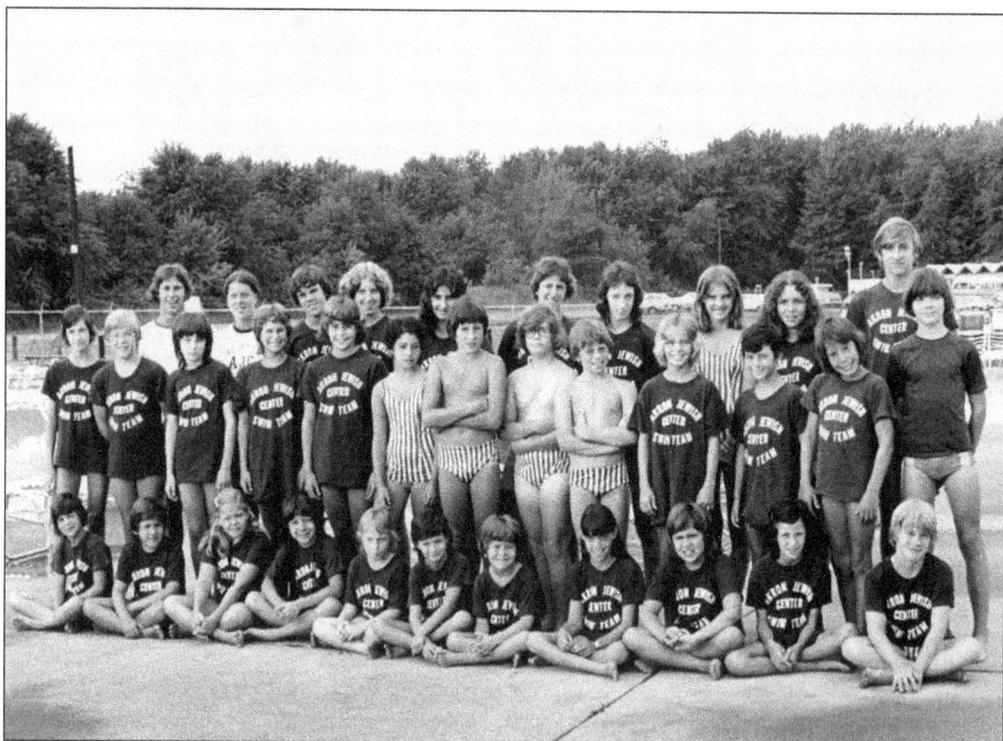

The indoor and outdoor pools at the Shaw Jewish Community Center on White Pond Drive are perfect for competitive swimming events. The Shaw Jewish Community Center has been able to attract students at all levels to participate in citywide swim meets. This photograph from the late 1970s shows the swim team, comprised of elementary, junior high, and high school swimmers.

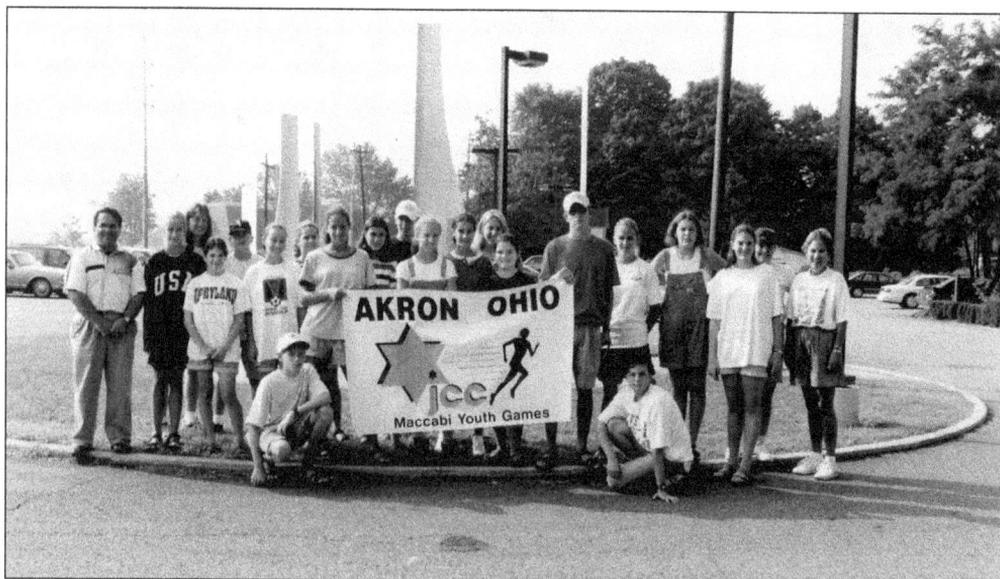

The Shaw Jewish Community Center continues its tradition of emphasizing sports programming by participating in the Maccabia Youth Games, an international event. Prior to the start of the games, the Akron team proudly displays its banner.

Edith Weinstein was a professor in the Community and Technical College at the University of Akron. She generously shared her talents with the Jewish community in several capacities. In 1987, Edith was elected as the first (and to this time, the only) woman president of the Shaw Jewish Community Center. In this photograph, she is installed as president by Alan Markey.

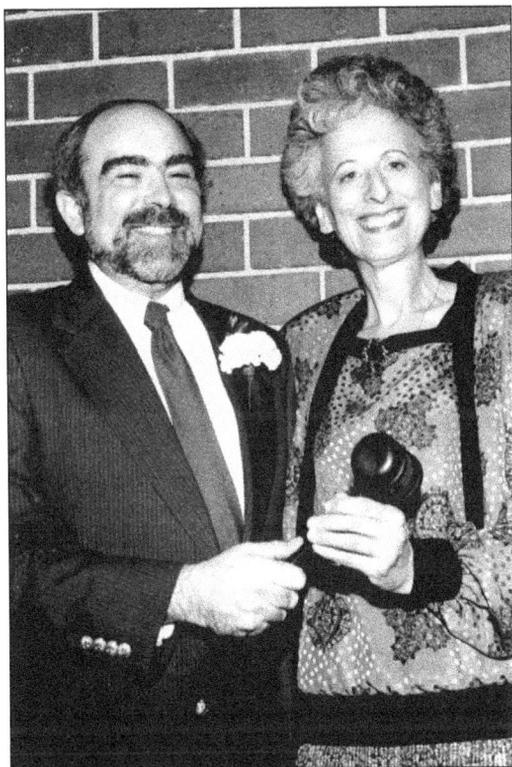

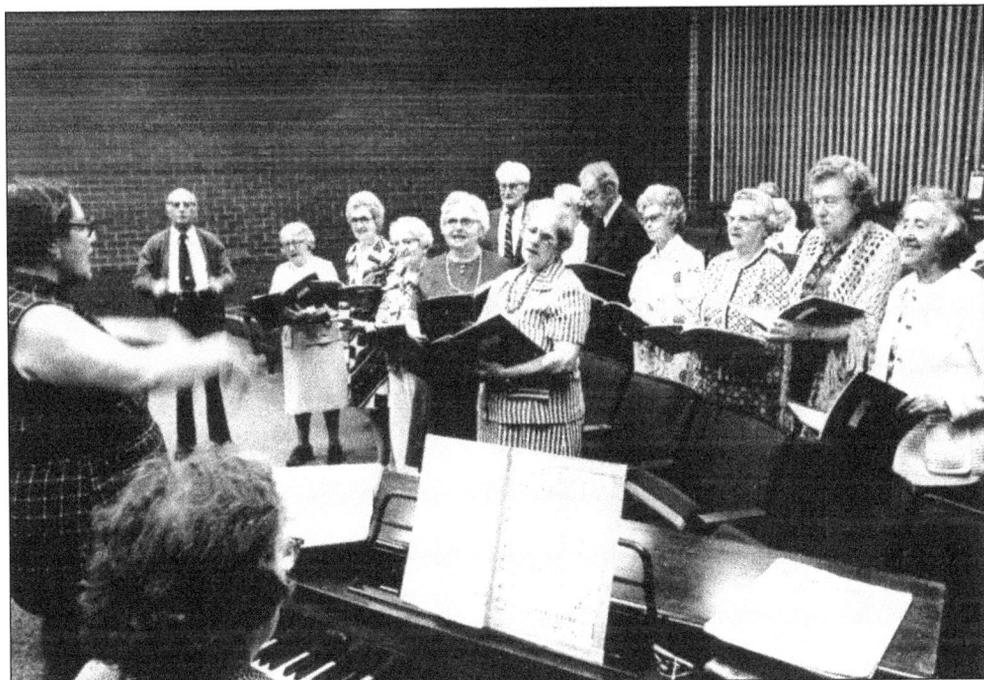

Today very active seniors participate in regular exercise groups, and trips to area museums, restaurants, and theater. In this photograph from the 1970s, the AJC seniors practice for a musical chorale under the direction of Tina Wolinsky at the White Pond Drive facility.

Jerry Shaw with his wife, Patsy, made it possible for the Akron Jewish Center's renaissance, facilitating its need to grow again in the 21st century by providing a substantial contribution to that end. In gratitude, the AJC board renamed the institution in their honor: the Jerry Shaw Jewish Community Center.

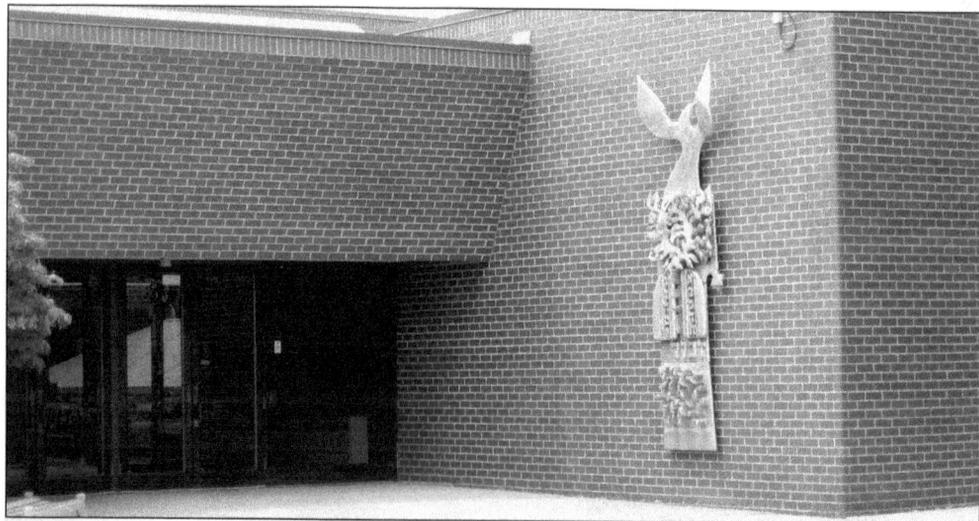

The Shaw Jewish Community Center remains a vibrant, active, and solid institution in the Akron community. It houses a myriad of organizations and still offers an amazing number of programs. The photograph of the Jerry Shaw Jewish Community Center doors reveals the entryway to all this and more. The Hakoah Club commissioned the sculpture on the right by Don Drumm, representing not only the dove of peace but also the phoenix rising from the ashes, in memory of the six million Jews of the Holocaust.

Five

HOUSES OF FAITH

Although economic opportunities drew Jewish immigrants to Akron, once settled, their primary focus was to build a house of worship and a religious school for children. German and Hungarian immigrants formed the Akron Hebrew Association in 1865. Now known as Temple Israel, it is the largest Jewish congregation in Akron.

Immigrants arriving from Eastern Europe in the late 1870s brought their traditional Orthodox form of Judaism. The first Orthodox congregation was organized by a group of Russian Jews in 1885 as Anshe Emeth congregation. The Orthodox Hebrew congregation, founded in 1893, began as a more diverse group, but in 1900, it became Sons of Peace.

Hungarian Jews formed the Ahavas Zedek in 1926 and met on Buchtel Avenue. It maintained a steady congregation until 1969, when it dissolved. A small congregation formed in Barberton, but there are no photographs of the activities of this congregation.

As future generations became more Americanized, the ethnic differences dissipated and most smaller congregations joined Anshe Sfard, which exists today as the only Orthodox congregation. Anshe Emeth changed its name to Beth El in 1927. Later they affiliated with the United Synagogue of America and serve as Akron's only Conservative congregation.

Jewish people began moving to suburban areas of Summit County and formed Temple Beth Shalom in 1977 in Hudson, Ohio.

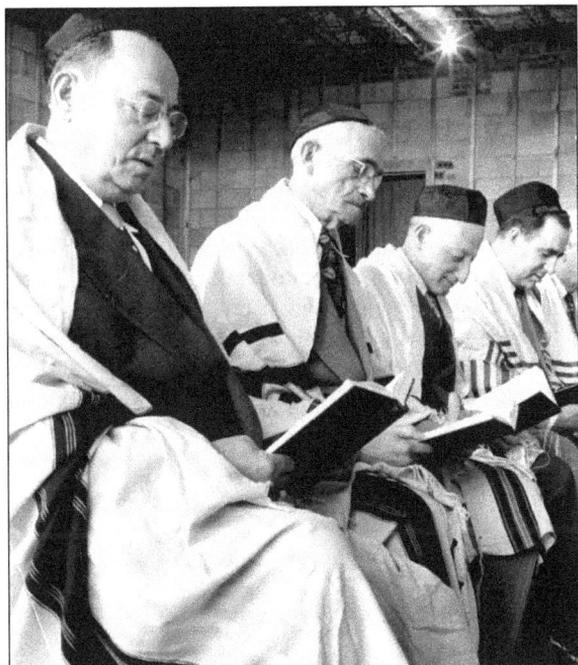

Members of the Anshe Sfard congregation could not wait to begin using their new Copley Road building for a prayer service. In this photograph, the unfinished walls in the background give the clue that this was taken in the late 1950s.

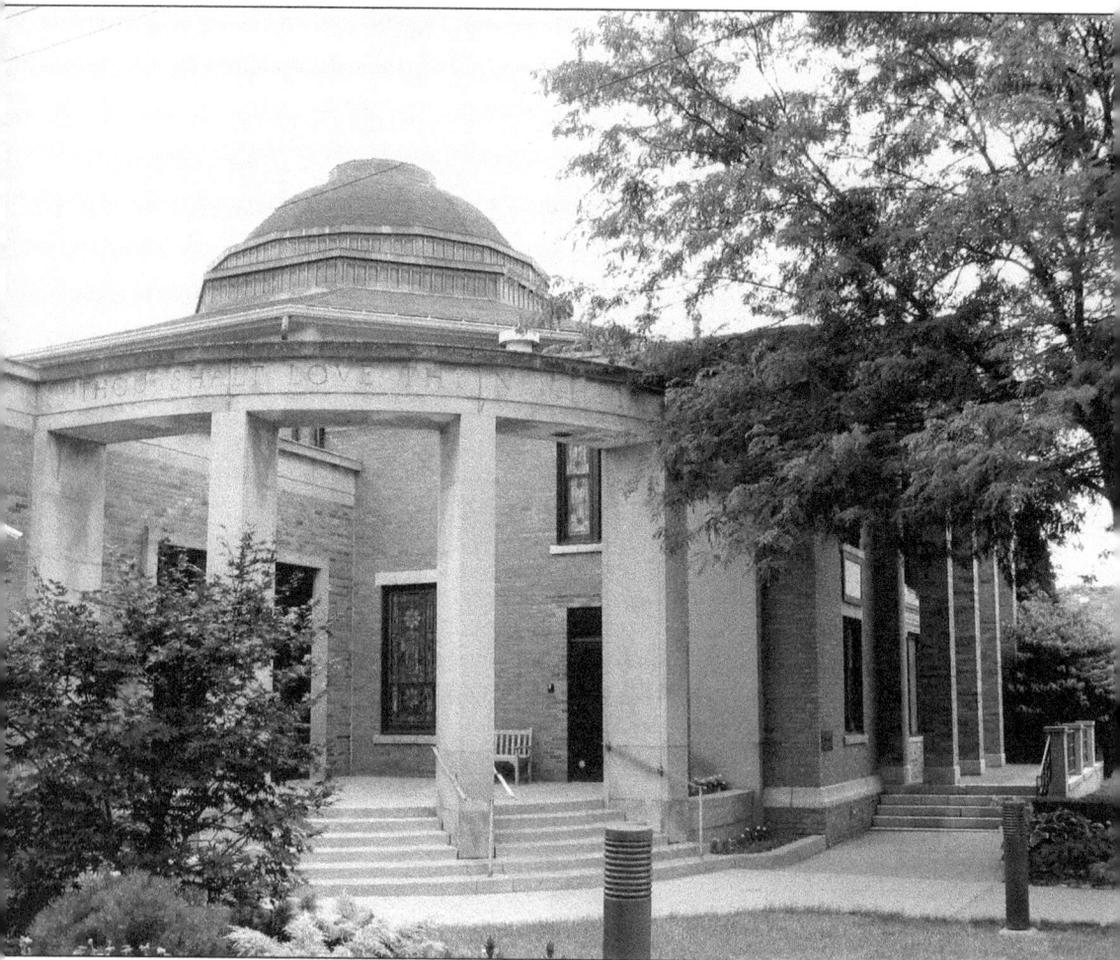

The oldest congregation in Akron, and one of the five oldest Reform congregations still operating in the United States, was founded in 1865 as the Akron Hebrew Association by two dozen, mostly German and Hungarian, Jewish families, among them I. Levi, H. W. Moss, and J. N. Koch. Services were held in various downtown office buildings until 1885, when it moved into the former home of St. Paul's Episcopal Church on High Street. In 1911, the congregation built a home of its own and has remained in the same location on Merriman Road ever since. Rabbi Isaac Meyer Wise, America's Father of Reform Judaism and founder of the Hebrew Union College, gave the dedicatory address on May 5, 1911. The festivities lasted for three days. The name of the synagogue was then changed to Temple Israel, a name suggested by a member, Sylvia Whitelaw. Through the years, Temple Israel has become an Akron landmark, and its rabbis have been distinguished by numerous outreach and educational programs. (Photograph courtesy of the Temple Israel archives.)

Morton Applebaum was the longest tenured rabbi in Temple Israel's existence. He came to Akron in 1953 and saw the membership of Temple reach the highest numbers in its history. He and his wife, Eleanor, were active members of the Jewish community. Rabbi Applebaum was the author of *What Every Jew Should Know About Judaism*, which served as the basis of his confirmation class courses. He also fostered interfaith activities and groups within the Akron community.

Leona Sacks will be remembered as the first woman president of Temple Israel, serving in that office in 1977–1978. She was president of Temple's Sisterhood and for many years was a dedicated Red Cross volunteer. (Photograph courtesy of the Temple Israel archives.)

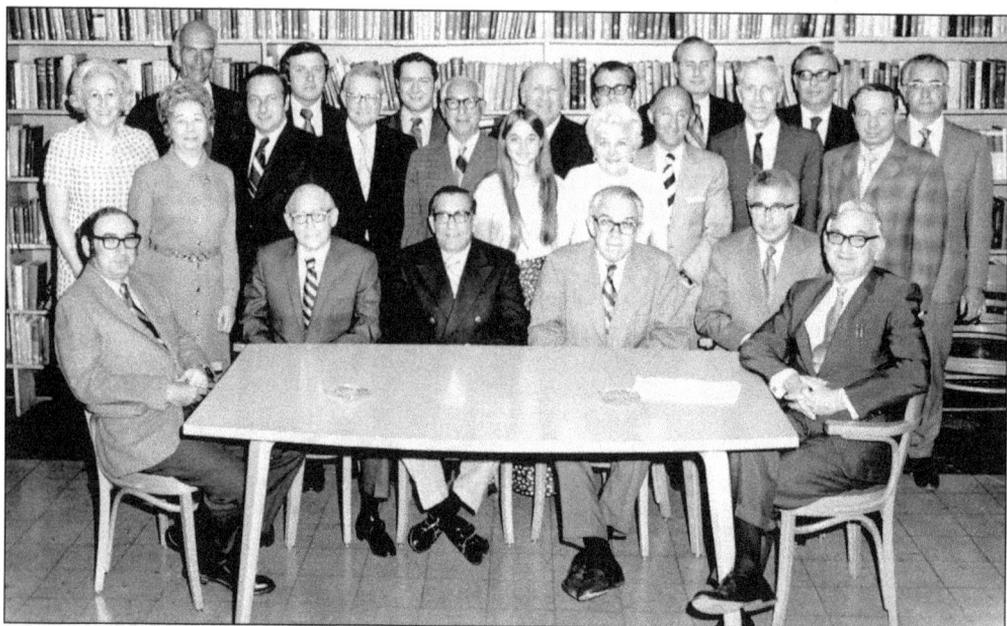

The Temple board congregates around the table in the library in the 1970s. Pictured here, from left to right, are the following: (first row) Jerry Holub, Herman Arenson, Dr. Jack Schwartz, Harry Schechter, Jack Goldsmith, and George Korman; (second row) Ruth Moss, Melvin Sacks, Meryl Sicherman, Dr. Reuben Pliskin, Mary Ann Heinick, Leona Sacks, Irwin Isroff, Sam Waisbrot, and Seymour Sussman; (third row) Mimi Folb, Sam Alexander, Art Axner, Robert Weisberger, Seymour Zipper, James Barnett, George Mild, William Wolford, and Jack Magilavy. (Photograph courtesy of the Temple Israel archives.)

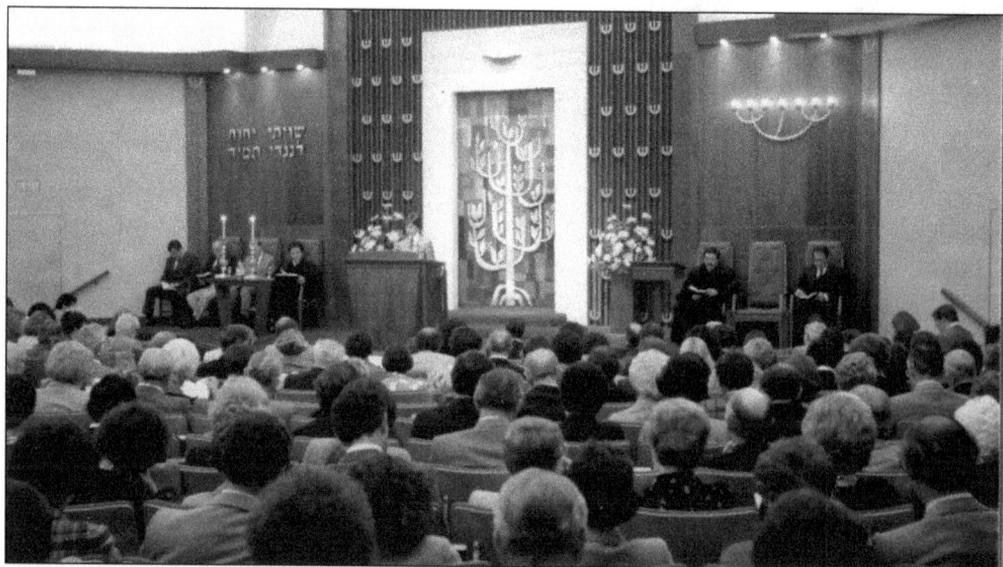

The main sanctuary was remodeled and an adjoining small sanctuary was added in the 1953 renovation of Temple Israel. Religious school classrooms, a library, and new offices were part of that addition, as well as the doors designed by Akron artist Don Drumm, donated by Sam Scherr in memory of his parents. In 1987, another renovation occurred under the leadership of president Dr. I. R. Weiner. (Photograph courtesy of the M. Sacks family.)

Rabbi David Lipper is the 12th rabbi to serve Temple Israel's congregation. Since coming to Akron in 2001, he has expanded adult education offerings, particularly a Torah study group, which has met every Saturday morning for the past four years. He has organized a number of family activities and instituted programs to better serve sick and elderly congregants. Like his predecessor, Rabbi David Horowitz, Rabbi Lipper takes an active role in Akron's interfaith community. He began an annual "Mitzvah Day," which, in its third year, attracted four area churches and hundreds of volunteers, helping community charitable organizations. He is assisted by Rabbi Lauren Werber, Temple Israel's first female rabbi. Rabbi Werber was instrumental in creating and teaching the first adult group to become b'nai mitzvot (sons and daughters of the commandments) at Temple in 2005. It was the same year Temple celebrated its 140th anniversary.

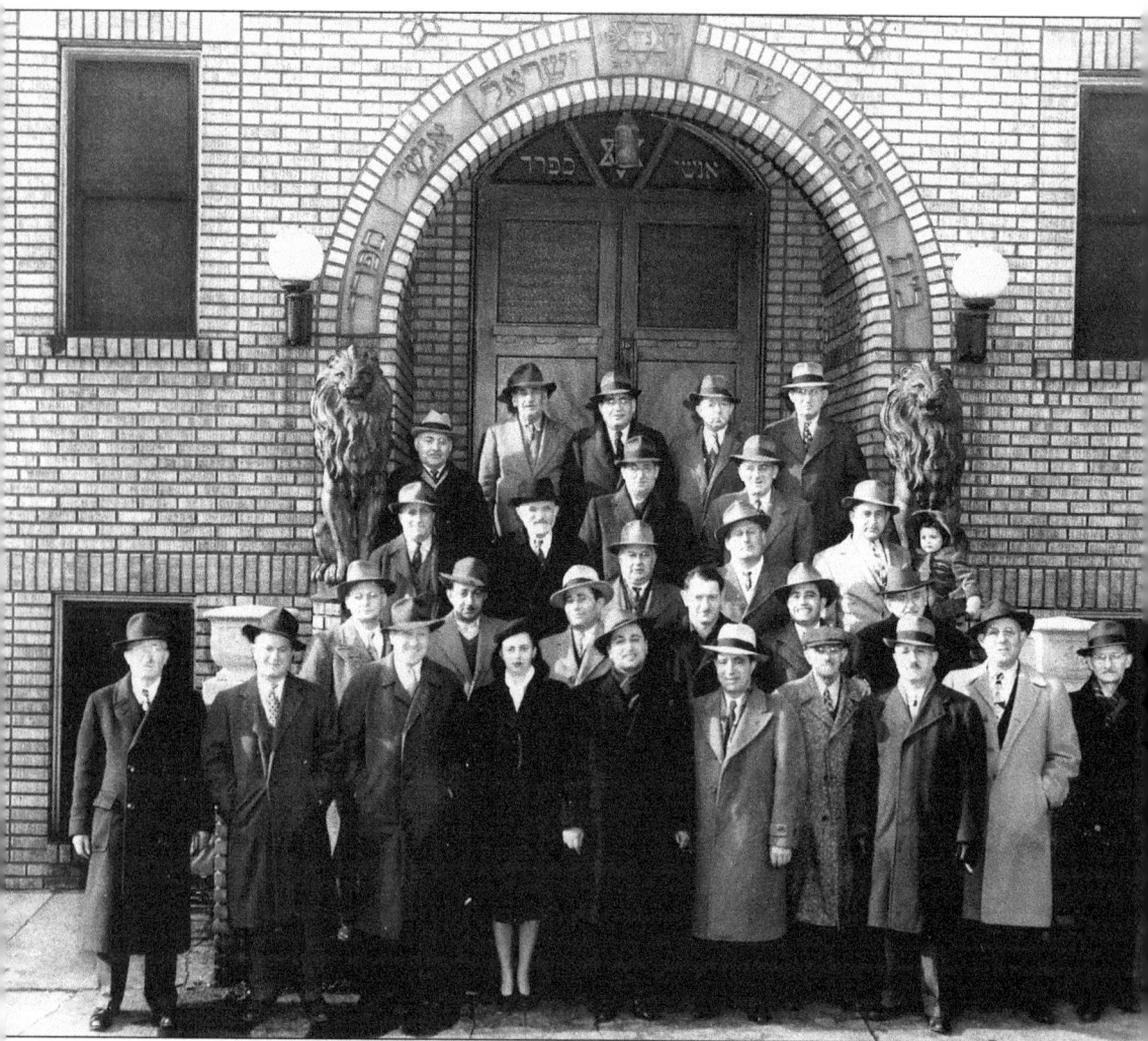

Members of Anshe Sfard pose in 1921 on the steps of their first building at the corner of Raymond Street and Euclid Avenue. Those identified are, from left to right, (first row) unidentified, Irving Zapilar, Ray Munitz, unidentified, Rabbi Ralph Pelcovitz, Hyman Ekus, Reuben Stein, Abe Mirman, Harry Cohen, and ? Manes; (second row) unidentified, Harry Ekus, Sam Ekus, Morris Waxman, Sam Berzon, and unidentified; (third row) William Stile, two unidentified men, Herman Kane, Lou Sobel, Harry Davidson, and Sam Schneiderman with his child; (fourth row) Isadore Zapiler, unidentified, Charles Glass, Isadore Serelson, and unidentified. (Photograph courtesy of Harvey Ekus.)

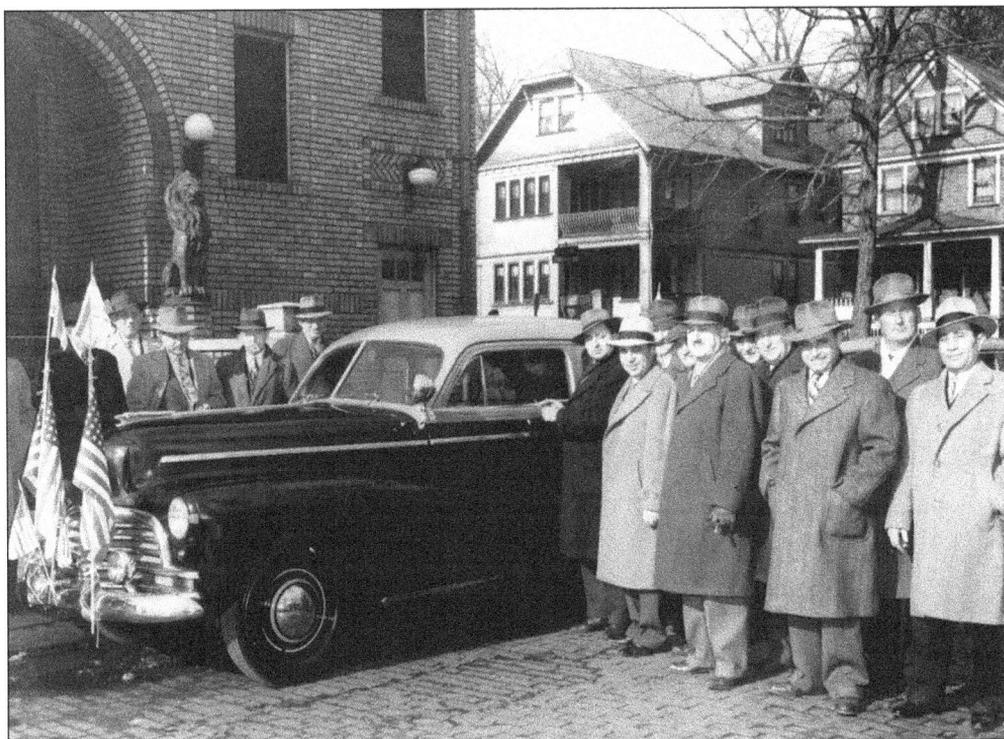

Rabbi Ralph Pelcovitz served Anshe Sfard congregation during the building of the Copley Road synagogue. In this 1946 photograph, members of the congregation present him a car upon his arrival to enable him to pursue community and civic duties. Seen here, from left to right, are (first row) Rabbi Pelcovitz, Hymie Ekus, Abe Mirman, Sam Berzon, and Sam Ekus; (second row) Ray Munitz, Ruben Stein, Herman Kane, D. Zimmerman, and N. Davidson. (Photograph by Vic Zinn.)

Rabbi Abraham Leibtag, seen here, was an inspiration to the entire community as well as to the Anshe Sfard congregation that he served for many years. He and his lovely wife, Florence, were an integral part of the Jewish scene.

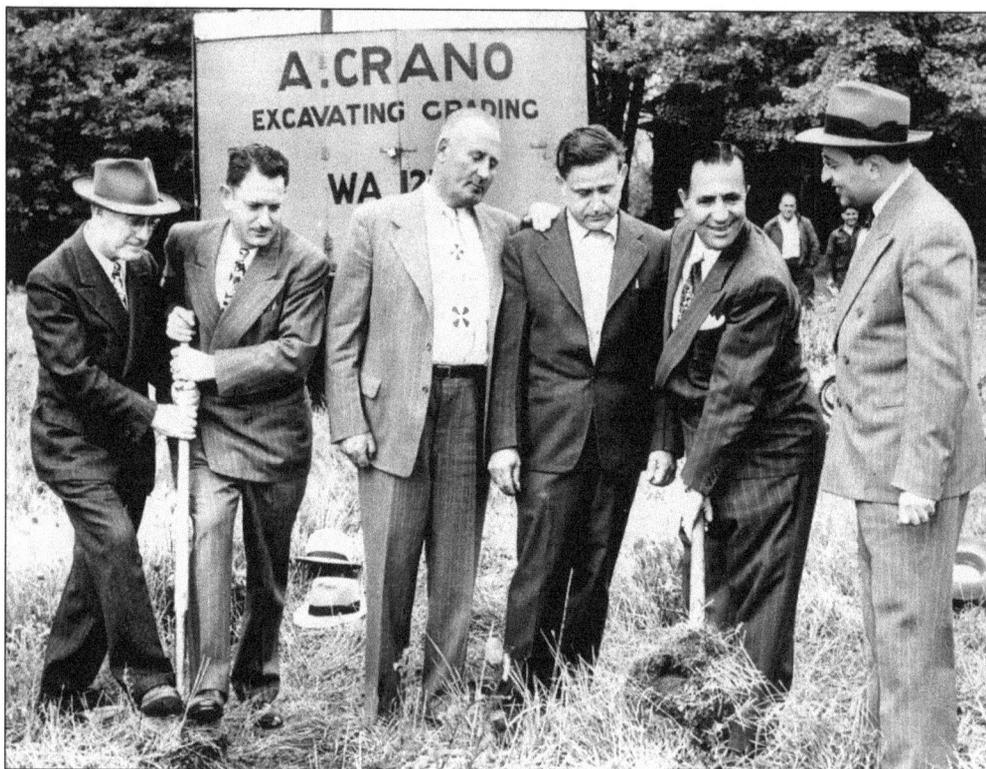

Anshe Sfard purchased land at the corner of Copley Road and Noble Avenue in the late 1940s, when congregants wanted the synagogue to be within walking distance of most congregants. Hymie Ekus led the congregation at that time and Rabbi Pelcovitz was the spiritual leader. This 1949 groundbreaking ceremony photograph includes, from left to right, Abe Columpus, Morris Waxman, Harry Davidson, Sam Schneiderman, Hymie Ekus, and Rabbi Ralph Pelcovitz. (Photograph courtesy of Harvey Ekus.)

The Anshe Sfard congregation's new building was completed in 1951 at the corner of Copley Road and Noble Avenue. In this photograph, synagogue members stand on the steps of the building after its dedication.

Rabbi Mendy Sasonkin and Kaila, his wife, are eager, knowledgeable, and energetic. They play a dual role in the community. Rabbi Sasonkin is spiritual leader of Anshe Sfard congregation and Chabad of Akron and Canton. His wife is principal of the Anshe Sfard School and director of Chabad. Their efforts have helped revitalize the Orthodox congregation and Chabad of Akron. They are pictured here in 2005, as they celebrate their 10th year in Akron.

The Ahavas Zedek was one of Akron's oldest Orthodox schuls, serving Akron's Hungarian Jewish population. They built their own synagogue in 1929 on Buchtel Avenue but shared a rabbi with other Orthodox congregations until 1939 when they hired Rabbi Avram Hartstein, shown with his beloved wife, Deborah. They had escaped the Holocaust. Rabbi Hartstein brought a renewed interest in religious life by instituting daily services, a free cheder for boys and girls, and making the synagogue the focus of family life.

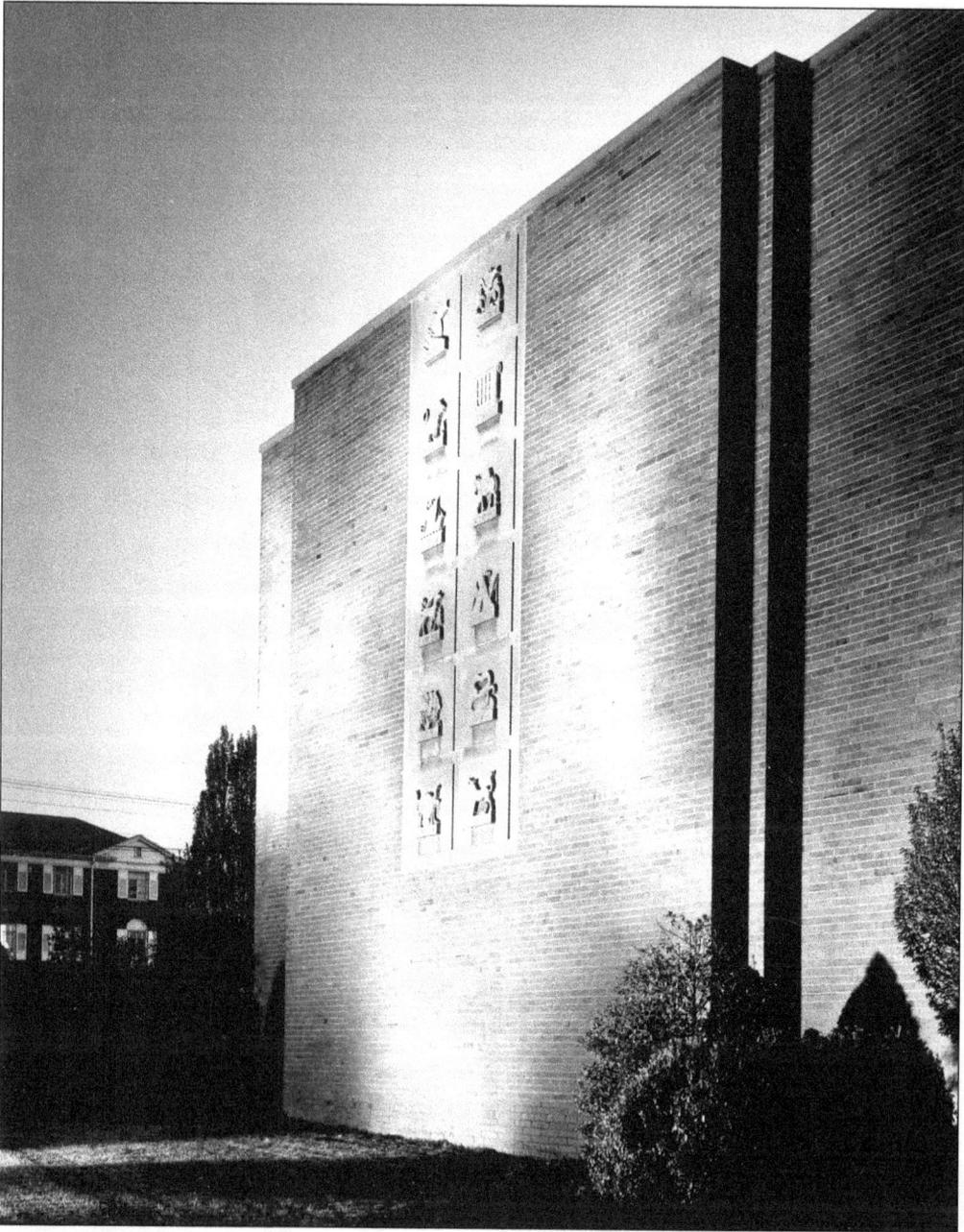

Beth El Synagogue, a conservative congregation affiliated with United Synagogue of America, was formed as Anshe Emeth congregation prior to World War I and was housed on Balch Street. This site later became the Akron Jewish Center. In 1951, Beth El moved to its present location on Hawkins Avenue in a contemporary building designed by architects Braverman and Halprin and constructed by Arnold Weinstein. An active and dedicated membership and professional clergy provide religious services, education at the Beth El Academy, lifetime rituals, and resources for living a full Jewish life. Pictured on these pages are some of the leaders of this vital congregation. (Photographs courtesy of the Beth El archives.)

Emeritus Rabbi Abraham Feffer, served
Beth El ably from 1968 to 1986. A
Holocaust survivor, Rabbi Feffer offered
a worldly and spiritual perspective to his
congregation and the community.

Max Schneier was the first president
of Beth El. His knowledge of ritual
helped to shape the religious aspects
of the congregation.

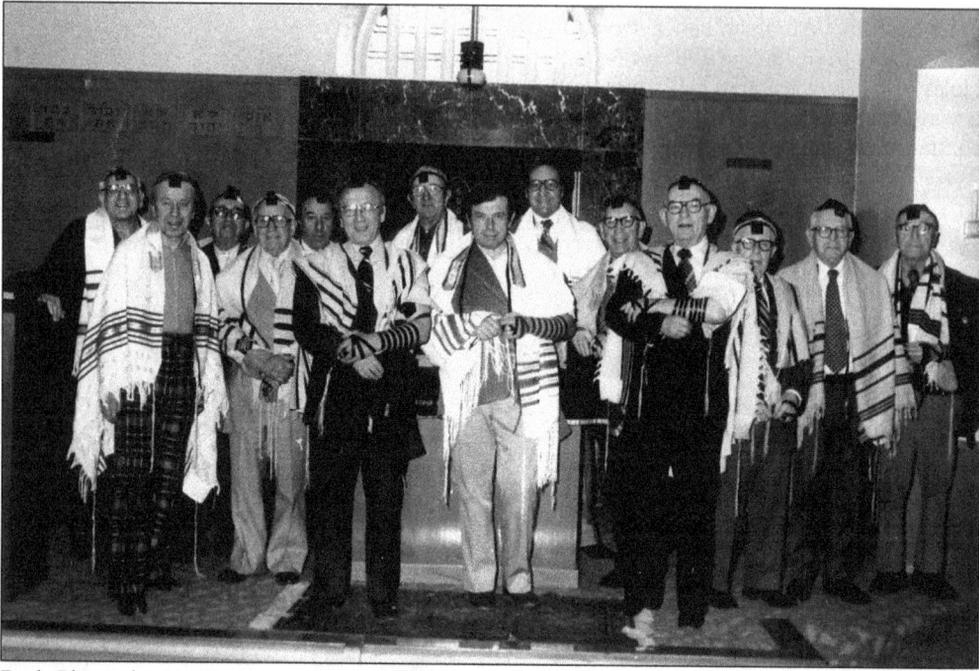

Beth El conducts services twice daily. The morning gathering of at least 10 people (a minyan) includes a ritual for binding men's arms and head with phylacteries, in accordance with the prayer that states: "And you shall bind them for a sign upon your hands and they shall be as frontlets between your eyes."

Isaac Sokol, one of the founders and trustees of the Federation of Jewish Charities and Anshe Emeth Synagogue (the forerunner of Beth El), was a successful businessman. A quiet and loving man, he is remembered as a "Tzadek," a righteous man, known for his compassion for others. The federation's Free Loan Society offered no or low interest loans to those in need and was a shining example of how the Jewish community assisted and looked after their own less-fortunate families and individuals.

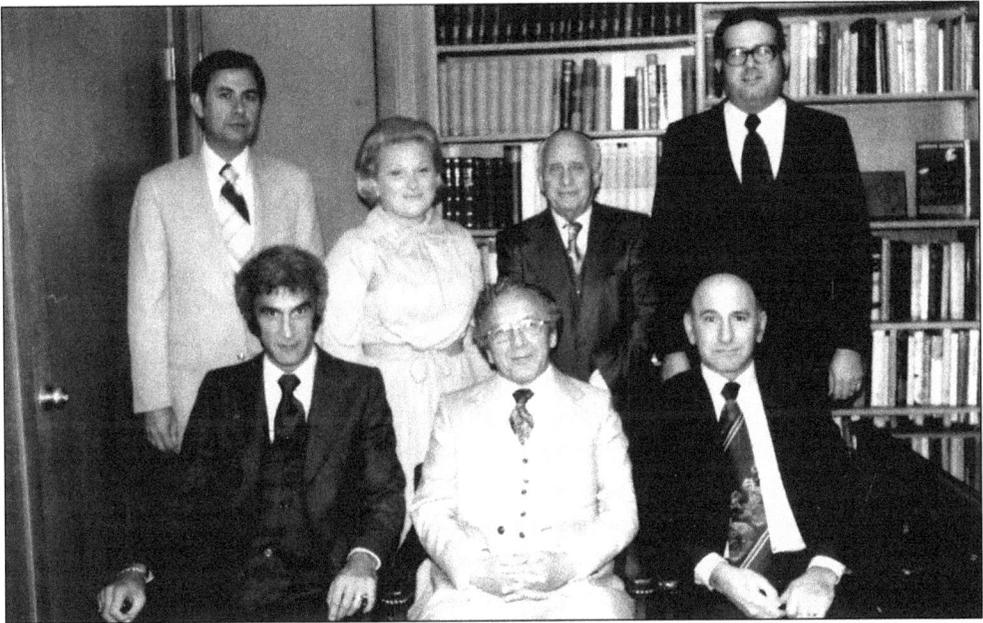

Officers of Beth El congregation work countless hours to maintain the synagogue, evaluate programs, solve congregational problems, and generally find economic stability. The group of officers pictured here did an exceptionally fine job of fulfilling their duties. In this 1978 photograph are, from left to right, the following: (first row) Aaron Kranitz (president), Rabbi Abraham Feffer, and Leonard Sweet; (second row) Emory Geller, Rochelle Stone, Max Schneier, and Dick Levin. (Photograph courtesy of the Beth El archives.)

Cantor Stephen Stein has been the chazzan at Beth El since 1980. He is credited with developing the Children's Choir and increasing the repertoire of the adult choir to greatly enhance the services. Today there are five former Beth El members who are cantors: Bruce Braun, James Gloth, Adrienne Kaplow, Martin Leubitz, and David Wolinsky.

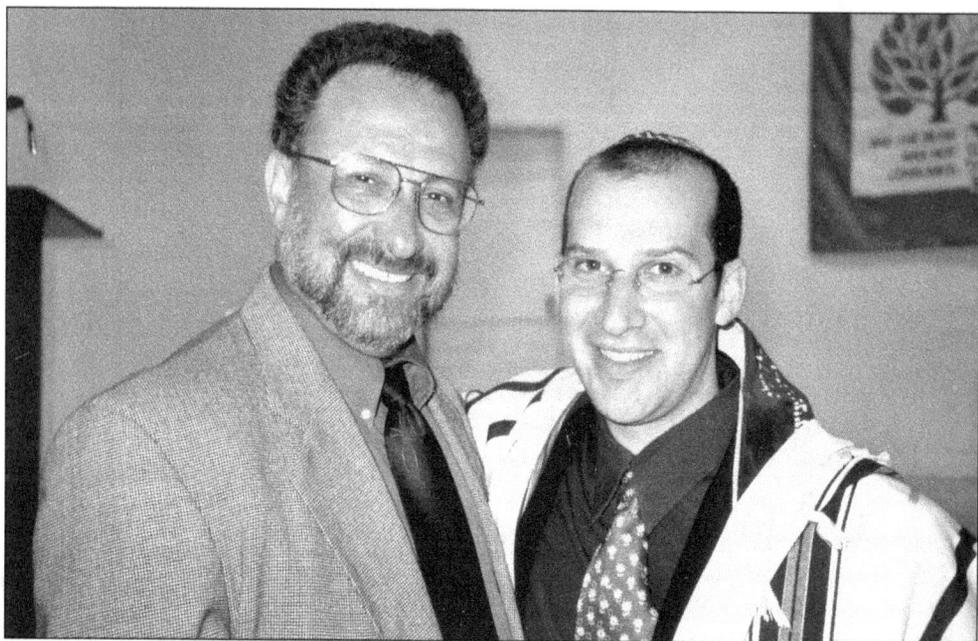

The Akron Jewish community is extremely proud of the local men and women who have been ordained as rabbis. They include Rabbis Alan Bennet, Sigma (Sissy) Coran, Jeffrey Foust, David Komerofsky, Aaron Koplin, James Lebeau, William Lebeau, and Adrienne Pollock. In this 2003 photograph, Akronite Rabbi S. Robert Waxman proudly stands next to his nephew, Joel Levenson, as Joel receives his rabbinic ordination from Jewish Theological Seminary of America. (Photograph courtesy of Sandra Levenson.)

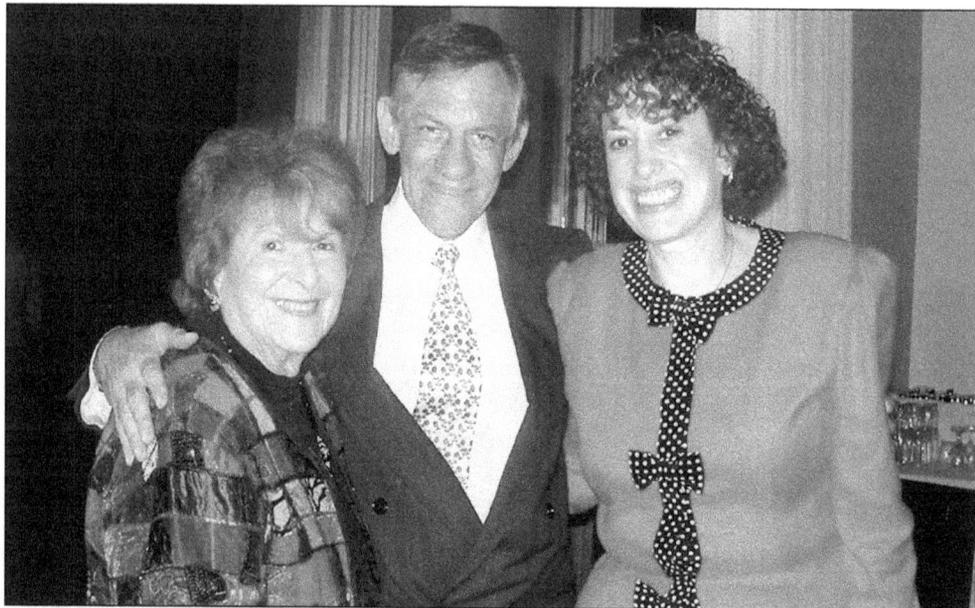

Susan Stone, rabbi at Hudson's Temple Beth Shalom, has been active in the Union for Reform Judaism and has been an advocate of acceptance of diversity within the congregation. Shown here, from left to right, are Evelyn Weinberger, John Stone, and Rabbi Susan Stone. (Photograph courtesy of Beth Shalom congregation.)

Six

Spirit of Community

Places of worship met the spiritual needs of the growing Jewish community, but it was the benevolent, philanthropic, and social organizations that took care of the day-to-day problems of people in need from the very beginning. The philosophy of assisting those less fortunate is fundamental to a practicing Jew. In 1935, the Federation of Jewish Charities brought together a number of small charities under one organization that today is known as the Jewish Community Board of Akron (JCBA). The JCBA, through fund-raising by a professional staff and volunteers, assists in supporting the Shaw Jewish Community Center, Lippman Day School, Jewish Family Service, and all religious congregations in Summit County. It also oversees the community's annual fund-raising drives for the State of Israel. The generosity of Akron's Jews is legendary.

In addition, there are sisterhoods and brotherhoods in each congregation, several dozen local chapters of national Jewish organizations, and a handful of men's and women's groups, which provide the community with an active social life.

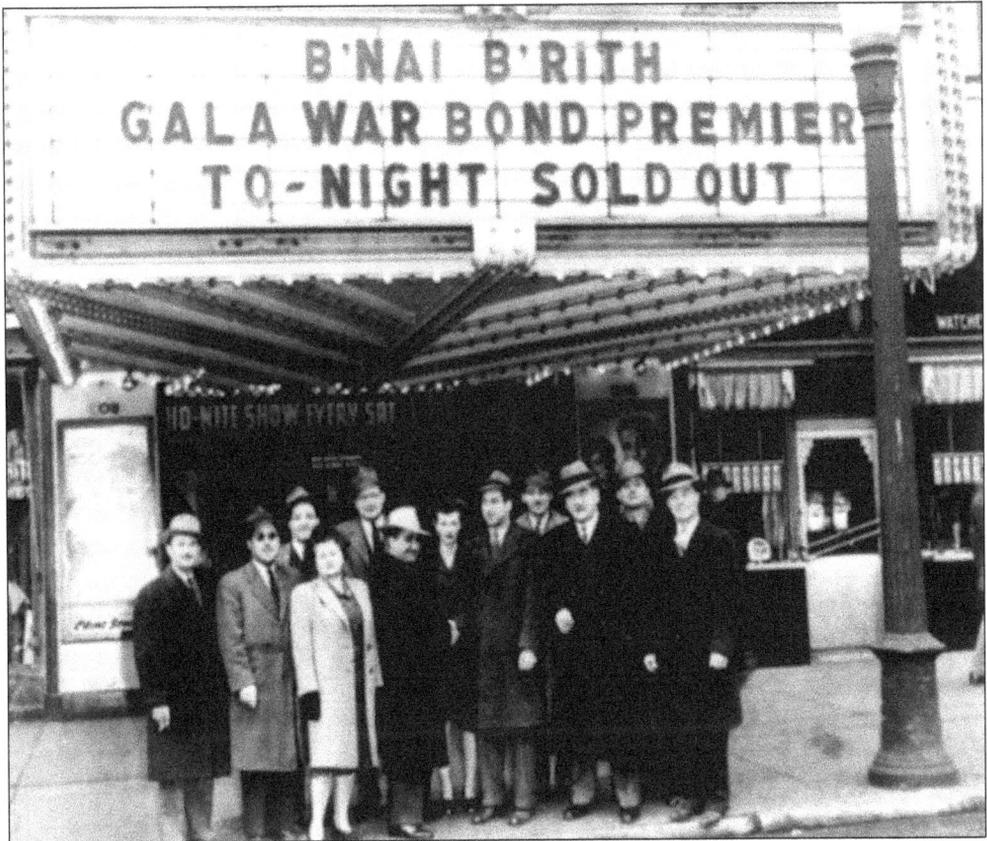

This photograph shows the success of the B'nai B'rith organization at their event at Loew's theater.

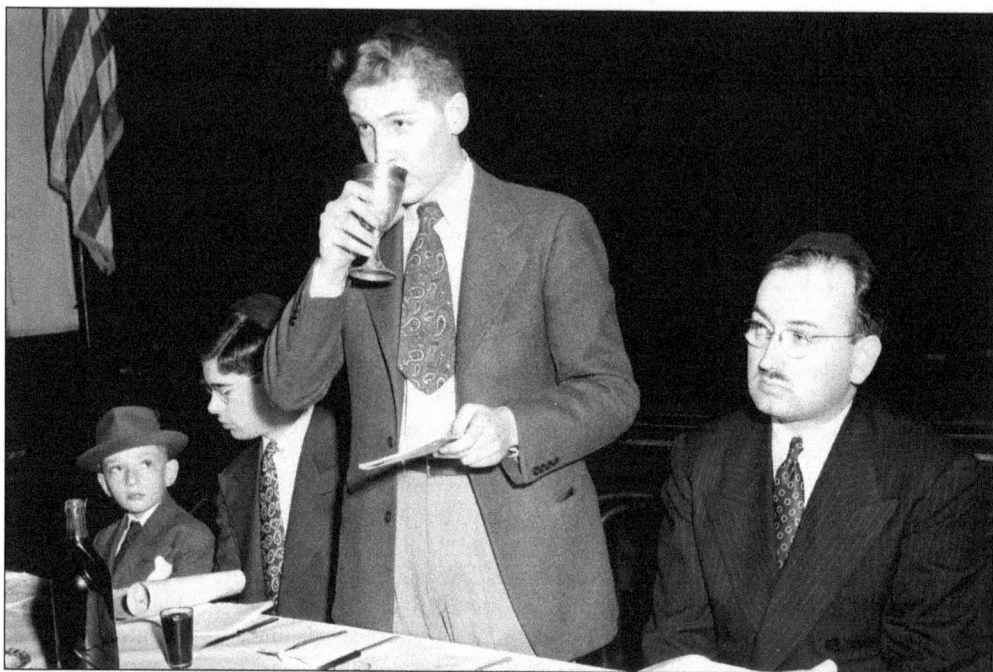

This AZA Chapter planned and executed this Passover seder using participants from all the AJC clubs. Seated, from left to right, are Burt Subrin, Harold Gold, Eddie Schneir (holding the wine cup), and Rabbi Avram Hartstein.

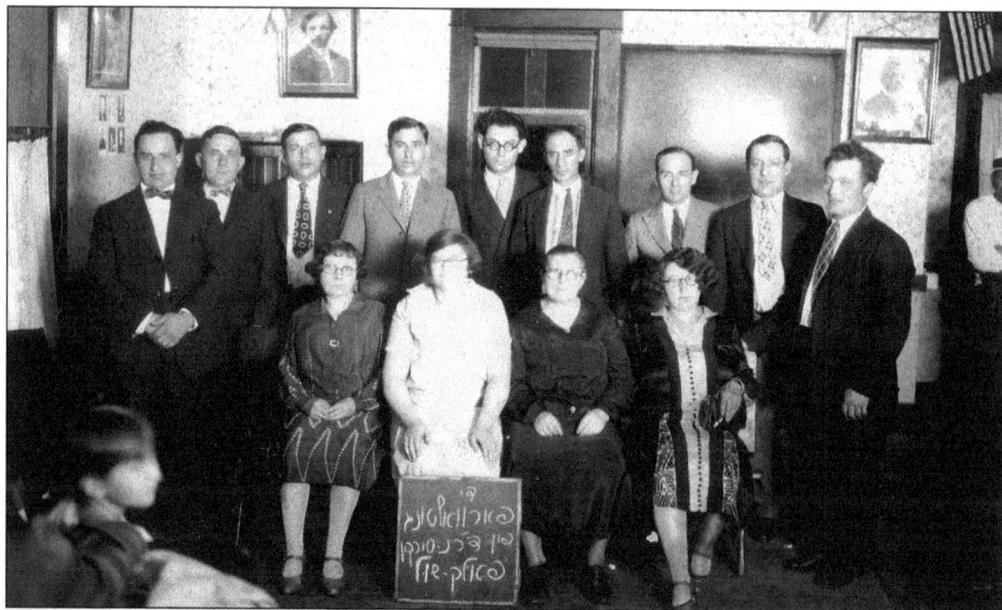

The Farband (Jewish National Workers Alliance) was established by early Eastern European immigrants as a mutual-aid, labor-oriented organization that espoused Zionist ideals. Traditionally, Farband members were also religiously oriented. Its school on Euclid Avenue was well attended and its social events formed strong bonds for members. The Farband Free Loan began in 1921 and gave $50 loans to business people. Max Rogovy (top row, fourth from left) is generally credited with its formation and fund-raising success.

Daughters of Israel was organized as the Franz Joseph Society in 1891. It is a social and charitable group, and membership reflects family ties. It is the longest continuing Jewish women's organization in Akron. This modern photograph includes, from left to right, Margie Moskovitz, Tammy Culp, Esther Cooper, Sybil Gertz, Patsy Siff, Rona Lowry, and Ellen Schneier. (Photograph courtesy of the Daughters of Israel archives.)

Hadassah, the largest women's organization in the world, has had a vibrant chapter in Akron for many years. Fund-raising and educational programs help the national organization fulfill its mission of providing health care and social services to the State of Israel. Each year the local group meets all the financial goals and often oversubscribes. In this photograph, the ladies of Hadassah await the professional models style show at a luncheon in the 1960s.

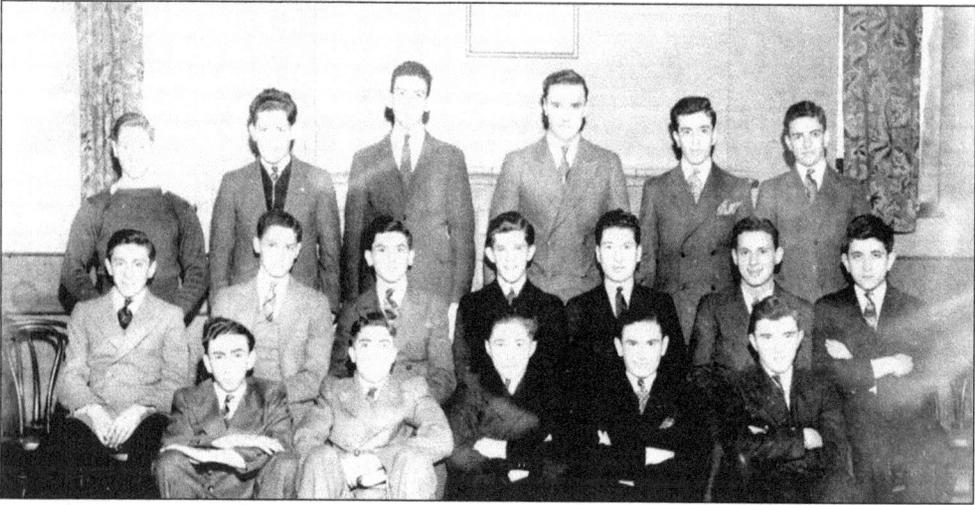

The Maccabees men's club met for several decades. This photograph was taken in 1936, when they were in their early 20s. These men remained friends all their lives. Those identified in this photograph are Sol Aidman, Nathan Ross, Harold Rosenthal, Sidney Rosenthal, Albert Cohen, Jack Manes, Victor Gross, Victor Rofsky, Martin Borodkin, Leon Friedman, Sid Savage, and Alex Marks.

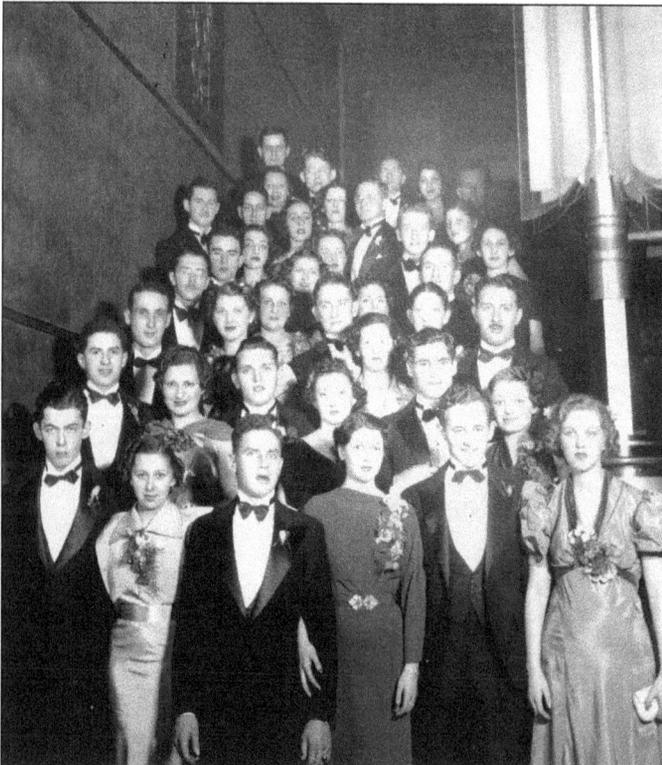

The Menorah Club, a men's social club, formed in 1929, when the AJC opened. In this 1937 photograph, the men and their escorts celebrate the eighth anniversary of the club at the Mayfair Casino.

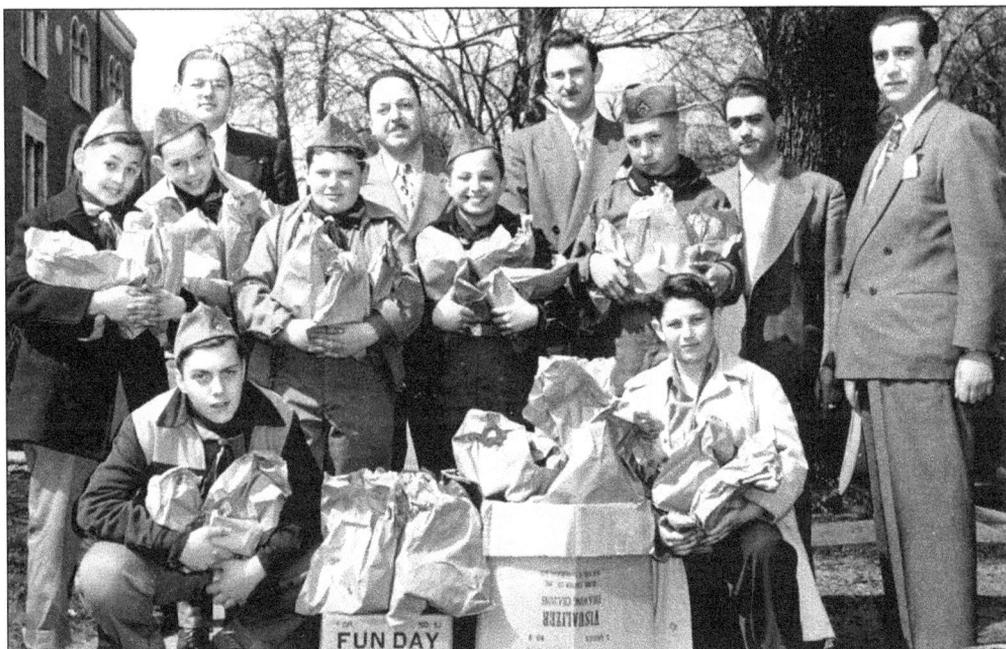

Boy Scouts had a presence in the Jewish community from the 1940s to the 1980s. Pictured in 1949 are, from left to right, the following: (first row) Mel Kent and unidentified; (second row) two unidentified scouts, Lou Gergis, Marv Rosenthal, and Manny Mazur; (third row) leaders Ted Marks, Harold Gibian, unidentified, Jack Magilavy, and Harry Nelson.

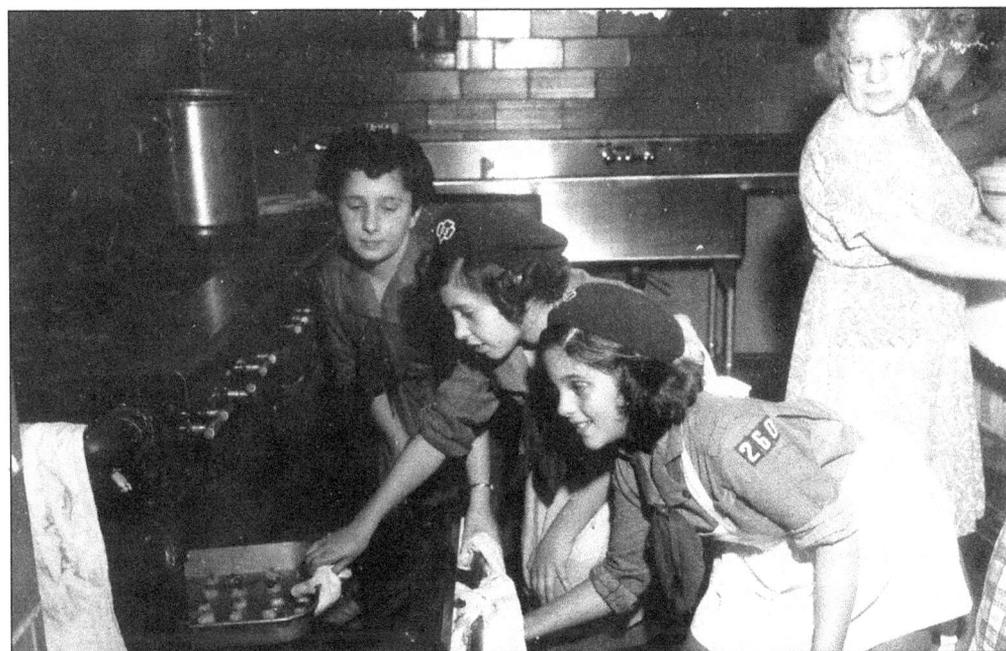

Girl Scout troop No. 260, comprised of Jewish girls and Jewish leaders, was active in the community until the mid-1980s. In this photograph, the Girl Scouts are earning their cooking badge under the watchful eyes of Sonia Allison. She was the resident cook at the AJC and apparently did not want the girls to invade her turf!

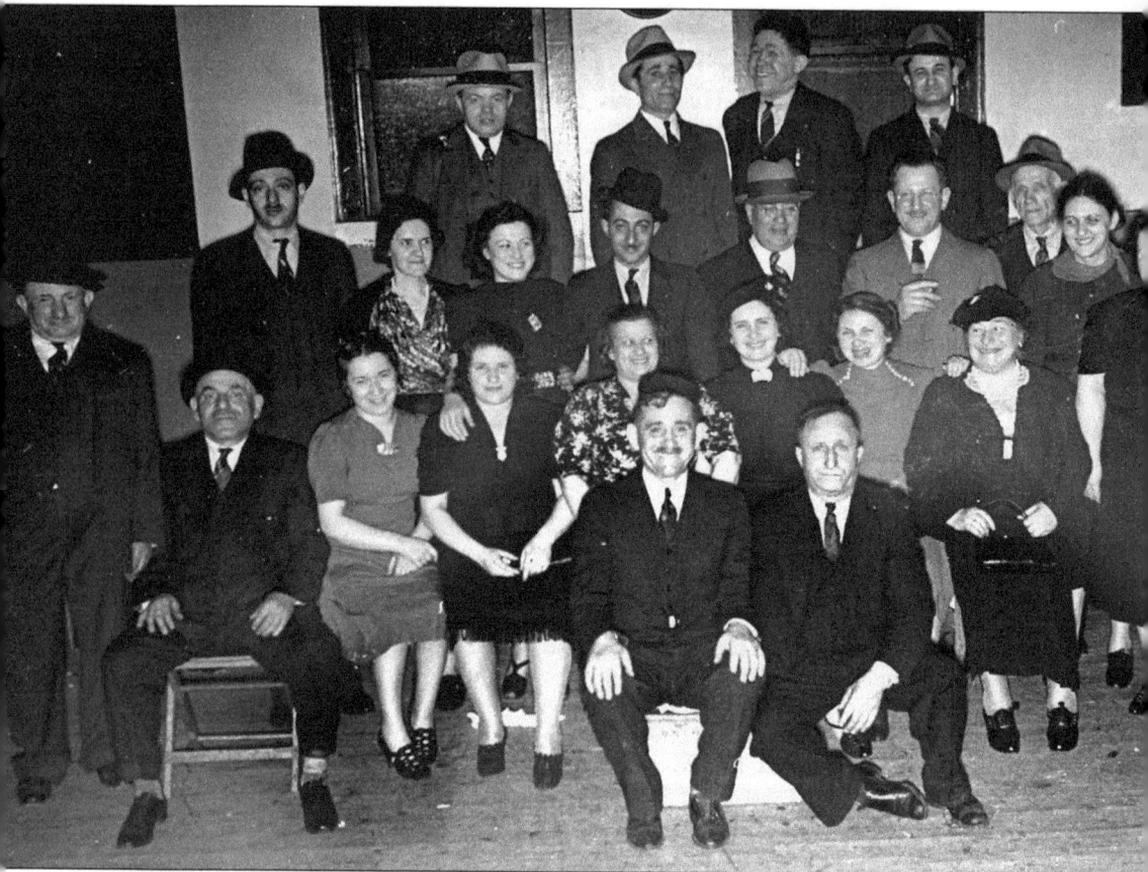

The basement of the Raymond Street Anshe Sfard served as a multipurpose room. In this very old photograph, those identified are Sam Ekus, Louie and Becky Lockshin, Sadie and Harry Ekus, Mr. Soble, Mr. Munitz, Hannah Ekus, Bernice Ekus, Celia Gould, Mr. Zimmerman, David Ekus, and William Stile. (Photograph courtesy of Harvey Ekus.)

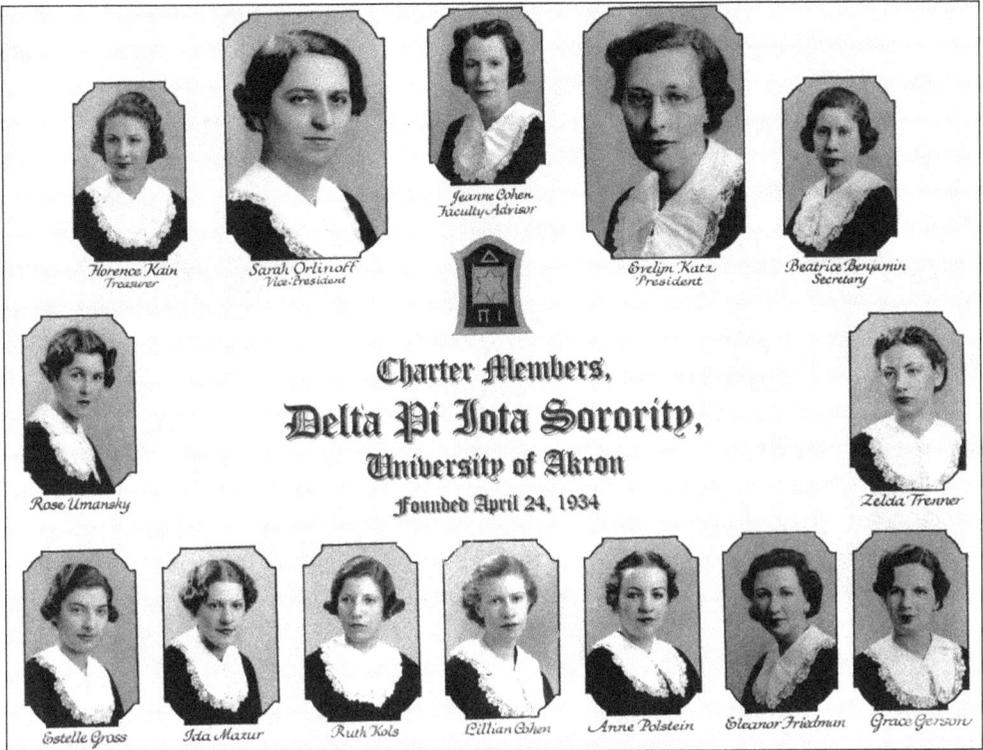

Charter Members,
Delta Pi Iota Sorority,
University of Akron
Founded April 24, 1934

Florence Kain
Treasurer

Sarah Orlinoff
Vice-President

Jeanne Cohen
Faculty Advisor

Evelyn Katz
President

Beatrice Benjamin
Secretary

Rose Umansky

Zelda Tresner

Estelle Gross

Ida Mazur

Ruth Kols

Lillian Cohen

Anne Polstein

Eleanor Friedman

Grace Gerson

Delta Pi Iota, a social sorority for Jewish women enrolled as students the University of Akron, was founded in 1934. Pictured above are the founding members of the sorority with their advisor. (Photograph courtesy of Mel Stern; reproduced by David Bloch, Bloch Printing.)

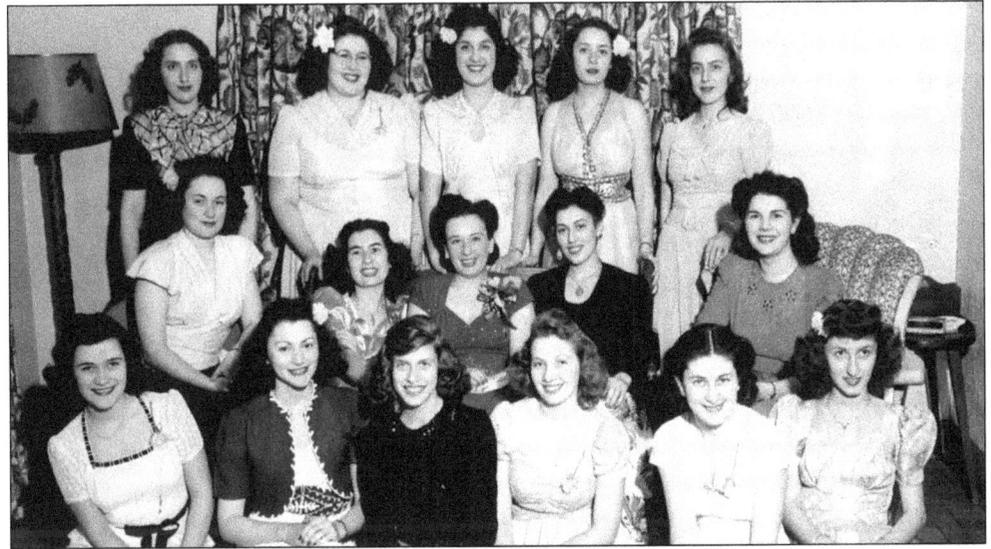

Delta Pi Iota maintained its identity on campus until the early 1960s, when it affiliated with the national sorority Sigma Delta Tau. Shortly thereafter, the sorority disbanded. In this photograph, from the late 1940s, Ann Umansky is seated on a tufted chair. She had been elected as the university's Sorority May Queen. (Photograph courtesy of Giddy Umansky.)

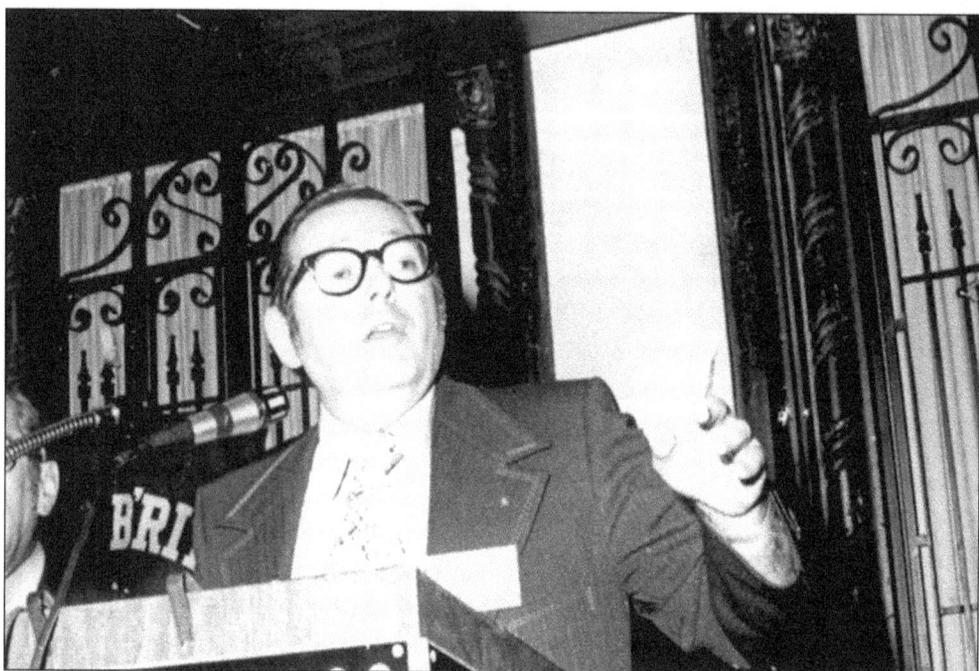

Ted Marks was recognized as a community leader throughout his adult years. As District II president of B'nai B'rith in 1974, he was also recognized in the larger region. This photograph shows Ted in action at a Chicago B'nai B'rith convention. (Photograph courtesy of Lila Marks.)

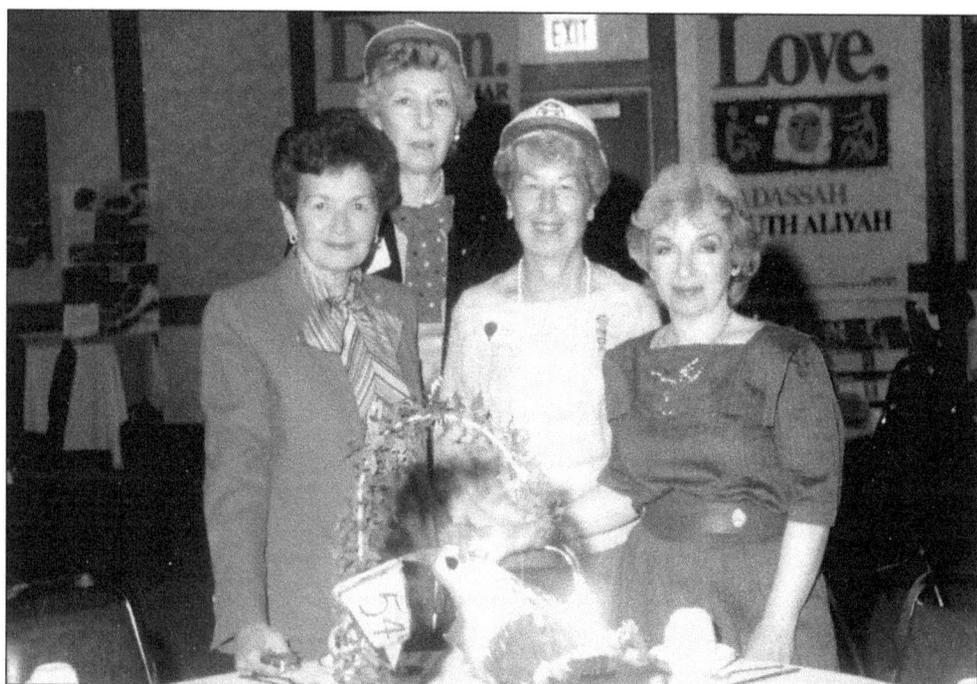

Most women's organizations hold a major fund-raising event annually. This group is attending the Hadassah Donor that raises funds for the Hadassah Medical Organization in Israel. Pictured here are, from left to right, Fran Union, Mel Stern, Shirley Luck, and ? Sigalow.

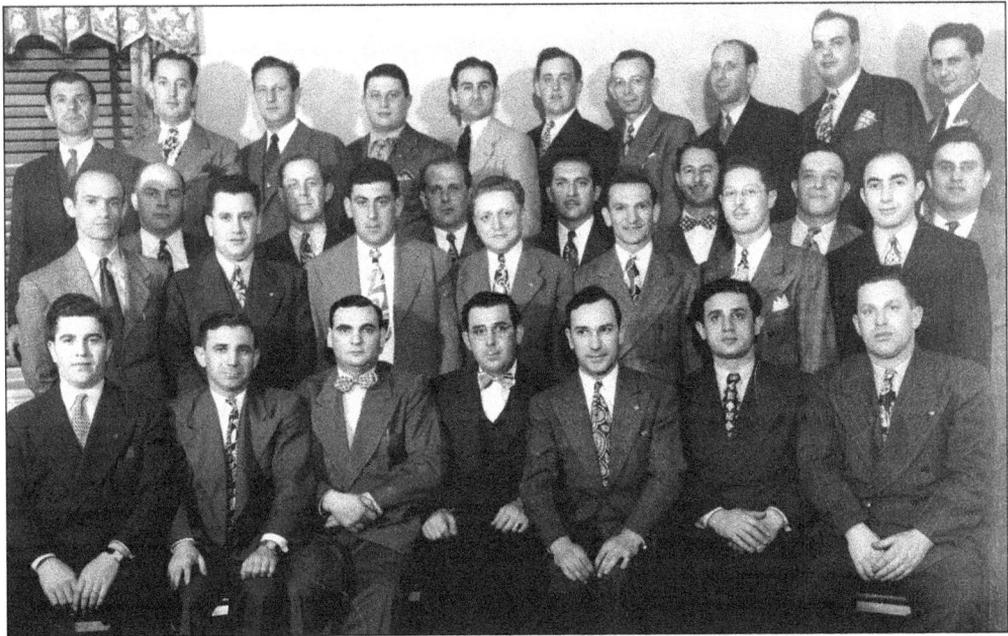

The Hakoah Club has been meeting continuously since the 1920s. It reigns as the oldest continuous Jewish men's club in Akron. As a philanthropic and social organization, it provides scholarships to high school seniors for college expenses and donates to a multitude of Jewish causes in the greater Akron area. Members and their families have a wonderful time together at their annual dinners and picnics. The picture above is from 1946; the one below, from 1995. (Photographs courtesy of Hakoah Club; the 1995 photograph by Bill Samaras.)

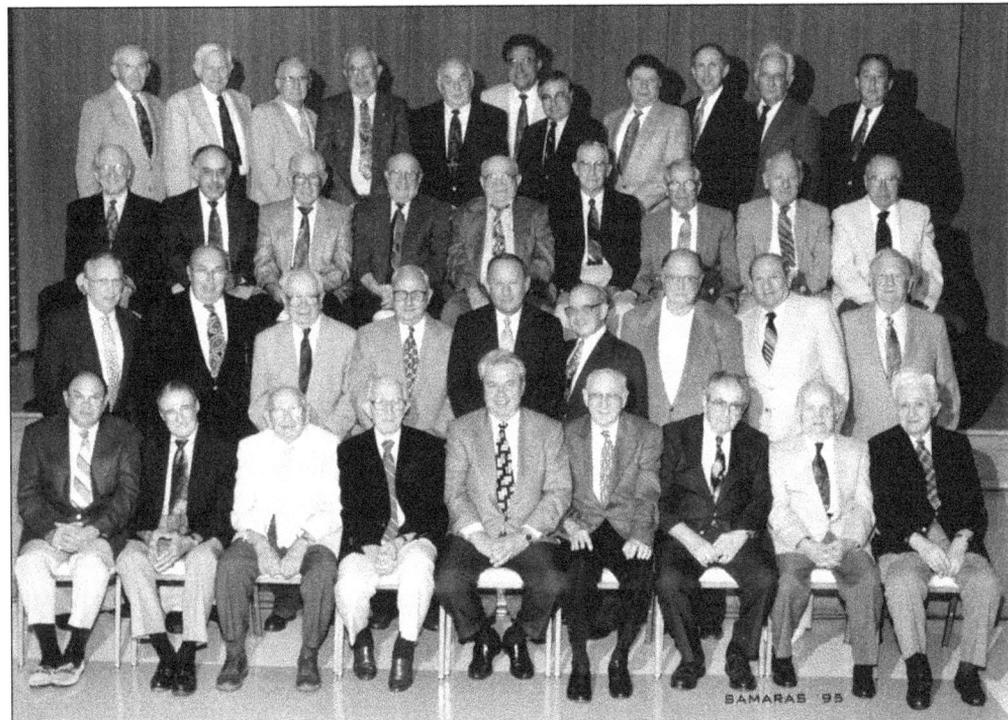

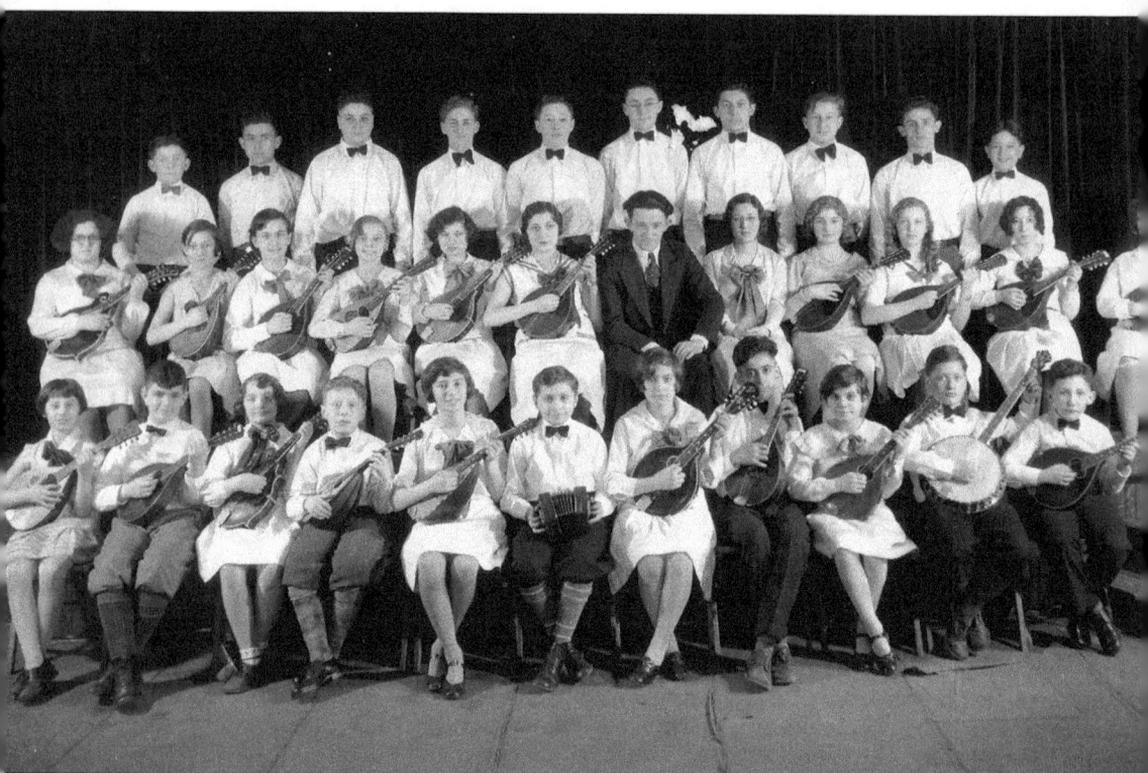

The Workman's Circle stressed Jewish culture in its programming. Pictured is the Mandolin Band from 1930, conducted by Dan Frohman. Musicians and singers identified are Harry Sabgir, Ruth Dunn, William Pliskin, Celia Gerin, Libby Daly, Bill Axelrod, Hannah Kodish, Sid Glazman, Sol Deutchman, Sylvia Waitskin, Annabelle Whitehouse, Libby Pliskin, Martha Lipsitz, Ida Cohen, Ida Goldner, Freda Schiff, Joe Deutchman, Donald Smith, Nate Glazman, Abe Pliskin, Jack Lipsitz, William Whitehouse, and Harry Rulnick. (Photograph courtesy of Joe Deutchman.)

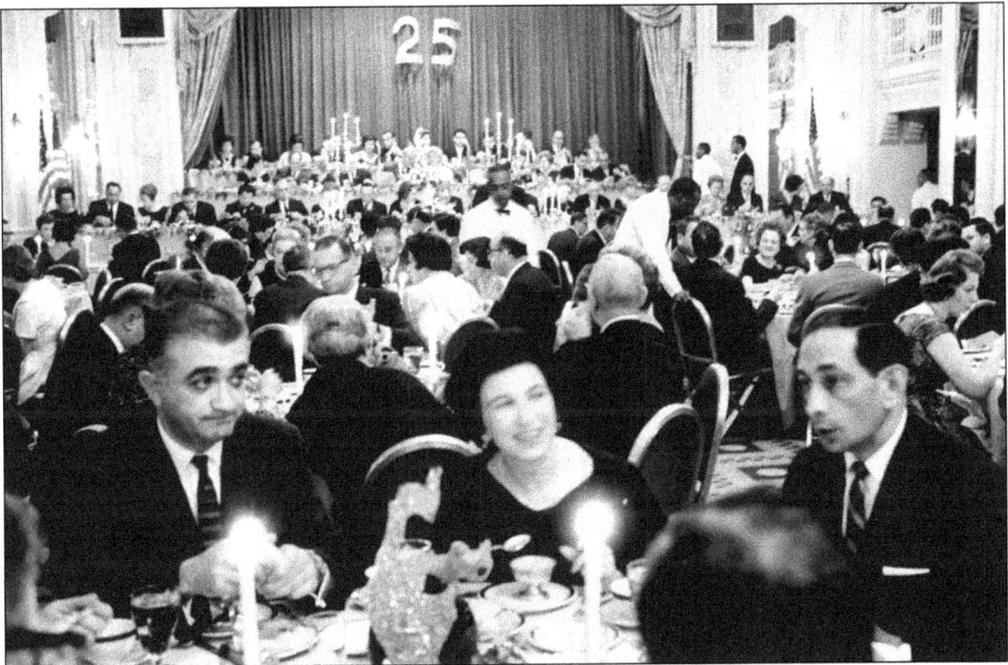

The Akron community, through the United Jewish Appeal and then Jewish Welfare Fund, vigorously and generously supported the founding of the State of Israel. Campaigns led by Ben Holub, Ben Sugar, Charles Schwartz, James Nobil, Dave Holub, Herman Rogovy, and Sidney Albert, among others, consistently raised more than the set goal. The 25th anniversary of the State of Israel in 1953 is the occasion for celebration at the Mayflower Hotel Ballroom.

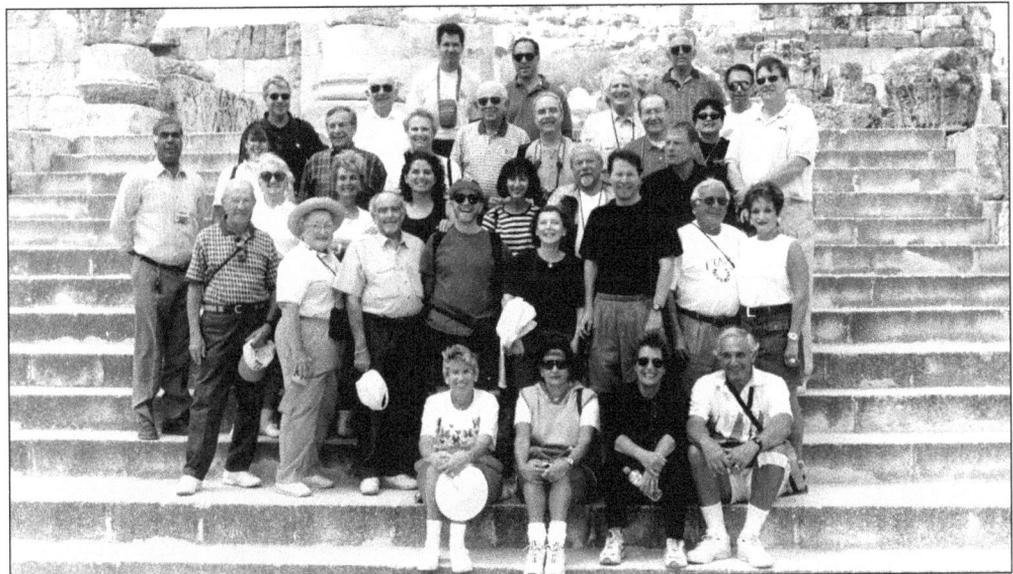

Almost every year, the Jewish Community Federation sponsors a mission to Israel. The mission gives the group an opportunity to tour the country and to see firsthand the accomplishments of prior fund-raising efforts and the needs remaining. The experience forges the bond between communities in a positive and lasting way. Here the group poses on the steps of the forum in Caesarea in 1989.

Jewish Family Service provides services and counseling to Akron families. In this photograph, prominent pediatrician Dr. Robert Stone and Beth El Rabbi Abraham Feffer affix a mezuzah on the doorpost of the Jewish Family Service offices in 1978.

Mike Wise has spent over 20 years serving the Akron Jewish community, through the Akron Jewish Federation. Mike was responsible for the reorganization of the community as the Jewish Community Board of Akron (JCBA) to reflect its present makeup and enable constituent groups to share resources. This innovation organization is a model for other midsized communities. Mike serves as executive director of JCBA.

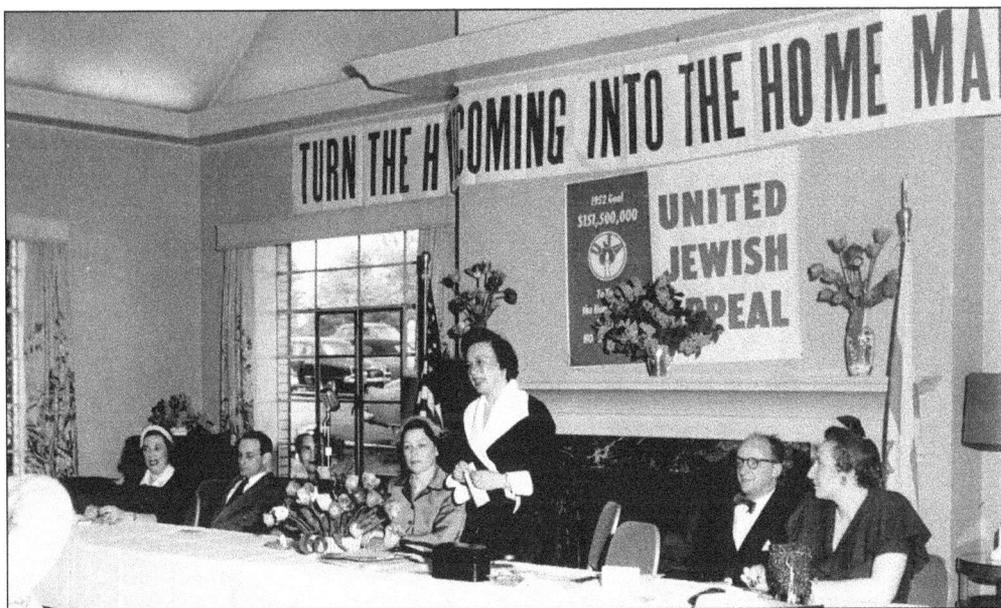

Nathan Pinsky was executive director of the Akron Jewish Community Federation for many years and energized the community toward philanthropy. Presiding over the 1952 meeting of the United Jewish Appeal luncheon is Estelle Albert. Joining her at the table are, from left to right, Sylvia Weinberger, an unidentified man, Jeanette Weil, Nathan Pinsky, and Rose Pinsky.

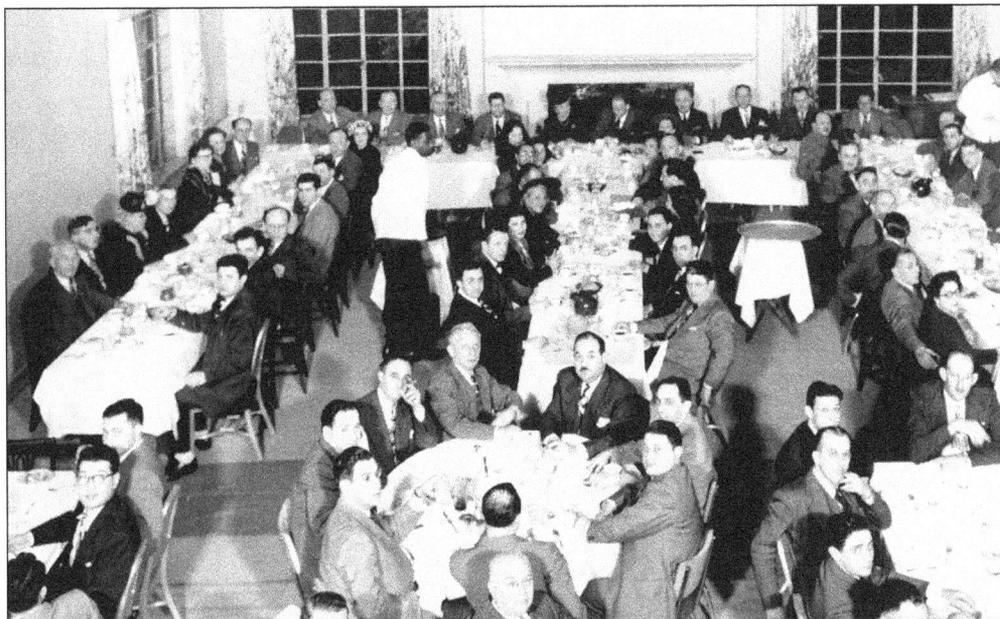

Rosemont Country Club was founded because Jews were not accepted into Akron's other country clubs, and as one of its founders remarked, "Some Jews like to play golf." There were two conditions for membership: membership in an Akron synagogue and a pledge each year to the Jewish Welfare Fund. Today all Akron country clubs are open to community membership. Here the men's division of the Welfare Fund holds a fund-raiser at Rosemont's former West Market Street site.

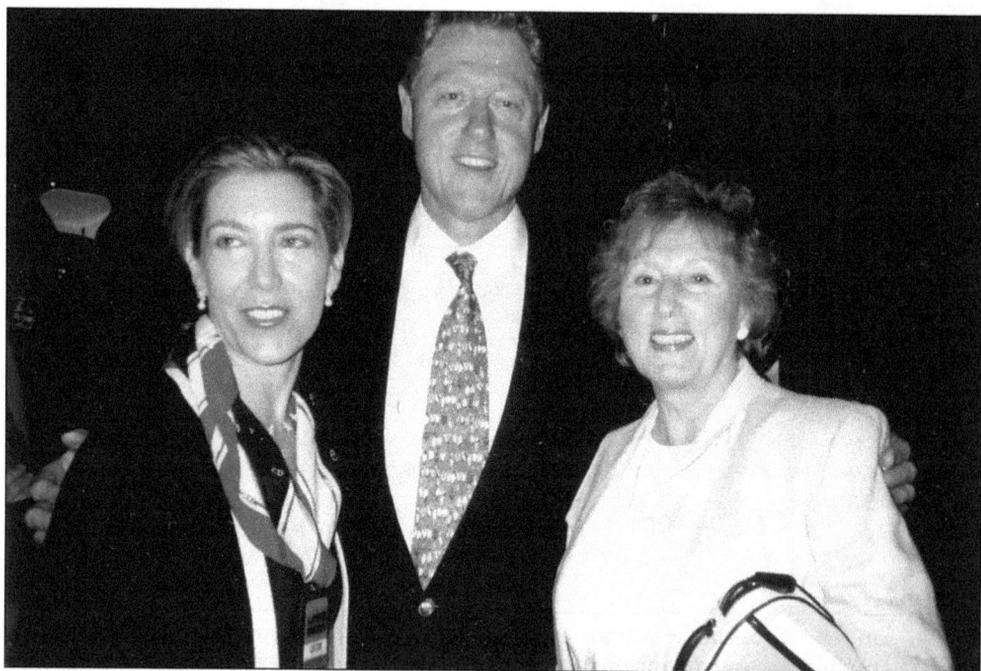

Who is that man standing next to Sylvia Lewis, the president of Na'amat USA? Sylvia has dedicated much of her life to this former Pioneer Women's organization but always finds time for service to Akron. In this photograph, Sylvia (right) and President Bill Clinton stand with an unidentified woman. (Photograph courtesy of Sylvia Lewis.)

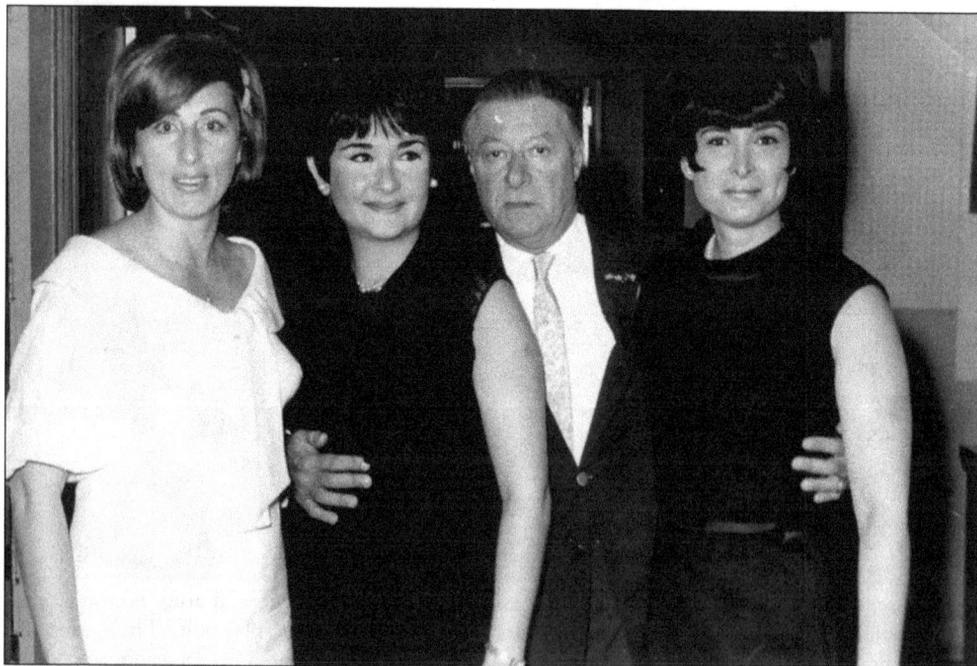

Akron's Jewish community has always generously supported the Israel Bond campaign and has done so in style. Here are, from left to right, Sylvia Lewis, Judy Wildman, and Elaine Apelbaum, along with their good friend George Jessel at a fund-raiser.

Seven

ENTREPRENEURIAL JOURNEY

While many Jewish immigrants earned money as peddlers, some came to America with resources. Koch and Levi Company, founded by two Jewish cousins, opened in 1845 and was Akron's first men's ready-to-wear establishment and remained in business for over 100 years. During that time, retail businesses in downtown Akron, Wooster Avenue, Copley Road, and East Market Street were predominantly owned by Jewish merchants. Many sons and daughters of first generation immigrants did not go into the family businesses but instead became professionals. Akron Jews were also successful in developing their own diverse endeavors such as: rubber, plastic and metal scrap; electronics; sheet metal; aluminum siding; jewelry and shoe manufacturing; automobiles, used parts, and related products; and barrel making. Service industries such as food distributors, industrial launderers, employment services, and dry cleaners were owned by Jewish families. The following pages illustrate a few old and new entrepreneurs.

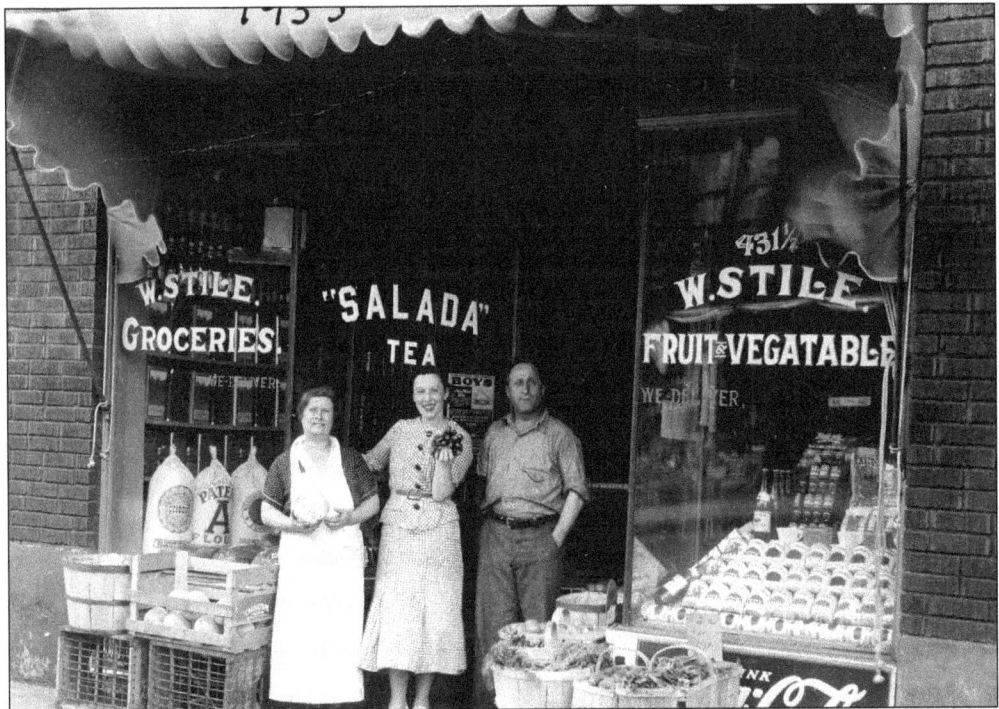

William Stile opened a grocery store on Wooster Avenue. He is pictured here with his wife, Pauline (left), and Ann Roseman. (Photograph courtesy of Bessie Stile Rothkin.)

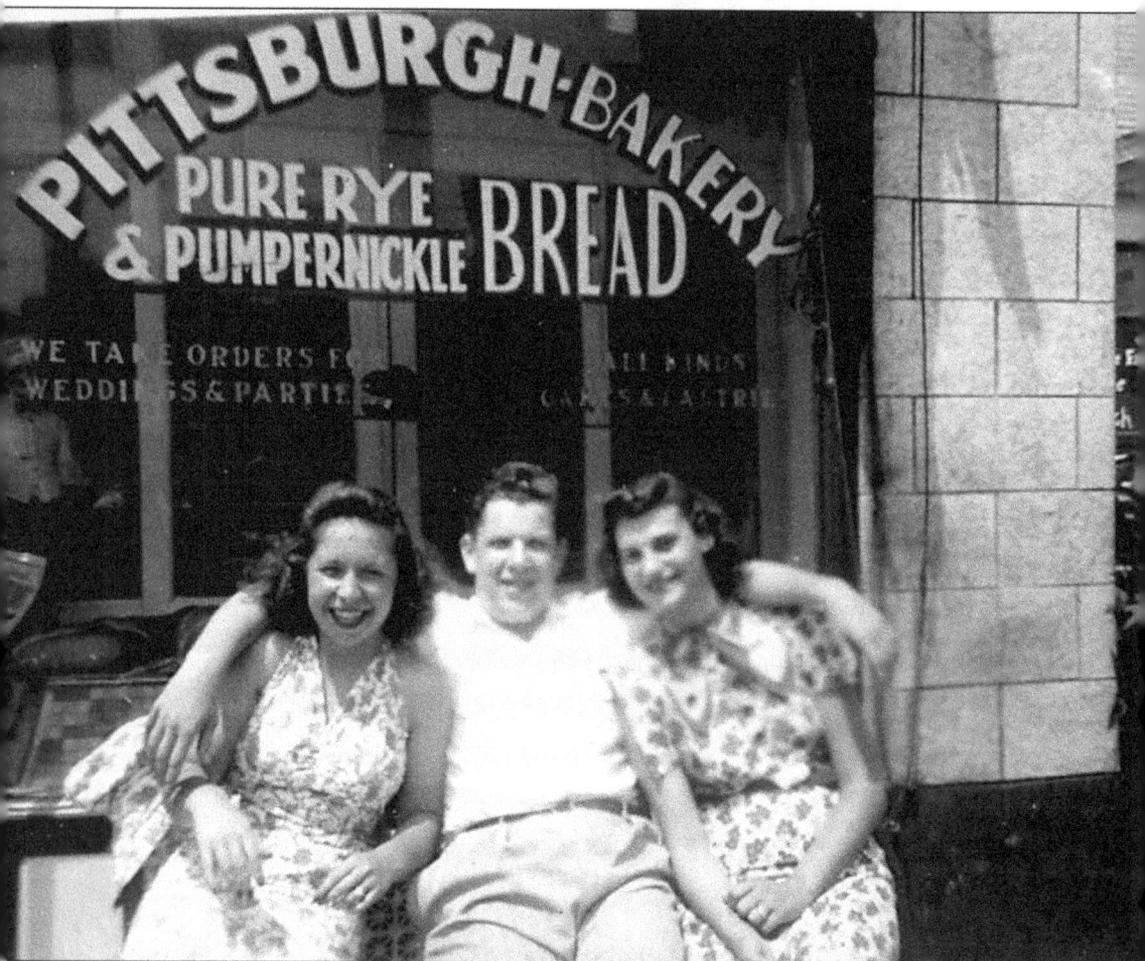

Two Jewish bakeries on Wooster Avenue, the New York Bakery and the Pittsburgh Bakery, were busiest on Thursdays, when women shopped for freshly baked challah and rye bread for their Friday evening Sabbath dinner and Saturday meals. Sitting in the front of the Pittsburgh Bakery in 1938 are, from left to right, Bella and Harry Kodish and Rosetta Penner. (Photograph courtesy of Bessie Stile Rothkin.)

Wooster Avenue, 1920–1950

(From Rhodes Avenue to Edgewood Avenue)	(Other side of the street)
Roseman's Deli	Sholitan's Drug Store
Stile's Grocery	Cohen Grocery (after Sarlson)
Siplow Grocery (after Stile closed)	Sarlson's Grocery
Daly's Butcher Shop (an alley where Reverend Goldstein slaughtered chickens)	Swedler's Poultry Store
	Smith Hardware
Rebeck's Fish Market	
Mintz Fish Market (after Rebeck)	Savage Mens Wear (also on Wooster Avenue)
Ida Goldwasser's New York Bakery	Portage Insurance
Munitz Kosher Meats	Cheplowitz Market
Kaplan Dry Goods	Wooster Sheet Metal
Pittsburgh Bakery	Galanti Kosher Meat
Polstein Poultry	

102

Lawrence Siff came to Akron in 1934 and made his mark as a successful entrepreneur and philanthropist. His stores included Siff Shoes, Wagoner Marsh, and, eventually, shoe stores in many states. He was a founder and president of Beth El and received a Distinguished Service Citation from the Jewish Theological Seminary. In his 32 years in Akron, Siff was one example of the many successful men in Akron who gave of themselves to improve the Jewish community.

Bringing the beauty of the art of the day to Akron has been the role of Akron Art Museum director Mitchell Kahan. His nearly 20-year tenure in Akron has seen the museum expand both artistically and, at present, physically.

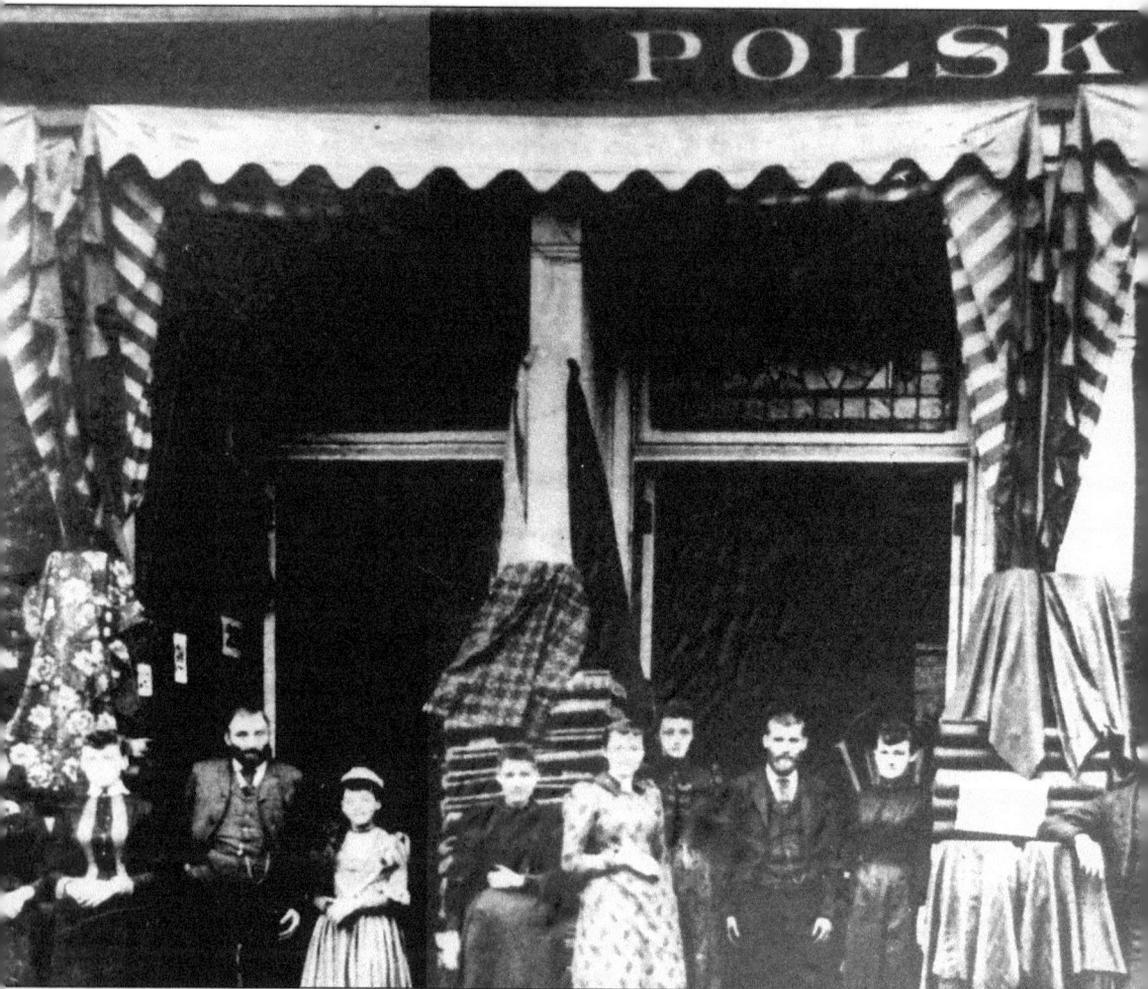

A. Polsky arrived in Akron in 1885 and built one of the major department stores in Akron, which stayed in business for more than 80 years. Shown here are the Polskys in front of the original store on Howard Street. Later Polsky's moved to South Main Street facing its strongest competitor, the M. O'Neil Company. Polsky was prominent in both the Jewish and Akron communities, a legacy upheld by his son, Bert. Today the Bert A. Polsky Humanitarian Award is given annually by the Akron Community Foundation to an outstanding member of the Akron community. Jewish businessmen of Akron achieved positions of prominence throughout the city. Many were leaders in the chamber of commerce and boards of trade. In the heyday of downtown Akron, Jewish merchants owned or managed over 60 businesses on Main Street and its vicinity. (Photograph courtesy of the University of Akron Archives.)

Federman's, a popular Main Street department store, employed many Jewish teens and young adults through the 1950s. This photograph shows the store as it was in 1917, on the northwest corner of Main and Mill Streets. (Photograph courtesy of the University of Akron Archives, Olson Collection.)

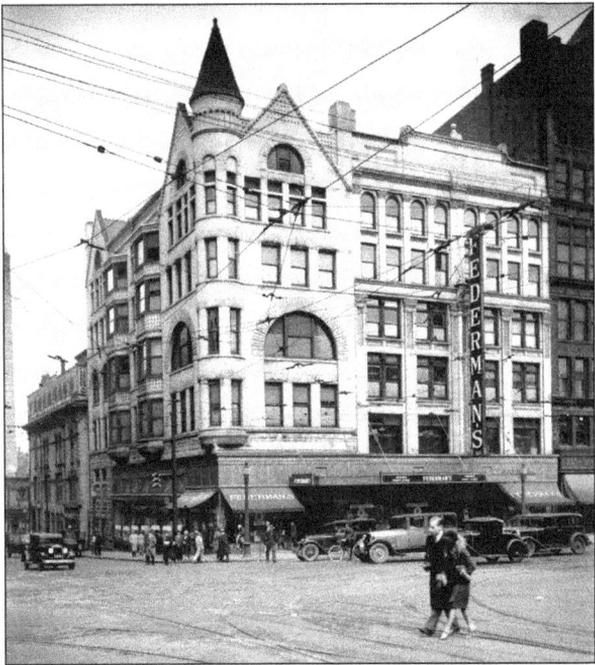

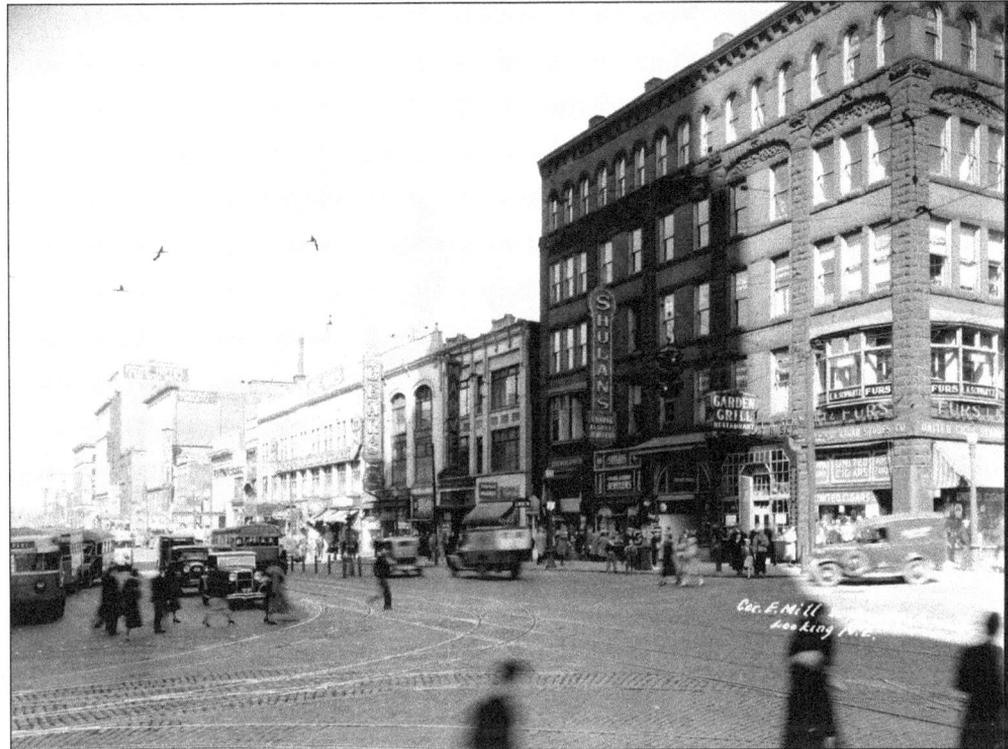

Shulan's has been one of Akron's finest jewelry stores and remains so today. Although no longer on Main Street, it is still owned and operated by the Shulan family. Pictured in 1930 is the Main Street store, which was located at 85 South Main Street. (Photograph courtesy of the University of Akron Archives.)

Morris (Morrie) Berzon is described as affable, generous, and a very good businessman and friend. His father, Sam, began the Annadale Junk and Glass Company in 1929. Since then, this major corporation became Annaco Incorporated and recycles scrap. This photograph shows, from left to right, Larry Berzon (Morrie's brother), Sam, and Morrie. (Photograph courtesy of Myrna Berzon,)

Morton Stein started the Brunswick Insurance Company in the early 1970s and his son Todd joined the business in 1979. They have built this risk management company into a multicity service company. Mort and Todd have accomplished much in the Jewish community by serving on the boards of the Akron Jewish Center, Jewish Federation, and, in Mort's service, chairing the Jewish Federation general campaign. (Photograph courtesy of the Stein family.)

The expansion of his soft drink business brought Julius Darsky to Akron from Youngstown. Willard Bear, on the right, owned a successful furniture business. Like many of their contemporaries, they held leadership positions in a variety of community and Jewish organizations. They were also responsible for raising significant funds for Jewish charities and the State of Israel.

Myers Industries began as Myers Tire Supply in 1933, a partnership of Louis S. Myers and his older brother, Meyer Myers. Their surname was Schneiderman. Isadore, the youngest brother, joined them later. All three changed their names to Myers because customers would call them "Mr. Myers." Louis Myers's son, Stephen, continued in the business until his retirement in 2005. Myers Industries is an international corporation. In this 1964 photograph, the three brothers are standing in the second row; from left to right are Louis, Meyer, and Isadore Myers. (Photograph courtesy of Myers Industries.)

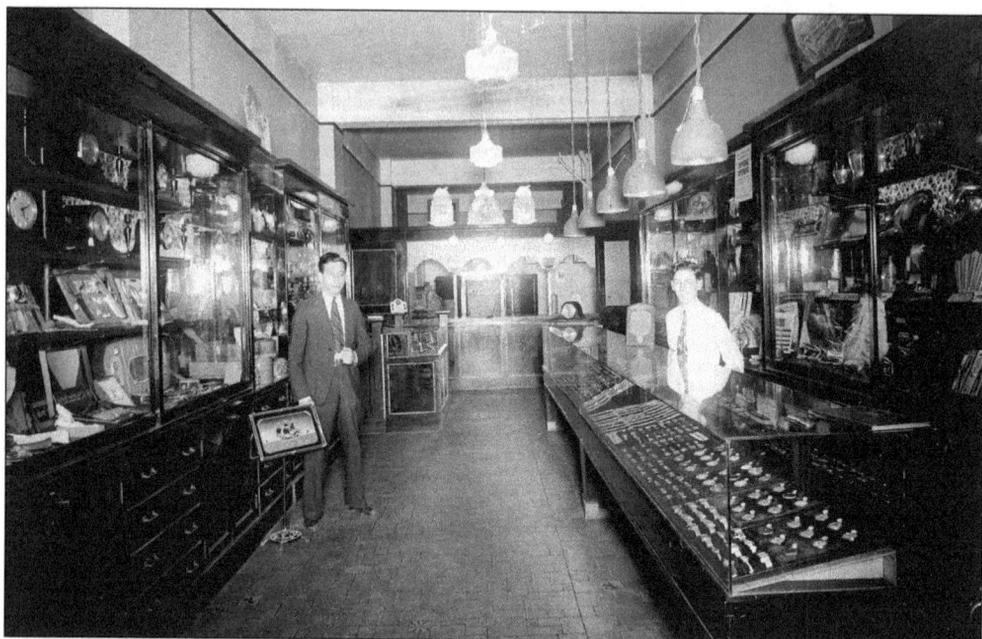

Al Backer opened his jewelry store on East Market Street in September 1929. With a large selection of fine jewelry and a location near the Goodyear Tire and Rubber Company, Backer's Jewelry thrived for 50 years, even through the Depression. Among other Jewish merchants in that area of East Market were Sokol Furniture, Portage Furniture, and the East Akron Cut Rate. Shown on the inside of his store are Al Backer (left) and Ben Shilesky. (Photograph courtesy of Joyce Levin.)

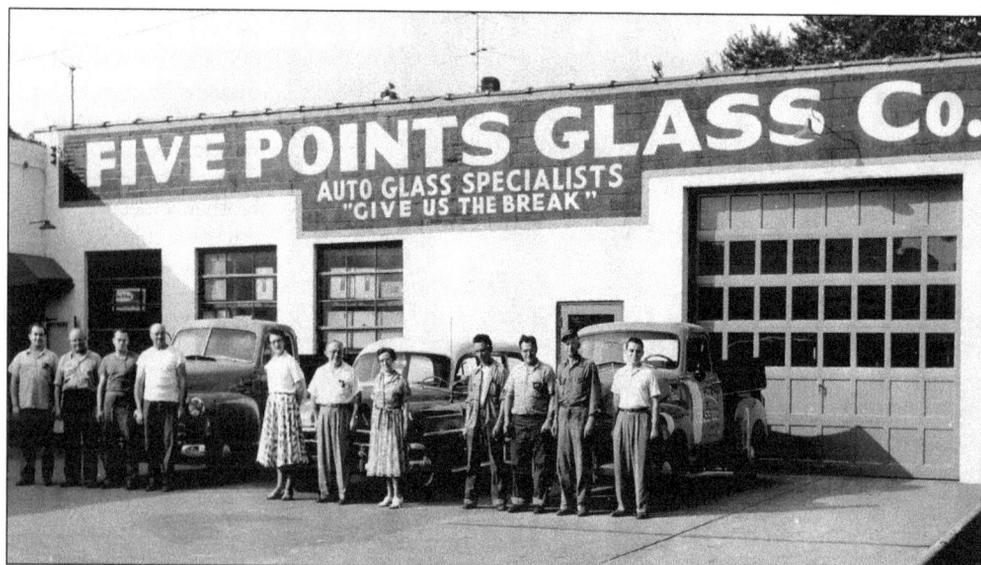

When Jack Rossen began selling glass at Five Points Glass on West Exchange Street, he was the third generation of his family to enter the glazing business. His grandfather carried glass on his back in Europe, and his father came to Akron and began a glass business there. Twenty years later, Jack's son Dick entered the business as the fourth generation. In this photograph, Jack (middle) stands with his employees. Dick is standing on the far right.

Louis (Louie) Lockshin and his wife, Becky, were very devoted to Jewish tradition. Louie had the foresight to start Workingman's Overall, a uniform company, when industry in Akron was booming. As he, his son David, and son-in-law Carl Osherow expanded the business, they changed the name to Uniwear. Third generation sons entered this thriving enterprise and, in recent years, the family sold to a national firm. Louie and his family were stalwart members of Beth El congregation. (Photograph courtesy of David Lockshin.)

Jacob (Jerry) Pollock's business career began when he founded Barberton Iron and Metal (now Barmet) in 1948. Since then, his acquisitions have continued and enabled him to become a major philanthropist to the Jewish community. Over the years, his varied companies included the largest aluminum, continuous casting sheet and coil facility in the United States, and the Flex Team Temporary Services Company, in which he is still involved on a daily basis. The community has tremendously benefited from Jerry's largesse. (Photograph courtesy of Rick Pollock.)

Akron's Jewish builders and developers have successfully established themselves over the years by building homes, commercial buildings, malls, and strip store centers. These major enterprises have become multigenerational, as original owners are now partners with sons and grandsons. Represented on these pages are four major developers. Victor (Vic) Gross of Castle Homes has successfully built homes, apartments, and condominiums throughout Summit County. In the photograph above, Vic is pictured with his son Scott, now a principal of Castle Homes. (Photograph courtesy of Mel Stern.)

The entrepreneurial spirit of William Stile, the peddler, spread throughout his family. Stile Companies is known for its quality homes. In this photograph are Lou Stile (William's son) and Lou's son Joel. (Photograph courtesy of Aaron Stile.)

Building homes is also the focus of Botnick Builders. They are credited for building the first condominium development in the area. Their homes are located all over Akron and the western suburbs. Their newest development in Bath, Ohio, is built with an ecological balance of green space and family living spaces. The precursor to the Botnick Company was begun by David Bloom, Steve's grandfather. In this photograph are Steve Botnick and his father, Irving. (Photograph courtesy of Dolores Botnick.)

Herb Newman of Summit Management Services has built low-income housing throughout Summit County, creating neighborhoods where residents take pride in their surroundings. Additionally, Herb has developed strip malls and shopping centers in suburban areas. Herb also served the city as director of Akron Metropolitan Housing Authority. In this recent photograph, Herb is pictured with his son Ed, who joined the business after college. (Photograph courtesy of Paula Newman.)

111

Selma Feldman, seen here with her grandchildren, was the first female Jewish attorney in Akron. She began her practice in the 1940s with her husband, Abe, when most wives were expected to maintain (clean) the home, raise the children, and become active in Jewish organizations as volunteers. (Photograph courtesy of Jim Feldman.)

Joseph (Joe) Kodish is an example of a quiet, unassuming man. He was awarded the Akron Bar Association's Professionalism Award and served as treasurer of the Summit County Bar Association. Joe is the head of the Summit County Public Defender's office and also has a private practice. His wife, JoEllen, retired from the Barberton Schools and is a valuable volunteer to an enormous number of organizations and individuals. (Photograph courtesy of the Kodish family.)

Judge Ted Schneiderman was elected to the Akron Municipal Court after a colorful and effective citywide campaign in 1982. Later he was elected to the Summit County Common Pleas Court. Known as a "take charge" judge, he was and is highly respected by his fellow judges and the Akron Bar. He had been an assistant city prosecutor and a partner in the law firm of Hershey and Browne. (Photography courtesy of Adam Rosen.)

Marvin Shapiro grew up in Akron, participating in AJC-sponsored sports and club activities. As an adult, he continued to be active in AJC affairs. Marvin started his career as a Summit County sheriff's deputy. Later he became an attorney. He served on the Akron Municipal Court and was elected to the Common Pleas Court in 2004.

Ben Maidenburg (center) became editor-in-chief and then president of the *Akron Beacon Journal* under John S. Knight (left), both shown at the *Beacon*. He is remembered as having a rough exterior, being a hard worker, honest, always demanding and getting the best from his fellow newspaper employees. Yet, inside, he was a gentle man. As the editor-in-chief, Ben took the newspaper to a position of national prominence. (Photograph courtesy of the University of Akron Archives.)

Eminent photographer Julius Greenfield was the chief photographer for the *Akron Beacon Journal* for many years. Many of the photographs within this volume were taken by Greenfield. Hundreds of weddings and family occasions were documented by his talents. This photograph provides a rare glimpse of a truly distinguished artist. (Photograph courtesy of Naomi Singer, daughter of Julius Greenfield.)

The Main Street Muffin Company is the creation of two friends who capitalized on selling their muffin and cookie batters to hotels and large food chains. Steve Marks and Harvey Nelson founded the company in 1987. It does a mega-million dollar business in sales and has long outgrown the business's original home on Main Street. Steve Marks's Family Foundation is the main sponsor of a nationally recognized marathon race, held in Akron in the fall. (Photography courtesy of the Marks family.)

Stan Bober, an accountant by profession, together with his wife, Esther, have been devoted to Jewish causes all their adult lives, focusing particularly on raising money to support the State of Israel—always with an unforgettable smile. Both have also held leadership positions at the Shaw Jewish Community Center.

115

Eminent surgeon Dr. Otto Steinreich served the community for over 50 years. He arrived in Akron in 1946 and, within a few years, made a name for himself as director of medical education, and chairman, Division of Surgery at St. Thomas Hospital. Otto served as associate dean for clinical sciences at the area medical school (Northeastern Ohio Universities College of Medicine). He was president of Beth El congregation and instrumental in planning the Shaw Jewish Community Center building on White Pond Drive. (Photograph courtesy of Michael Steinreich.)

Larry and Harriet Richman have shown true concern for the needs of others, both professionally and in their volunteer hours. Larry, a radiologist, has served as president of Beth El congregation and as a long-term officer of Jewish Family Service. He serves on the team that trains residents of third-world countries to perform mammography. Harriet is president of Mobile Meals Incorporated and a member of the Women's Board of Akron City Hospital. (Photograph courtesy of the Richman family.)

Eight

BEACONS OF LIGHT

The Jewish history of Akron was forged by the dreams, dedication, and achievements of a special group of men and women whose vision created the institutions and organizations that remain the jewels of the Jewish community. Some of those institutions and organizations are mentioned earlier in this book, as are some of the individuals. It is not possible to name everyone who generously gave to make Akron a wonderful place not only for themselves but also for their children and grandchildren. This chapter highlights only a few "beacons of light"; the memory of many, many more remained undimmed.

"As these . . . candles give light to all who behold them, so may we, by our lives, give light to all who behold us." —*The New Union Prayer Book.*

Jewish War Veterans of the United States of America was formed in 1896 by Civil War veterans, originally to fight anti-Semitic remarks. Its preamble states that its purpose is to preserve the memories and record of patriotic service performed by men and women of the Jewish faith and to maintain the graves of the heroic dead. In 1932, the Akron Post 62 was granted a charter to perform service in this community, and in 1933, the auxiliary was formed. Both branches of the Jewish War Veterans continue to carry on the principles of the organization, volunteering at Brecksville's VA hospital, raising funds for various children's welfare programs, and maintaining 455 graves at seven cemeteries throughout the city. In this photograph, from left to right, are Harold Mermelstein, Julius Garman, Joe Deutchman, Sid Cheplowitz, and Sam Garman.

In August 1945, Jack Kent boarded a 3,000-troop ship for his military assignment in the Pacific Theater. He represents the hundreds of Akron Jewish men and women who served their country admirably in World War II. The authors salute their courage and patriotism. (Photograph courtesy of the Kent family.)

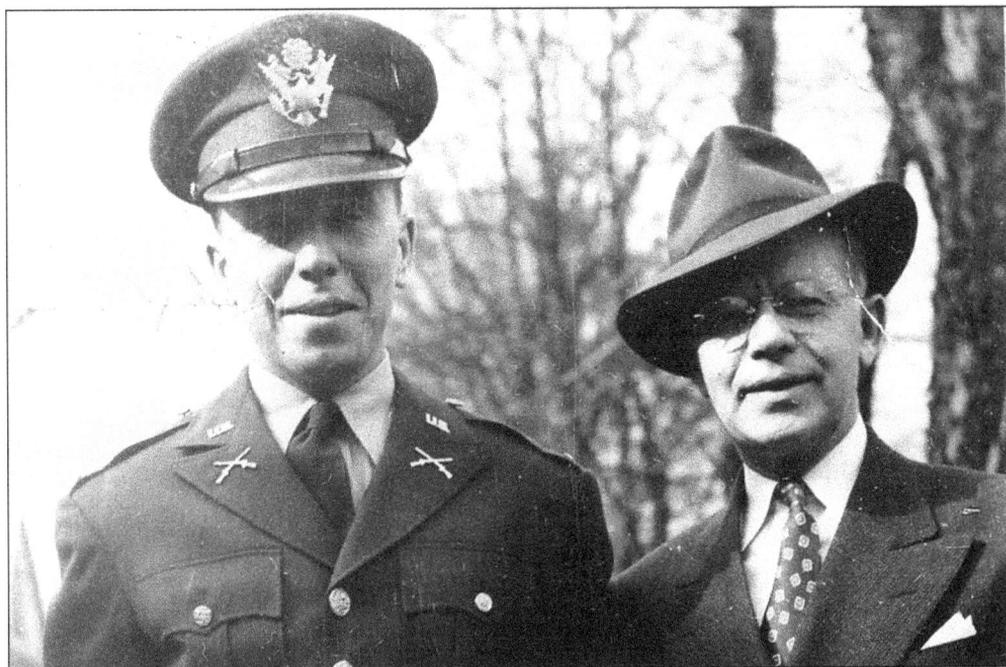

Bernard (Bernie) Rosen was stationed at Pearl Harbor during the attack of World War II, an experience that shaped his life and values thereafter. Following that assignment, he became an officer, served in Europe, was wounded, and received a Silver Star. Bernie was highly respected as an attorney, activist, and advisor to organizations. He was an accomplished raconteur who was frequently invited to be the emcee for organizational events. Bernie was appointed as a trustee at the University of Akron. (Photography courtesy of Adam Rosen.)

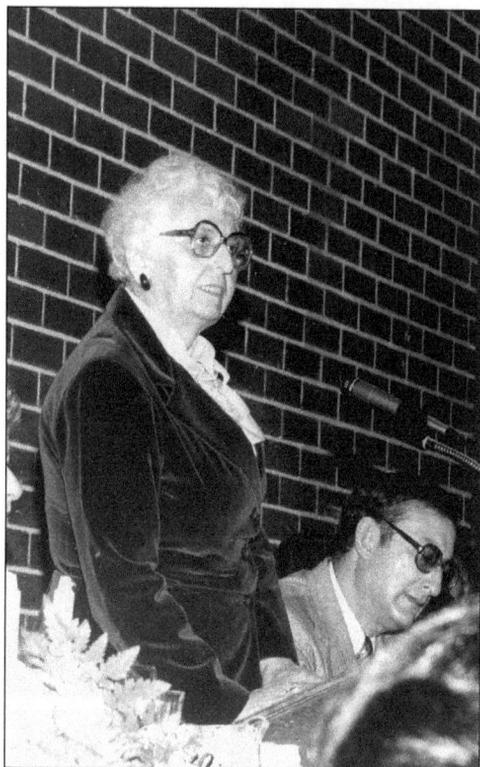

An outstanding community leader, Dr. Sarah Orlinoff was a professor in the College of Education at the University of Akron. Her leadership of Hadassah, Anshe Sfard, and the Shaw Jewish Community Center was extraordinary. Her wisdom and problem solving were valuable assets. One could never refuse her requests for time and treasure. In this picture, Dr. Sarah is installing officers at the Shaw Jewish Community Center in 1978.

The Akron Jewish community was honored to have leaders of organizations at the national level. In this photograph, Sylvia Lewis (on the left), national president of Na'amat USA (formerly Pioneer Women), and national board member Michelle Levin are attending a national Na'amat meeting. (Photograph courtesy of Sylvia Davidson Lewis.)

Max and Yetta Rogovy dedicated their lives to working for Jewish causes, particularly Zionist activities. Max Rogovy was the founder of the Farband Organization in Akron and organized their school. Yetta Rogovy worked tirelessly for related activities such as Pioneer Women and Jewish National Fund. Each was honored by national organizations for major fund-raising activities on behalf of these important groups. This is a photograph of Mr. and Mrs. Rogovy from the 1930s. (Photograph courtesy of Diane Greene.)

Meyer Lifsitz devoted many hours to the Workman's Circle organization. His dedication enabled this organization to maintain its Yiddish culture and labor-oriented ideals. Lifsitz was a successful businessman who started Portage Insurance Agency. He is remembered as a true philanthropist and community leader.

Clifford and Judy Isroff have contributed much to the Jewish and secular communities. Their love of the arts is shown through Clifford's leadership on a major capital campaign for the Cleveland Orchestra and Judy's tenure as president of the Akron Art Museum and chair of its building project. Clifford served as a trustee of the University of Akron, Temple Israel, Jewish Welfare Funds, and many other causes. Judy was the first woman to serve as president of the Akron Jewish Federation.

Jack Saferstein directed the Akron Metropolitan Housing Authority during the period of its major growth. He was a dedicated advocate for decent housing for all residents of Akron. In this photograph, Lenore Glauberman, president of the Center Auxiliary, presents Saferstein, president of the AJC, a check. Looking on, from left to right, are Charlotte Essner, Mona Nobil, and Leslie Flaksman.

Gloria Reich served as an editor of the *Akron Jewish News* for more than 30 years. She literally gave a face and a name to the Jewish community in her monthly columns. Active in Hadassah, Temple Israel Sisterhood, and the Woman's Division of the Welfare Fund, Gloria Reich is a priceless asset.

Elsie Reaven was an example and mentor to the women of Akron. In the 1960s, she enrolled at Kent State University and earned a master's degree in political science. She was elected to Akron City Council in 1971 and, later, to the at-large seat. Active in the fight for fair housing and an advocate for women's rights, Elsie was respected for never compromising her values. She is seen here with her husband, Sidney, a prominent Akron attorney. (Photograph courtesy of the Reaven family.)

The son of Lithuanian immigrants, Jerry Lippman and his wife, Goldie, started manufacturing a heavy-duty hand cleaner in 1946 in the basement of their home. It was a boon to mechanics and rubber workers. Today GOJO Industries is an international business. Jerry was always committed to social justice, education, and philanthropy. He never forgot the help he received from others and, as he became successful, generously gave back to the Jewish institutions of Akron, including the Jerome Lippman Day School, named in his honor. (Photograph courtesy of GOJO Industries.)

Jerry Holub learned from his father, Ben, the importance of contributing to the community, both in time and money. A lawyer, Jerry has always been active in Temple Israel, the Akron Jewish Center, the Jewish Federation, and the Akron Bar Association. No job is too small or too large. He was honored by the bar as the recipient of the Professionalism Award. Jerry is respected by all who know him. His prodigious memory has helped to preserve the history of this town. (Photograph courtesy of Margie Holub.)

Sidney and Estelle Albert helped to improve the quality of Jewish life in Akron. Sidney Albert was a major donor to Beth El, Jewish Federation, and numerous organizations. Estelle Albert was founder of Beth El Sisterhood, chair of Women's Division of Welfare Fund, and active in the secular community. They were the "power couple" of the 1940s and 1950s. Their daughter, Susan, celebrated the first bat mitzvah in Akron. In this 1956 photograph, Sidney and Estelle watch Susan register at Brandeis University. (Photograph courtesy of Melvyn Myers.)

Astronaut Judith Resnik was born in Akron in 1949 and tragically died in the explosion of the space shuttle Challenger on January 28, 1986. Her legacy to the community continues, as students realize the potential of women in the scientific world. She was a true hero to the community and to the United States. (Photograph courtesy of the Resnik family.)

Dr. Robert and Rochelle (Dienoff) Stone have devoted their time to a multitude of secular and religious organizations. Rochelle was the first woman president of Beth El congregation and the recipient of United Way's distinguished Service Award. Robert is president of the Akron Medical Society and has been president of Jewish Family Service. He was voted "Outstanding Pediatrician" of Ohio and "Premier Physician" of the Crohn's-Colitis Foundation. Children's Hospital Respiratory Center was named after him in 2003. (Photograph courtesy of the Stone family.)

Adventure, exotic travel, and RV experiences combine with Jewish values when Marty and Sue Spector travel. They observed Shabbat and kashruth in places where these terms are foreign. In Akron, both are active in Jewish causes. Sue is former president and donor chair of Hadassah. As an accountant and advisor, Marty works with endowment investment, is a trustee of the Jewish Community Board of Akron, and former chair of the Summa Health System Foundation. In this photograph, they are visiting Israel. (Photograph courtesy of the Spector family.)

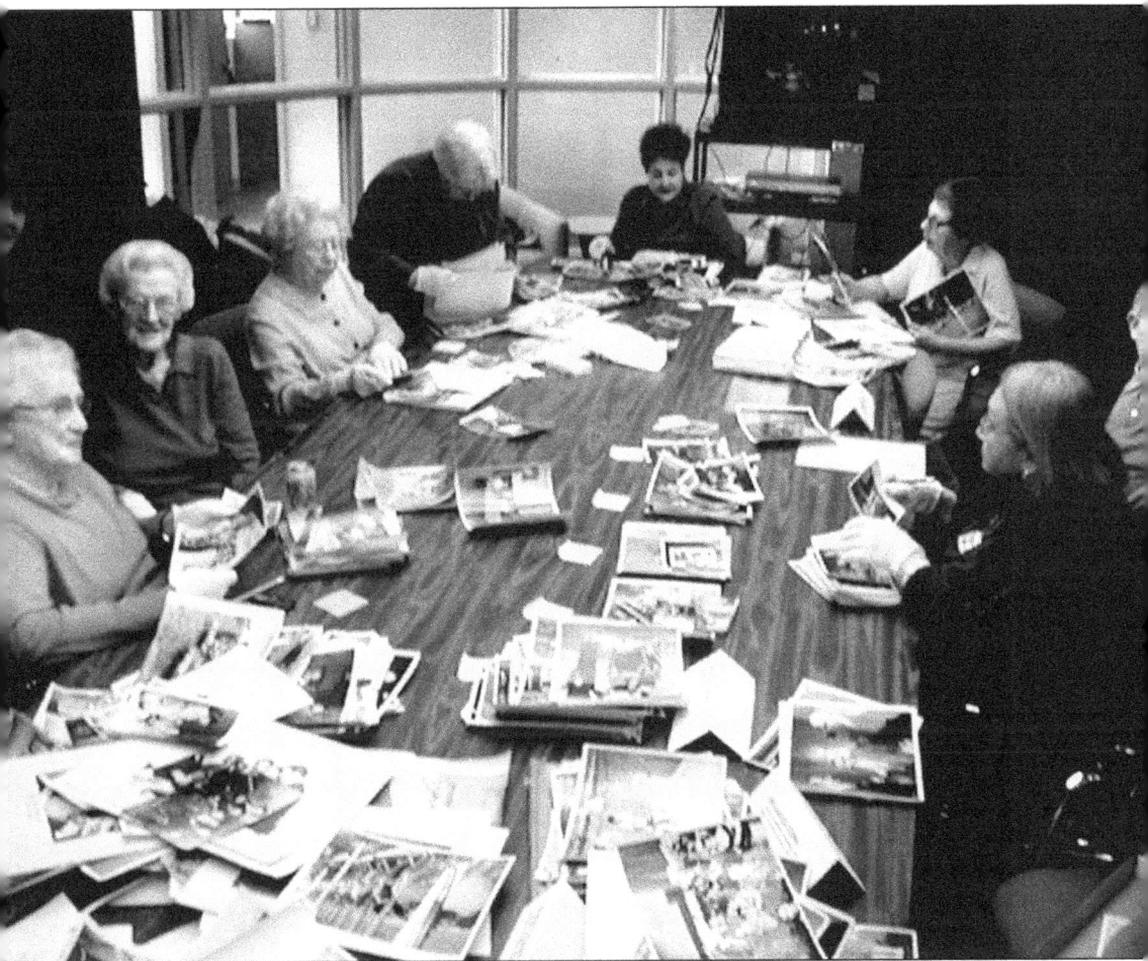

In the beginning, 32 white-gloved volunteers gathered around the table at the Shaw Jewish Community Center to share the memories that only photographs can bring. In the hunt for "just the right one" are Patty Vigder, Carolyn Narotsky, Ruby Kodish, Esther Posen, Patsy Siff (standing), Esther Levin, and Ruth Moss. Their success resulted in this volume.

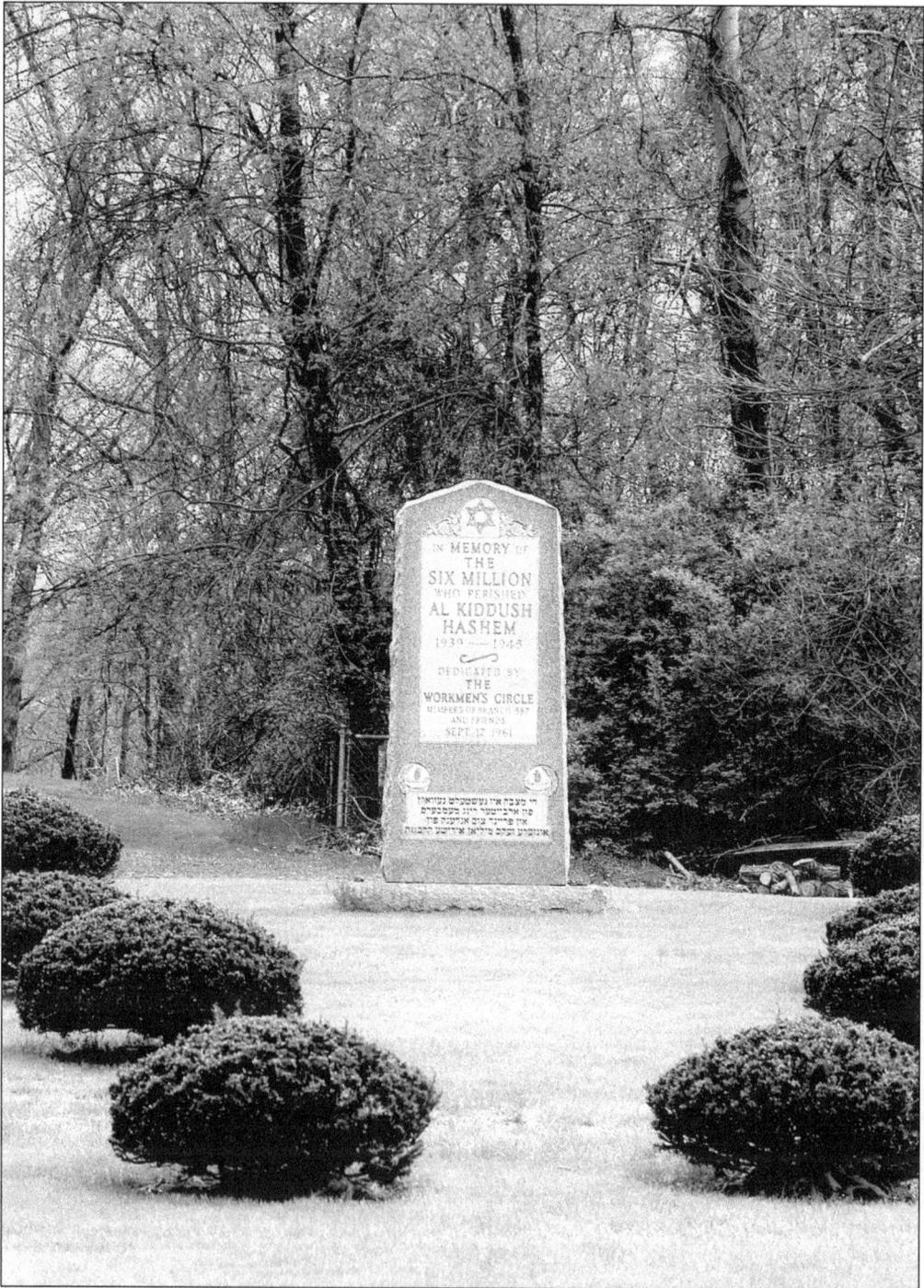

Although Akron is situated in the midwestern part of the United States, the roots of its Jewish community reach back to Europe. During World War II, the Holocaust directly impacted many Akron families. It is important that this tragedy is never forgotten. This photograph shows the Holocaust Memorial tablet, dedicated on September 17, 1961, at the Workman's Circle cemetery to the memory of the six million European Jews who died in that war. (Photograph by Aaron Rapport.)

www.ingramcontent.com/pod-product-compliance
Lightning Source LLC
Chambersburg PA
CBHW050640110426
42813CB00007B/1869